Shinji Nishikawa

GODZILLA:
The Encyclopedia

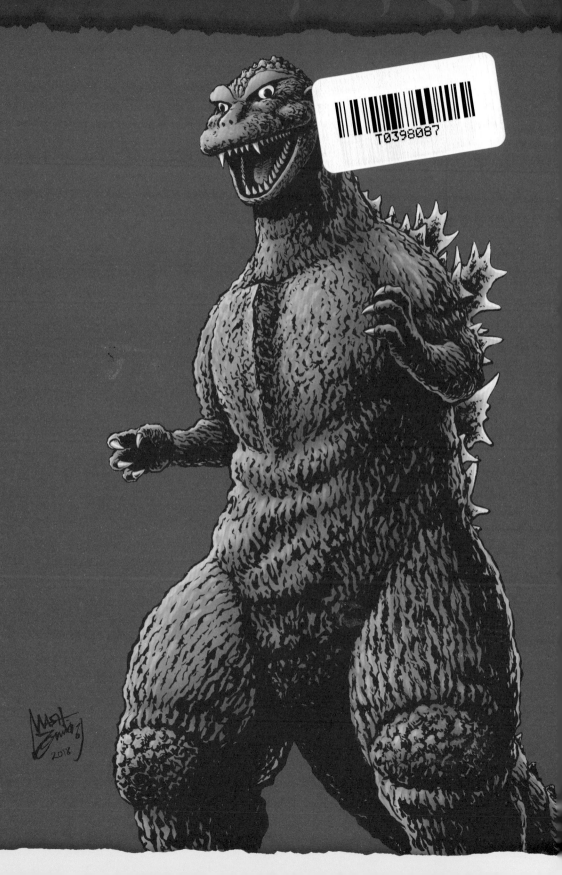

Showa Godzilla Series

1954
"Godzilla"
Godzilla006

1955
"Godzilla Raids Again"
Godzilla010
Anguirus012

1962
"King Kong vs. Godzilla"
Godzilla014
King Kong016

1964
"Mothra vs. Godzilla"
Godzilla018
Mothra020

1964
"Ghidorah, the Three-Headed
Monster"
Rodan024
King Ghidorah026

1965
"Invasion of Astro-Monster"
Godzilla030

1966
"Ebirah, Horror of the Deep"
Godzilla032
Giant Condor033
Ebirah034

1967
"Son of Godzilla"
Godzilla036
Minilla038
Kamacuras040
Kumonga042

1968
"Destroy All Monsters"
Godzilla044
Anguirus046
Gorosaurus048
Manda050
Baragon052
Varan054

1969
"All Monsters Attack"
Gabara056

1971
"Godzilla vs. Hedorah"
Hedorah058

1972
"Godzilla vs. Gigan"
Gigan062

1973
"Godzilla vs. Megalon"
Godzilla064
Megalon066
Jet Jaguar068

1974
"Godzilla vs. Mechagodzilla"
Mechagodzilla070
King Caesar072

1975
"Terror of Mechagodzilla"
Mechagodzilla074
Titanosaurus076

Heisei Godzilla Series

1984
"The Return of Godzilla"*
Godzilla080
Shockirus083
*Released in the U.S. as "Godzilla 1985."

1989
"Godzilla vs. Biollante"
Godzilla084
Biollante086

1991
"Godzilla vs. King Ghidorah"
Godzilla090
Godzillasaurus092
Dorat093
King Ghidorah094
Mecha-King Ghidorah096

1992
"Godzilla vs. Mothra"
Godzilla098
Mothra100
Battra102

1993
"Godzilla vs. Mechagodzilla II"
Godzilla106
Mechagodzilla108
Super Mechagodzilla110
Rodan112
Babygodzilla114

1994
"Godzilla vs. Spacegodzilla"
Godzilla116
Spacegodzilla118
Littlegodzilla120
M.O.G.U.E.R.A.122

1995
"Godzilla vs. Destoroyah"
Godzilla124
Destoroyah126
Godzilla Jr130

Godzilla: The Encyclopedia

Millennium Series

1999
"Godzilla 2000: Millennium"
Godzilla............................134
Millennian...........................136
Orga...................................138

2000
"Godzilla vs. Megaguirus"
Meganulon...........................140
Meganula............................140
Megaguirus.........................142

2001
"Godzilla, Mothra and King Ghidorah:
Giant Monsters All-Out Attack"
Godzilla..............................144
Baragon.............................146
Mothra...............................148
King Ghidorah.....................150

2002
"Godzilla Against Mechagodzilla"
Godzilla..............................152
Mechagodzilla: Multi Purpose-Fighting
System Kiryu (Heavy Armed Type)............154
Mechagodzilla: Multi Purpose-Fighting
System Kiryu (High Mobility Type)............156

2003
"Godzilla: Tokyo S.O.S."
Mechagodzilla: Modified Multi
Purpose-Fighting System Kiryu..............158
Kamoebas...........................160
Mothra...............................162

2004
"Godzilla Final Wars"
Godzilla..............................164
Minilla................................166
Monster X..........................168
Kaizer Ghidorah...................170
Gigan.................................172
Ebirah................................174
Manda................................176
Anguirus............................178
Rodan................................180
King Caesar........................182
Kamacuras.........................184
Kumonga............................186
Hedorah.............................188
Zilla...................................190

SHIN GODZILLA

2016
"SHIN GODZILLA"
Godzilla (2ⁿᵈ Form)................194
Godzilla (3ʳᵈ Form)................195
Godzilla (4ᵗʰ Form)................196
Godzilla (5ᵗʰ Form)................197

Theatrical CGI Animated Film

2017
"GODZILLA: Planet of the Monsters"
Godzilla Earth.......................198
Godzilla Filius.......................198
Servum...............................199

2018
"GODZILLA: City on the Edge of
Battle"
Mechagodzilla.......................200

2018
"GODZILLA: The Planet Eater"
Ghidorah.............................201

Godzilla Singular Point

2021
"Godzilla Singular Point"
Godzilla aquatilis...................202
Godzilla amphibia..................202
Godzilla terrestris..................202
Godzilla ultima......................203
Rodan................................204
Anguirus............................204
Manda................................205
Salunga..............................205
Kumonga............................205
Jet Jaguar...........................206

**Lecture on how to draw
Godzilla's face**.......................208

**Heroines deeply involved
with the monster**...................212

People and terms.................214

Index.................................215

This is an illustrated book about Godzilla and other monsters, brought to life by manga artist and character designer Shinji Nishikawa, who has himself designed monsters for many Godzilla movies and TV shows. The types of monsters featured within are "modeling-based," and the differences in detail in monster suits and guignols are also noted (even if the monsters are the same in the story, if they are shaped differently, they are presented individually.) The monsters introduced here are predominantly from the TOKUSATSU film series from the first "Godzilla" released in 1954 to the "SHIN GODZILLA" released in 2016, the theatrical CG animated film series from 2017 to 2018, and the "Godzilla Singular Point" from 2021.

GODZILLA ANATOMICAL FILE

Godzilla Showa Era (1954-1975)

Godzilla
1954 "Godzilla"

Cargo ship EIKO MARU is lost off the Ogasawara Islands after being hit by a mysterious, intense light and explosion, an event which leads to a series of similar shipwrecks. A group of vessels heading out to investigate encounter a mysterious gigantic creature on Odo Island, which they name "Godzilla" based on island folklore. Later, Godzilla approaches the Japanese mainland.

Godzilla
1962 "King Kong vs. Godzilla"

A glowing, radioactive iceberg is discovered floating in the Arctic Ocean. It turns out to be Godzilla, frozen in the previous film. After attacking a nuclear submarine, it escapes from the iceberg and destroys a nearby military base. Trusting its homing instinct, it heads back to Japan and makes land in Matsushima Bay in Miyagi Prefecture.

Mothra
1964 "Mothra vs. Godzilla"

Following a typhoon, Mothra's eggs, previously safe on Infant Island, wash up on the shore of Shizunoura Village. Mothra heads to Japan and battles Godzilla, but runs out of power defending its eggs. Later, the eggs hatch and two larva emerge to challenge Godzilla.

Godzilla
1965 "Invasion of Astro-Monster"

The X aliens, residing on Jupiter's 13th moon, approach Earth to enlist Godzilla and Rodan to defeat the menacing King Ghidorah. Godzilla, dormant in Lake Myojin, is captured by spaceship and transported to the X planet, where it fights King Ghidorah together with a little help from Rodan.

Ebirah
1966 "Ebirah, Horror of the Deep"

Ebirah is a giant shrimp-like creature lurking in the waters off Letch Island, attacking passing ships. The yacht YAHLEN, caught up in a sudden squall, is also targeted by Ebirah, but its vulnerability lies in the yellow juice which comes from local berries, and doesn't dare appear when the juice is dispersed on the island.

Godzilla
1955 "Godzilla Raids Again"

A pilot crash-lands on Iwato Island and witnesses a battle between Godzilla and a mysterious monster during his rescue. They eventually disappear again under the waves, but Godzilla later emerges in Osaka, where it engages in battle with Anguirus, its relentless pursuer.

King Kong
1962 "King Kong vs. Godzilla"

Legend has it a "Giant Demon God" has awoken on the isle of Faro in the Solomon Islands. King Kong appears to protect the inhabitants from a giant octopus that attacks the island, but is later put to sleep by a narcotic red fruit and transported to Japan.

Radon
1964 "Ghidorah, the Three-Headed Monster"

A woman who claims to be Venusian appears in the crater of Mt. Aso and utters a prophesy: "Leave the mountain immediately. Volcanic gases in Earth's crust will bring Rodan back to life!" Rodan soon appears, cracking through the crater. It then attacks Godzilla, who has landed in Yokohama Harbor.

Godzilla
1966 "Ebirah, Horror of the Deep"

Godzilla sleeps peacefully deep in a cave on Letch, not far from Infant Island. However, a local secret society is committing evil acts. In order to destroy it, Godzilla is awakened from the energy of a lightning strike and has to fight the Giant Condor and Ebirah!

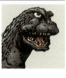

Godzilla
1967 "Son of Godzilla"

Godzilla lands on Sollgel Island and rescues Minilla from being pecked to death by the Kamacuras. After destroying two of these mantis-like creatures, Godzilla watches over Minilla's growth as a kind of protector, and saves it from the fearsome Kumonga.

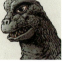

Anguirus
1955 "Godzilla Raids Again"

A mysterious monster appears to tussle with Godzilla on Iwato Island, with both of them sinking beneath the waves. It turns out to be a belligerent species of carnivorous dinosaur called the Ankylosaurus, also known as Anguirus. After Godzilla lands in Osaka Bay, Anguirus comes ashore. The two duel it out at Osaka Castle.

Godzilla
1964 "Mothra vs. Godzilla"

After the passing of super typhoon No. 8, Godzilla suddenly appears from the bottom of a now reclaimed stretch of Kurata Beach. It proceeds on a path of destruction from Yokkaichi toward Nagoya, laying waste to an industrial complex and Nagoya Castle. Later, Mothra flies in at the behest of Sakai and Junko, but Godzilla engages it in battle.

King Ghidorah
1964 "Ghidorah, the Three-Headed Monster"

In the distant past, Venus was an advanced planet boasting a far more prosperous civilization than Earth until all science and culture was destroyed by a monster originating from space. Soon a meteorite falls to earth near Kurobe Dam, and the flames that emerge transform into King Ghidorah as it begins its journey of mayhem.

Giant Condor
1966 "Ebirah, Horror of the Deep"

Giant Condor is a massive bird said to inhabit the island of Letch. It swoops down on Godzilla, who is sleeping peacefully on a rocky beach, attacking fiercely with claws. Godzilla's heat ray ignites the Condor's wings, and it crashes into the rocks, billowing smoke, before sinking into the sea.

Minilla
1967 "Son of Godzilla"

An egg buried deep in the rock of Sollgel Island is dug up by Kamacuras. The shell cracks and breaks open, hatching little Minilla. Godzilla teaches the little fellow how to spit heat rays. It becomes attached to Saeko, who feeds it nuts, and it later returns the favor by saving her from the Kamacuras using its new powers.

Kamacuras
1967 "Son of Godzilla"

The Kamacuras are a type of giant praying mantis that have grown massive due to a combination of abnormally high heat (over 70ºC/58ºF) and synthetic radioactivity. Makino gave the Kamacuras their name. Three of them attack a rocky hill from which a mysterious energy is radiating. They eventually break it down, digging out an egg from which hatches little Minilla.

Anguirus
1968 "Destroy All Monsters"

Anguirus lives on an island of monsters off the coast of Ogasawara, where it gets along well with Godzilla and other creatures. Controlled by the Kilaak aliens, it defends its home base in Izu along with Godzilla. Breaking free, it fights King Ghidorah in Aokigahara and delivers a neck-crushing bite.

Baragon
1968 "Destroy All Monsters"

Baragon has been living on Monster Island near Ogasawara, but is reported on the news to have appeared in Paris, and is later seen in Amagi, Izu. After the Kilaak aliens lose control of it, the monsters gather at Aokigahara to fight King Ghidorah.

Hedorah
1971 "Godzilla vs. Hedorah"

Hedorah is a creature spawned from toxic sludge in Suruga Bay. When dry, it takes the form of simple mineral particles, but immersing itself in water activates it and it grows to gigantic size. It first appeared as a mysterious creature at the site of a collision between two ships, and was also seen in the form of a giant tadpole.

Megalon
1973 "Godzilla vs. Megalon"

Megalon is a monster from the undersea kingdom of Seatopia, a peaceful nation before it was destroyed by human underground nuclear tests. Megalon is unleashed to fight a war of vengeance against the terrestrials up above. It emerges from dried up Kitayama Lake, and is led to Tokyo, where it battles both Godzilla and Anguirus.

King Caesar
1974 "Godzilla vs. Mechagodzilla"

Also known as Mighty King Azumi, this guardian deity of Okinawa was laid to rest on a rocky hill at Cape Manza. Awakened from sleep through prayers offered by Nami, heir to the Azumi royal family, it battles Mechagodzilla. After Mechagodzilla is placed in a full nelson by Godzilla, the King takes over and tackles it in spectacular fashion.

Kumonga
1967 "Son of Godzilla"

Kumonga is a giant spider that lurks deep in the earth at the bottom of a valley on Sollgel Island. Awakened by a rock tumbled in by Minilla, it crawls out of the valley. After attacking the humans, it shoots its deadly webs at Minilla to capture it, later doing the same to the Kamacuras. However, the threads prove weak against heat.

Gorosaurus
1968 "Destroy All Monsters"

Gorosaurus lives on Monster Island near Ogasawara, and is friendly with Godzilla and pals. Mind controlled by the Kilaak aliens however, it goes on a rampage and emerges from under the Arc de Triomphe in Paris. After breaking free of the Kilaak, the monsters gather in Aokigahara for the final battle.

Varan
1968 "Destroy All Monsters"

Varan lives in harmony with Godzilla and friends on their Monster Island home. It is not known if it is under control of the Kilaaks, but it also disappears from the island, and is later seen gathering at Aokigahara to fight King Ghidorah.

Gigan
1972 "Godzilla vs. Gigan"

Gigan is a space monster controlled by electronic signals sent from M Space Hunter Nebula Aliens. It turns up together with King Ghidorah, leaping through space and laying waste to Tokyo. Anguirus rams Gigan, but it slashes its face as well as Godzilla's left shoulder.

Jet Jaguar
1973 "Godzilla vs. Megalon"

Jet Jaguar, a robot created by Goro Ibuki, is manipulated by M Space Hunter Nebula Aliens and used to guide Megalon on its path of destruction in the human world. Luckily Goro regains control of the robot through an ultrasonic wave and uses Jet to enlist help from Godzilla. Jet Jaguar breaks free of the mind control and transforms into a giant as it faces off against Megalon, fighting alongside Godzilla.

Mechagodzilla
1975 "Terror of Mechagodzilla"

Mechagodzilla No. 2 makes its appearance, as No. 1 was destroyed at the end of the previous film and remade by the Planet 3 Aliens of the Great Cosmic Black Hole. However, its activation device is incorporated into beautiful cyborg Katsura. Titanosaurus meets up with Mechagodzilla No. 2 in the center of Yokosuka and begins to lay waste to the city.

Godzilla
1968 "Destroy All Monsters"

Godzilla is content on the island for monsters off the coast of Ogasawara, peacefully co-habitating with the other giant creatures. However, it finds itself being governed by the Kilaak aliens, who force it to lay siege to New York and then Tokyo. Once freed, it battles King Ghidorah in Aokigahara.

Manda
1968 "Destroy All Monsters"

Serpent-like Manda lives on Monster Island and gets along well with Godzilla and pals until it is ruthlessly manipulated by Kilaak aliens. After appearing in London, it heads to Tokyo, where it wraps itself around a monorail, destroying it. Gaining freedom from the Kilaaks, it gathers with other monsters at Aokigahara.

Gabara
1969 "All Monsters Attack"

Young Ichiro dreams of Gabara on Monster Island, which just so happens to be the same name as the bully who torments him daily. Gabara is mean to poor Minilla, but is defeated in battle thanks to Minilla's diligent training and of course is no match for the mighty Godzilla.

Godzilla
1973 "Godzilla vs. Megalon"

Godzilla bothers no one on Monster Island, but makes its way to Japan after receiving a distress call from Jet Jaguar. It quickly challenges Megalon to a fight, just as it was about to dispatch the now giant Jet Jaguar. In a pinch when surrounded by flames, it is eventually saved by Jet Jaguar's flying ability.

Mechagodzilla
1974 "Godzilla vs. Mechagodzilla"

Godzilla emerges from an exploding Mt. Fuji and uncharacteristically attacks comrade Anguirus. Just as it is setting its sights on an industrial complex in Tokyo Bay, another Godzilla appears. It turns out the first Godzilla was a Mechagodzilla copy created by a Black Hole Planet 3 Alien.

Titanosaurus
1975 "Terror of Mechagodzilla"

Dr. Mafune discovers a dinosaur at the bottom of the Ogasawara Sea and names it Titanosaurus. He takes control of it, forcing it to attack and destroy research ship AKATSUKI, which had been searching for the remains of Mechagodzilla. Its weakness, ultrasonic waves, is later discovered by AKATSUKI II.

Shōwa Godzilla Series
GODZILLA
1954

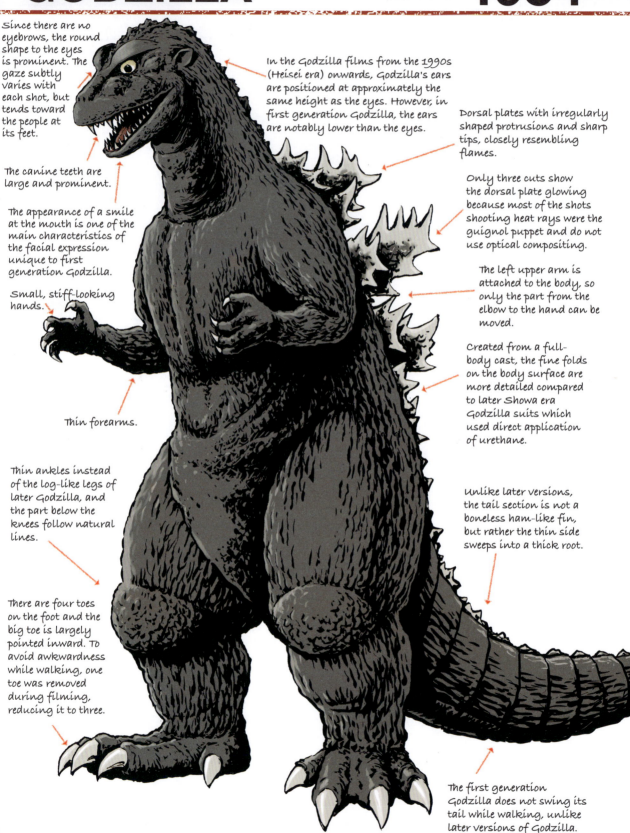

Since there are no eyebrows, the round shape to the eyes is prominent. The gaze subtly varies with each shot, but tends toward the people at its feet.

The canine teeth are large and prominent.

The appearance of a smile at the mouth is one of the main characteristics of the facial expression unique to first generation Godzilla.

Small, stiff-looking hands.

Thin forearms.

Thin ankles instead of the log-like legs of later Godzilla, and the part below the knees follow natural lines.

There are four toes on the foot and the big toe is largely pointed inward. To avoid awkwardness while walking, one toe was removed during filming, reducing it to three.

In the Godzilla films from the 1990s (Heisei era) onwards, Godzilla's ears are positioned at approximately the same height as the eyes. However, in first generation Godzilla, the ears are notably lower than the eyes.

Dorsal plates with irregularly shaped protrusions and sharp tips, closely resembling flames.

Only three cuts show the dorsal plate glowing because most of the shots shooting heat rays were the guignol puppet and do not use optical compositing.

The left upper arm is attached to the body, so only the part from the elbow to the hand can be moved.

Created from a full-body cast, the fine folds on the body surface are more detailed compared to later Shōwa era Godzilla suits which used direct application of urethane.

Unlike later versions, the tail section is not a boneless ham-like fin, but rather the thin side sweeps into a thick root.

The first generation Godzilla does not swing its tail while walking, unlike later versions of Godzilla.

Godzilla 1954

"Godzilla"

Interestingly, Godzilla was called the "Green Monster" overseas because of the strong impression made by the vibrant green in the poster.

◎ **What color is Godzilla?**

As "Godzilla" (1954) was in black-and-white and no color photographs exist, the exact body color of the first Godzilla is a recurring mystery.
The prevailing theory is that it was blackish gray, but some say it was more brownish.
Whatever color the suit may have been, it was intended to look best on black-and-white film, and not necessarily the color that was originally intended.

◎ **Did the eyes move on the first Godzilla?**

Godzilla's eyes appear to move differently depending on the shot. There was no device to move them, but it is thought that they could have been manipulated by hand.

◎ **Can't the left arm of the first Godzilla be raised?**

The right arm could move from the right shoulder, but as the left arm was attached to the body, Godzilla could only move the part from the elbow to the hand.

◎ **Could the mouth of the suit version of Godzilla open and close?**

In some photos where the mouth is wide open, a stick-like object can be seen inside. This was not a mechanism to move the mouth, but rather a prop to hold it open.

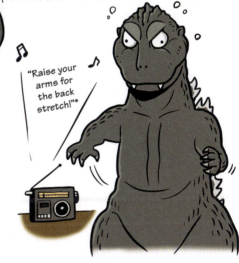

"Raise your arms for the back stretch!"*

* A traditional exercise radio program broadcast every morning in Japan.

The Enduring Mystique of the "First Godzilla"

The first Godzilla was the first costumed (suit) monster, and was created through a process of trial and error, with a production process and materials worlds apart from those used for later versions. It debuted in 1954, and as nearly 70 years have passed, many things remain a mystery to this day.

On the other hand, the discovery of new documentary materials and analysis can reveal things that were once mysteries or even overturn previously-held beliefs. It is something akin to archeology, and I truly believe the first Godzilla will continue to stir the hearts of its fans.

007

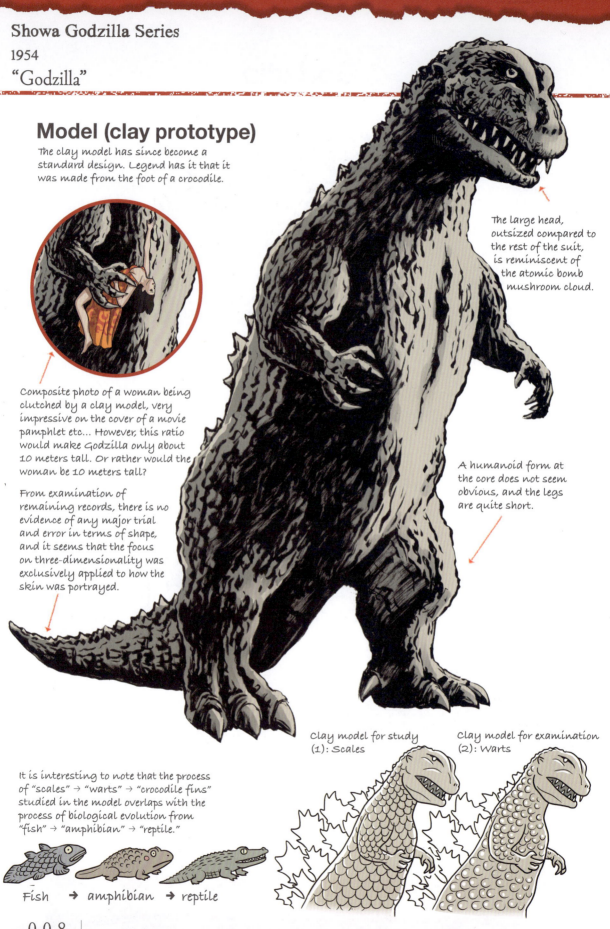

Godzilla: The Encyclopedia

GODZILLA 1954

Hand-dancing guignol

- Dark eyes larger than the suit-type.
- Large contrast between left and right sides of the face.
- Round face with a short nose. Similar to the clay prototype.
- Teeth pointing outwards
- Thick lower jaw
- Neck is also short.
- Hands are short and small, and of course unmovable.

Face of the suit

What is a guignol? In France, a glove-type puppet is referred to as a "guignol." The first Godzilla suit was so stiff that it could barely move its head. Because the mouth couldn't be manipulated as required, a small puppet with only the upper half of its body was used for most close-ups. Since then, in Tokusatsu (special effects) films these small puppets are often called "guignol" or "muppet" on set.

The guignol was employed in such memorable scenes as "Godzilla first appears on Odo Island," "biting the train," "blasting heat ray close-up," "face appears behind the chicken coop on the roof of the building," "howling at the clock tower at Wako," and "knocks down the steel tower with the announcer." In a certain sense, the guignol left as strong, or perhaps even stronger impression than the suit. The guignol face is also instantly recognizable because it is noticeably different from that of the suit.

Godzilla reminds us of a real creature but is uniquely not

There are a number of contrivances used in the design of Godzilla to bring it to life, but in my opinion the greatest of them all is the epidermis. This incredible skin, both living and at the same time rock-like and inorganic, encapsulates the essence of Godzilla, a living creature and at the same time an embodiment of the forces of nature. Though based on a crocodile, there exists no creature with a similar sheath, so it doesn't directly evoke any specific living being, further reinforcing the idea of Godzilla as a unique entity.

This is a major difference between Japanese monsters and non-Japanese, which often seek reality by borrowing from known beasts. Some speculated Godzilla's body surface had been scorched off by the H-bomb blast, but examining the model, it seems the charred bits were sculpted separately from the basic pattern of the epidermis, which was left off the suit. From this, I concur that Godzilla's skin in its present state is its original natural condition.

009

Showa Godzilla Series
GODZILLA
1955

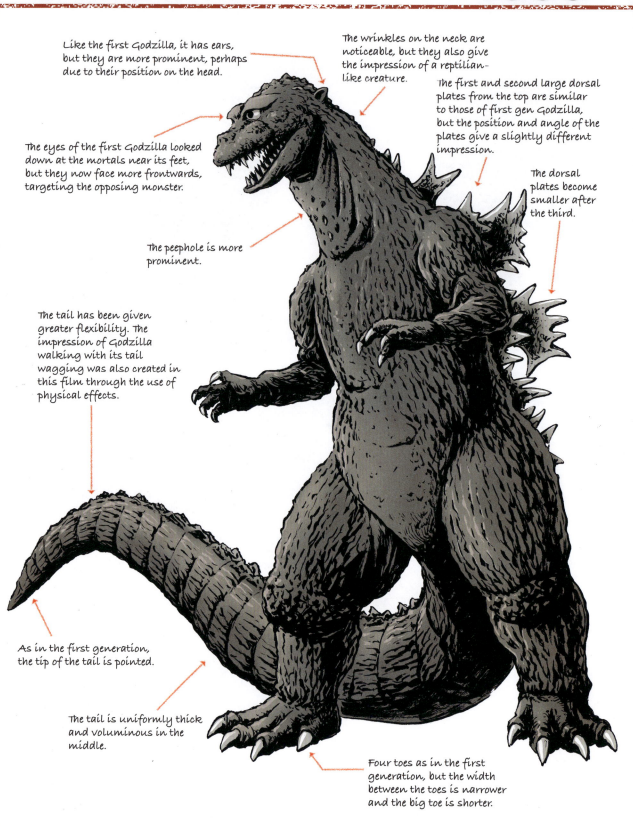

- Like the first Godzilla, it has ears, but they are more prominent, perhaps due to their position on the head.

- The wrinkles on the neck are noticeable, but they also give the impression of a reptilian-like creature.

- The first and second large dorsal plates from the top are similar to those of first gen Godzilla, but the position and angle of the plates give a slightly different impression.

- The eyes of the first Godzilla looked down at the mortals near its feet, but they now face more frontwards, targeting the opposing monster.

- The dorsal plates become smaller after the third.

- The peephole is more prominent.

- The tail has been given greater flexibility. The impression of Godzilla walking with its tail wagging was also created in this film through the use of physical effects.

- As in the first generation, the tip of the tail is pointed.

- The tail is uniformly thick and voluminous in the middle.

- Four toes as in the first generation, but the width between the toes is narrower and the big toe is shorter.

010

Godzilla

1955

"Godzilla Raids Again"

Explanation

Just like the first Godzilla, the true color of this Godzilla is not known. Since only six months had passed since the first film, it is assumed they attempted to make it the same color, but it is possible that it is slightly dissimilar as a result of utilizing different material.

When seen from the front, Godzilla in this film has a more slender neck and broader shoulders. Combined with the expression on the face, it gives a more human-like impression.

After being buried under mountains of snow and ice on Kamiko Island, Godzilla went into a state of hibernation. It slept for seven years.

This time Godzilla's guignol has larger, more outward-facing teeth than with the first generation, perhaps due to the scene where it chomps on Anguirus, giving it a slightly peculiar appearance. All cuts in which Godzilla uses heat rays are represented by the guignol.

Evolving suit materials

Because of the tremendous impact of the first Godzilla, created from whole cloth, the Godzilla used in "Godzilla Raids Again" is often underestimated, but the behind-the-scenes evolution as a creature suit is remarkable. Raw rubber swapped out latex for the outer skin and the muscle went from a cloth bag filled with cotton to urethane, new materials that greatly reduced weight. In addition, gussets were set at the base of arms and legs to ensure movement, and the looped tail could be animated by hand. The eyes and mouth became motorized. This basic set-up has remained unchanged to the present day. In other words, the suited monster was almost complete in its second production, only one year after its birth.

011

Showa Godzilla Series
ANGUIRUS

The tip of the tail has more dense spines than the rest of the body.

The shell was originally made to be split in half, but was modified and pasted together into a single piece during the course of filming. The two rows in the center appear to have been added at that time.

The Hannya (Japanese female demon) mask-like face, similar to that of Godzilla in this film.

Seven horns on the back of the head. The center horn is the longest.

The tail is longer than that of Godzilla.

It has fangs at the tip of its mouth, and the other short teeth are in a row.

Four toes on each limb, the same as Godzilla.

Fine scales have been sculpted all over the body.

When walking, it does not kneel, but walks with the whole of its foot on the ground. To wrestle with Godzilla, it often rears up on its hind legs.

Godzilla: The Encyclopedia

Anguirus

1955

"Godzilla Raids Again"

Explanation

Anguirus is the first monster Godzilla fights, and the first four-legged monster in the film series. It has no special abilities like Godzilla's heat ray, its only weapons being its fangs and great agility. Its spiked carapace would seem to be highly effective for defense, but in no scene is it used as such. Anguirus, together with Godzilla, who took up the mantle against it, displayed the ferociousness of a wild beast like no other creature.

Anguirus's carapace was designed to split open from side to side in the hatchling model. The suit was initially sculpted the same, but was modified and pasted together in one piece due to hardships with filming. One wonders how it would have turned out if this feature had appeared in the film. It seems to me it could only be used as an intimidation tactic.

The guignol was also very active in the Anguirus fight scenes. They engaged in a fierce battle, tearing at each other's throats.

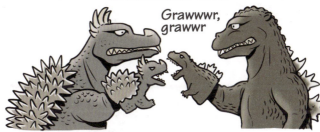

The speedy movement of Anguirus

Anguirus was created as Godzilla's first monster antagonist. While the second generation version (1968) comes off as cute, first generation Anguirus was ferocious and even more threatening than Godzilla. Four-legged monsters do not have the natural posture of humans, and when depicted by a suit-wearing performer, their body shape and movements inevitably appear unnatural and sluggish. To express agility in this film, they made use of micro speed photography. This is a double-edged sword that detracts from the huge sense of miniature destruction and special effects however, and consequently has not been used often in subsequent films, but it does go a long way in creating the unique atmosphere of this film.

013

Showa Godzilla Series
GODZILLA 1962

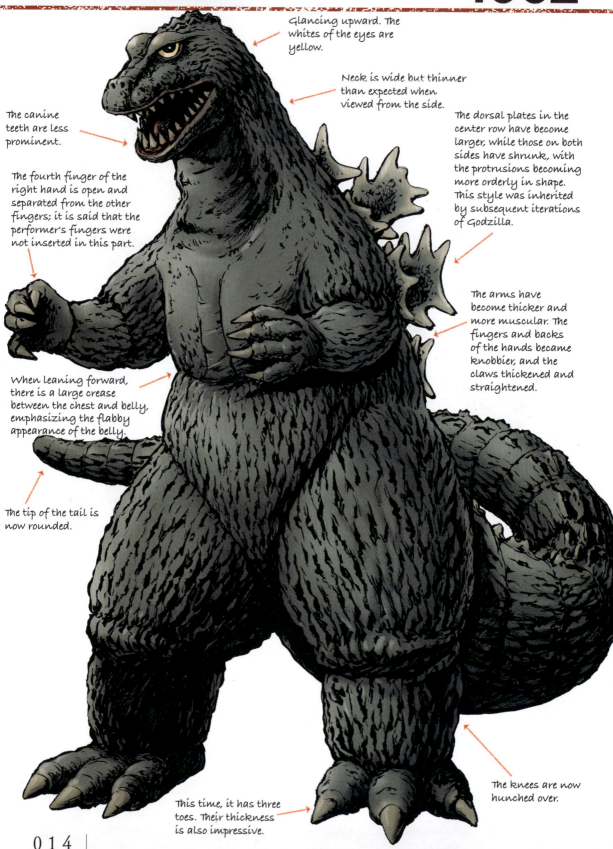

- Glancing upward. The whites of the eyes are yellow.
- Neck is wide but thinner than expected when viewed from the side.
- The dorsal plates in the center row have become larger, while those on both sides have shrunk, with the protrusions becoming more orderly in shape. This style was inherited by subsequent iterations of Godzilla.
- The canine teeth are less prominent.
- The fourth finger of the right hand is open and separated from the other fingers; it is said that the performer's fingers were not inserted in this part.
- The arms have become thicker and more muscular. The fingers and backs of the hands became knobbier, and the claws thickened and straightened.
- When leaning forward, there is a large crease between the chest and belly, emphasizing the flabby appearance of the belly.
- The tip of the tail is now rounded.
- This time, it has three toes. Their thickness is also impressive.
- The knees are now hunched over.

014

Godzilla

1962

"King Kong vs. Godzilla"

Explanation

Godzilla, returning seven years after "Godzilla Raids Again," differs in form from its predecessors. Its characteristics, such as lack of ears, three toes, and well-defined dorsal plates, were inherited by later Godzilla models and became the standard Showa Godzilla. On the other hand, the reptilian appearance and voluminous lower body are features unique to this particular Godzilla.

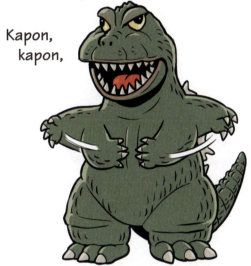

The shoulder-snapping motion is fun.

Kapon, kapon,

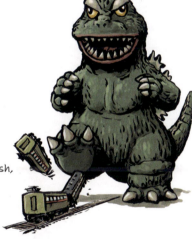

Godzilla in this movie looks fearless in profile, but its frontal aspect looks a bit peculiar with its wide mouth and close set eyes.

This is the first film in the Godzilla series to be made in color and thus the first time Godzilla's body color is revealed. The color of the suit seems to have been gray, but it appears greenish, perhaps due to the coloring of the film. This may be the result of the contrast with the reddish body color of King Kong, Godzilla's mighty antagonist.

Adaptions which led to later Showa Godzillas

What exactly is the reason for the significant changes made to Godzilla's form in this movie, compared with the previous iterations? The first Godzilla also had three toes, cut off during filming as they were a hindrance, so it is conceivable that they went with three toes from the beginning for the same reason. The removal of the ears, along with the change in facial features, could stem from the director's desire to create a more reptilian Godzilla, but it is conceivable that the reason for this is that director Eiji Tsuburaya, a devotee of the original "King Kong," wanted to make Godzilla more dinosaur-like as an homage to the T-Rex that King Kong battled in that classic film.

Godzilla: The Encyclopedia

015

Showa Godzilla Series
KING KONG
1962

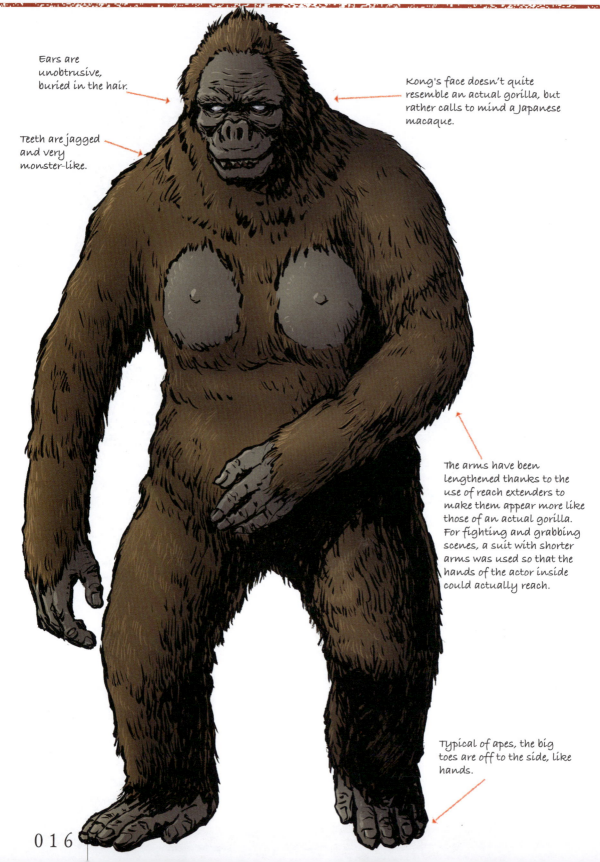

Ears are unobtrusive, buried in the hair.

Kong's face doesn't quite resemble an actual gorilla, but rather calls to mind a Japanese macaque.

Teeth are jagged and very monster-like.

The arms have been lengthened thanks to the use of reach extenders to make them appear more like those of an actual gorilla. For fighting and grabbing scenes, a suit with shorter arms was used so that the hands of the actor inside could actually reach.

Typical of apes, the big toes are off to the side, like hands.

King Kong

1962

"King Kong vs. Godzilla"

Explanation

King Kong is Godzilla's predecessor as a giant monster and worldwide star, yet merely being a giant gorilla it is at a disadvantage against the mighty Godzilla, who possesses special energy powers. The story embraces this fact, with King Kong emerging the loser in its first confrontation with Godzilla. In the final battle, however, King Kong gains the upper hand with its newly-acquired special electrocution ability. It was a brilliant way to add to the story and lend more excitement to their confrontation.

King Kong is inferior to Godzilla in terms of defense and long-range attacks, but in close combat, it is Godzilla's match in power, speed, and martial arts ability!

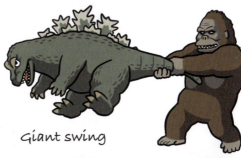

Giant swing

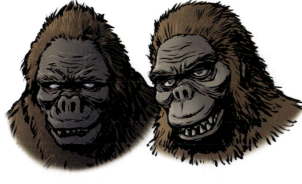

There are two types of heads: one for close-up shots and the other for action shots. The left image is for action scenes. Transparent parts are used for the eyes, which appear to lack pupils. The right image is for close-up photography.

Over-the-shoulder throw

Stone throwing

Attacks with a deadly weapon

King Kong maximizes the merits of the human form

One of the key points in the design and modeling of a suit-type monster is how to make it less obvious that it is a human wearing a suit. On the other hand, this shape makes it relatively easy for the performer inside to move about, and the King Kong in this film took full advantage of it, entertaining us with hilarious gestures and fighting skills that made full use of its creative techniques. This "disguising action limitations due to limited movement of a costumed monster by hitting a humanoid opponent" style would later be showcased in the film "Ultraman vs. Frankenstein."

017

Showa Godzilla Series
GODZILLA 1964

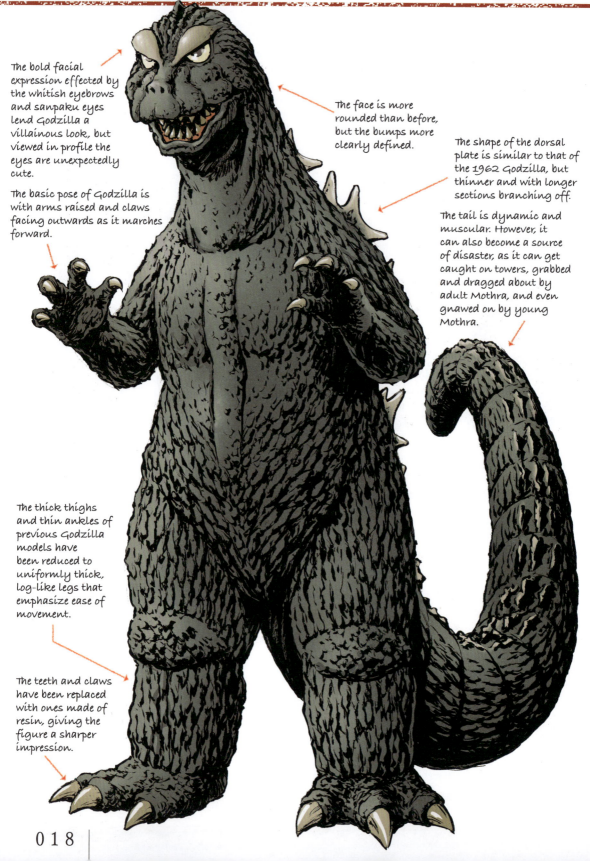

The bold facial expression effected by the whitish eyebrows and sanpaku eyes lend Godzilla a villainous look, but viewed in profile the eyes are unexpectedly cute.

The basic pose of Godzilla is with arms raised and claws facing outwards as it marches forward.

The face is more rounded than before, but the bumps more clearly defined.

The shape of the dorsal plate is similar to that of the 1962 Godzilla, but thinner and with longer sections branching off.

The tail is dynamic and muscular. However, it can also become a source of disaster, as it can get caught on towers, grabbed and dragged about by adult Mothra, and even gnawed on by young Mothra.

The thick thighs and thin ankles of previous Godzilla models have been reduced to uniformly thick, log-like legs that emphasize ease of movement.

The teeth and claws have been replaced with ones made of resin, giving the figure a sharper impression.

018

Godzilla

1964

"Mothra vs. Godzilla"

Explanation

Following 1962 Godzilla, which represented a major departure from the original, the 1964 Godzilla underwent another complete makeover. The slim, gently sloping form, with its solid flesh and sharply detailed, highly finished suit, became the prototype for the subsequent style of Showa Godzillas.

Godzilla in this movie is a villain, a role that is guaranteed to get it beat up. Even so, the punishment it takes truly puts to shame all movies that came before.

In the introduction scene and during the attack on Nagoya, Godzilla shook its body, forcing the cheek flesh to shake and tremble, a distinctive characteristics of the 1964 version. However, this may not have been intentional on the part of the producers, as it seems to have been corrected in the latter half of the film when the cheeks no longer quiver quite so much.

The representative Showa Godzilla is the 1964 version

The 1964 Godzilla was a popular suit that came to represent the character for many years in the Showa era, combining standard features that would become the definitive form of subsequent Godzillas, along with unique elements such as the whitish eyebrows, sanpaku eyes, quivering cheeks, and V-shaped flow of folds in its lower abdomen. Its appeal lies not only in the perfected appearance, but also in the maturity of Haruo Nakajima's performance and the presence of the "creature" Godzilla when he moves in unison with a well-fitted suit.

019

Showa Godzilla Series
MOTHRA
1964

Mothra was made in different sizes: large, medium, and small. The Mothra in this picture is the same size as Godzilla's costume.

There are many possibilities for the origins of Mothra's wings. The forewings are modeled after the Madagascan sunset moth with an eyelet pattern, while I believe the hind wings are those of the Eudocima tyrannus. If curious please learn more about these moths and butterflies.

Unlike previous iterations, the molds on the eyes bulge outward.

There are several differences from actual insect moths, one of which is the adult moth has the same mouth as the larva. In that sense, it's no surprise adult moths can shoot thread.

Mothra's large legs are constantly moving, even in flight. Of the three legs on each side, the two in the rear seem to move in tandem.

Mothra eggs are said to equal 153,820 chicken eggs, but if this were the actual volume, then the diameter is only a tad over 50 times larger. As an average chicken egg diameter is a mere 6 cm, this would come out to 3 meters. It would seem the fishermen got cheated.

People sometimes tease Mothra about how it gave birth to such a large egg, but as the Cosmos say, "The egg grew much larger in the earth," intimating they were much smaller when laid. I wonder if the eggshell is soft as it grows.

Godzilla: The Encyclopedia

Mothra (imago & egg)

1964

"Mothra vs. Godzilla"

Explanation

Following the massive success of "King Kong" overseas, Mothra was chosen as Godzilla's opponent after it exploded in popularity three years earlier in the independent film "Mothra" (1961). It was the first flying kaiju to face Godzilla, and although fully-manipulated model monsters tend to fall short of costumed ones in terms of presence, Mothra's color, size, and superbly articulated movements lent it an impact that rivals that of Godzilla.

Mothra's wings are a powerful weapon, as they stir up strong winds and spread poisonous powder. However, they are vulnerable to Godzilla's heat rays.

Mothra's legs have a strength that belies their slender appearance, and it can use them for scratching attacks or to grab Godzilla's tail and drag it away.

Cosmos

These are priestess-like fairies who serve their god in "Mothra" (1961). At first, they do not speak human language and emit only electronic sounds, thought to be their original tongue, but their telepathic abilities enable them to communicate in Japanese. Their clothes were also primitive, like buckskin, but in "Godzilla vs. Mothra," they wore gorgeous regalia fit for the stage, even on Infant Island. In the follow-up "Ghidorah, the Three-Headed Monster," their outfits returned to that of "Godzilla vs. Mothra" but they were much more familiar with civilized society, even being invited to appear on TV.

The Inception of Linking Monster and Human Drama

The Cosmos are an inseparable part of the Mothra lore. They were created to bridge the dramatic gap between monster and human, which was needed due of the monster's inability to communicate with humans. This method was carried over to the Gamera series and others, creating a more straightforward narrative structure in which a main character, be it boy or girl, has a special connection to the monster. Settings in which aliens and other entities control the monsters are similar, but in those cases the monster often has no agency. This idea was further explored with giant transformable heroes such as Ultraman, in which the main character of the human drama is also the main character in the battle with the monster, a device particularly effective on TV.

No. 1 in terms of likability? The charm of Mothra

Being an insect, and a moth at that, one might expect Mothra to be abhorred, in fact, it is extremely popular. At first glance the design seems to be a realistic imitation of an insect, but it is exquisitely free of "ick factor." The reason why a moth was chosen as opposed to a butterfly can probably be chalked up to Japanese familiarity with silkworms, but while the antennae and part of the wings are those of a butterfly, the claws are something like that of a small bird. The eggs are simply larger versions of bird eggs. The impressive depiction of "death and rebirth" and "generational change" is also unusual for a monster, and this ties Mothra to its characterization as a symbol of motherhood and a guardian of nature and life.

021

Showa Godzilla Series
MOTHRA
1964

In the scene where larva hatches from the egg, a human hand inside the egg manipulated the guignol for the top half of the body, but the slimy texture and blood vessels give the scene a realistic feel. The body color is also a bit brighter, as if it had just been born.

The first generation had a plump, round face, but this larva has a vaguely bony appearance. The roundness around the eyes is exaggerated. Rounded eye sockets are now squared off.

Both larvae have the same blue eyes as the first generation, but the larva in the next film, "Ghidorah, the Three-Headed Monster" had red eyes. Whether from anger or grieving over the death of its brother, no reason for this is given. The larva that appeared in "Destroy All Monsters" couldn't have been the same creature, but also sported red eyes.

Compared to the first generation, the mouth is larger and more square. The mouth shuts mechanically without any gap, but in a cute way. It looks like a bite from this would be quite painful.

The head has three pairs of large feet (six in total).

Brush-like hairs grow on the side of the body. They are also used to hide the wheels which move it.

The tip of the tail is three-pronged. Like the mouth, it changes little as an adult.

Mothra (larva)

1964

"Mothra vs. Godzilla"

Explanation

Whilst Mothra is defeated by Godzilla, the larvae that hatch from its abandoned eggs manage to get the upper hand. This was the first intergenerational revenge scenario in a monster movie. It is surprising that the larvae are born as twins, but it does make a certain amount of sense as they have shrunk since "Mothra" (1961). One of them goes on to appear in "Ghidorah, the Three-Headed Monster," a clear indication that this is a sequel.

In "Mothra" (1961), the larva was represented by a huge model that holds six performers, but this time it was smaller. This was due in part to fight scenes with Godzilla, but also so that the structure was small enough to move mechanically.

The bite of the Mothra larvae seems quite powerful, as Godzilla is in agony when bitten on the tail, but in "Ghidorah, the Three-Headed Monster," Godzilla allows himself to be bitten on the tail and playfully lifts it up. Was Mothra being gentle to a pal?

The larva gets a piggy-back ride from Rodan, and together they perform a coordinated attack. Support from other monsters is crucial for slow-footed Mothra, and this may also be an indication that Godzilla and team highly value the power of its web.

It is also an excellent swimmer, easily traveling between Japan and Infant Island.

The dramatic appeal of Mothra

In "Godzilla vs. Mothra," Mothra appears as an adult and then as a larva, the opposite of its appearance in "Mothra," which both lends the story a surprising twist and avoids the awkwardness of Godzilla being defeated by a beautiful and slender adult Mothra. It also adds the dramatic narrative of a child avenging its parents. In the previous "King Kong vs. Godzilla," the two foes fought to a draw, a rather ambiguous outcome, but in this outing a winner and loser are clearly defined in the second round, with both sides given ample chance to showcase their skills (although such elements were present in "King Kong vs. Godzilla" as well). And yet, both sides have an excuse for avoiding total defeat, i.e. adult Mothra dies of old age and passes the baton to the next generation and Godzilla only falls into the sea because it faced two enemies. It is a very well-written script that pays great respect to its stars.

023

Showa Godzilla Series

RODAN

1964

The name "Rodan" comes in a roundabout fashion from the Japanese translation of Pteranodon, but while that prehistoric bird had only one crest, Rodan boasts two, its main characteristic.

Unlike the first generation, which displayed beast-like eyes with almost no white, this Rodan's facial expression is much more distinctive thanks to these unique eyeballs and pupils.

Compared to the first generation, the neck and throat have elongated, and the head has shrunk.

The wing bones are much thicker.

Pteranodon means "wings and no teeth," but Rodan definitely has teeth.

Spines running from chest to abdomen are another difference that sets it apart from the first gen. These spines protrude like a mountain of swords, creating a menacing aura.

Since this is a suit, the leg joints are the same as that of humans, but the flying model has reverse-joint bird feet. The legs are strong enough to lift a 20,000 ton Godzilla, but it seems to have a bit of trouble walking.

024

Godzilla: The Encyclopedia

Rodan

1964

"Mothra vs. Godzilla"

Explanation

In the last scene of "Rodan! The Flying Monster" (1956), a pair of Rodans are incinerated in the eruption of Mt. Aso. The new-and-improved version that emerges from Aso in "Ghidorah, the Three-Headed Monster" (1964), is no longer a mere giant creature that perished in a volcano, but a super kaiju on the same level as Godzilla. Its appearance differs from that of the first generation, and it seems to depict more a character than a monster, with humorous facial expressions and gestures. Rodan agrees wholeheartedly!

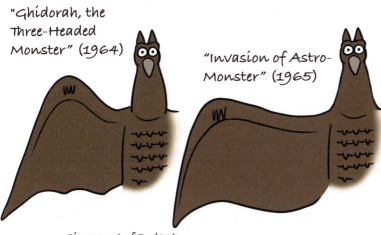

"Ghidorah, the Three-Headed Monster" (1964)

"Invasion of Astro-Monster" (1965)

Rodan's new kit in this film was also used in "Invasion of Astro-Monster" (1965) and "Destroy All Monsters" (1968), but the shape of the wings was significantly different. The arms (shoulders to fingers) were extended, considerably longer than the arms of the actors inside. The wings are therefore larger and the silhouette more similar to a rectangle than a triangle. Many other areas were modified, including neck and thighs.

Since most of Rodan's scenes present it in flight, the flying prop was used. The costume version appears in surprisingly few scenes.

The second-generation Rodan, where "maneuverability" was a requirement

With a vital fight scene between costumed monsters in "Ghidorah, the Three-Headed Monster," there arose a necessity for a second generation Rodan that could move freely. The same was true with Godzilla in "Godzilla Raids Again" but unlike the mighty lizard, which boasts essentially the same limbs as humans, bird-shaped Rodan had to adopt a style which allowed ease of movement for the people inside as a trade-off for realism. In fact, the flying prop and guignol are used extensively in the film, and the suit only appears during the side-by-side standing shots with Godzilla. Even so, the fact that the suit is used is remarkable. On the other hand, the flying prop showcases the technological improvements, with a beautiful silhouette and the ability to flap its wings, feats nearly impossible in the first iteration.

025

Showa Godzilla Series
KING GHIDORAH 1964

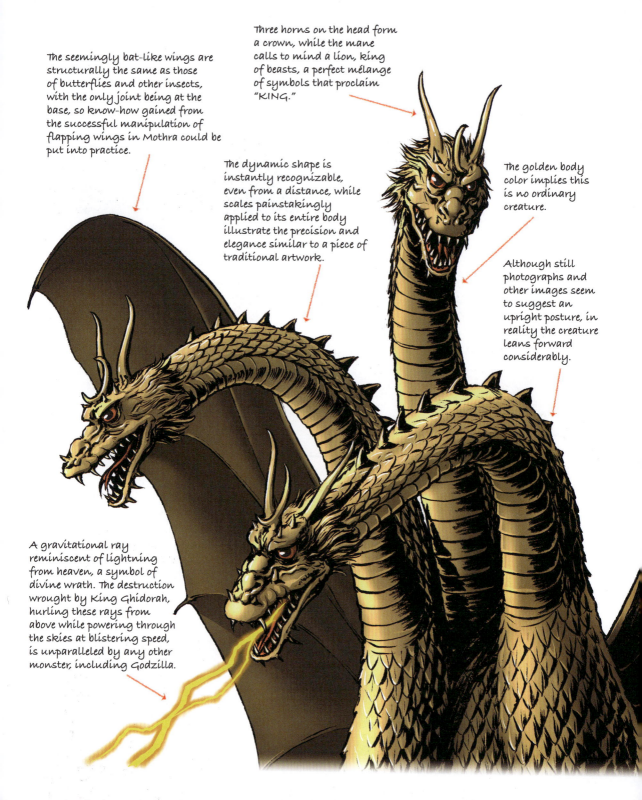

The seemingly bat-like wings are structurally the same as those of butterflies and other insects, with the only joint being at the base, so know-how gained from the successful manipulation of flapping wings in Mothra could be put into practice.

Three horns on the head form a crown, while the mane calls to mind a lion, king of beasts, a perfect mélange of symbols that proclaim "KING."

The dynamic shape is instantly recognizable, even from a distance, while scales painstakingly applied to its entire body illustrate the precision and elegance similar to a piece of traditional artwork.

The golden body color implies this is no ordinary creature.

Although still photographs and other images seem to suggest an upright posture, in reality the creature leans forward considerably.

A gravitational ray reminiscent of lightning from heaven, a symbol of divine wrath. The destruction wrought by King Ghidorah, hurling these rays from above while powering through the skies at blistering speed, is unparalleled by any other monster, including Godzilla.

King Ghidorah

1964

"Ghidorah, the Three-Headed Monster"

Explanation

The three heads, two tails, and massive wings dominate the surrounding space in all directions, up, down, left, and right; the design is the highest level of effort and difficulty for a costumed monster that walks independently. In addition, the exquisite timing and speed of the special effects (in particular the use of gunpowder for small explosions on parts where bullets are supposed to land) and optical synthesis of a ray of light barrage is exhilarating. This is the birth of a monster worthy of the mantle "King," a creature truly the culmination of all special effects technology up to that time, and in every respect still unrivaled.

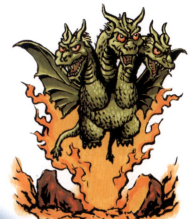

King Ghidorah's destructive power is demonstrated in the scene where it blasts gravitational rays while flying, filmed using a flying prop, which may leave even greater impact than suit-version Ghidorah. Building on previous work with Mothra, a wing structure capable of manipulation was created, fluttering like the wings of a butterfly.

To the later King Ghidorah

King Ghidorah also appeared in the next film, "Invasion of Astro-Monster" (1965). At first glance, no changes are noticeable, but the length of the neck has been extended. The same suit appeared in "Destroy All Monsters" (1968), but scales were added near the base of the wings.

The second Toho Tokusatsu* "space monster," King Ghidorah

*Toho Tokusatsu: Toho's live-action films or television programs that make heavy use of practical special effects

The bold design, a blend of traditional Asian dragon/yamata-no-orochi (a legendary eight-headed and eight-tailed Japanese dragon/serpent) with a Western dragon, is both fresh and compelling as a mythical creature renowned since time immemorial. However, it may be too subversive to give King Ghidorah, the first full-fledged space monster, such a mantle out of the blue. Usually, when we hear the words "space monster," top of mind is a creature like Dogora, which has an irregular form quite alien to life on Earth. Indeed, Toho's first space monster in a Tokusatsu film was "DOGORA, THE SPACE MONSTER," released a few months before "Three Great Monsters: The Greatest Battle on Earth," in which King Ghidorah first appears. Could it be possible that the lack of marked success led to a change in direction and a reimagining of King Ghidorah? Incidentally, the title "Super Space Monster" is also a polite way of expressing that King Ghidorah is more powerful than Godzilla and Rodan, which are labeled "great monsters," but this may also be inspired by the use of "Great Space Monster" in Dogora. If this is the case, I can't help but think that we should be more grateful to Dogora for serving as a building block for the well-known and popular King Ghidorah.

Showa Godzilla Series

Although the height of the monsters in "Ghidorah, the Three-Headed Monster" is formally established, each character is a combination of suits, guignol, flying props, and other models, the result being proportions are not always consistent. Here we have a size comparison based on King Ghidorah.

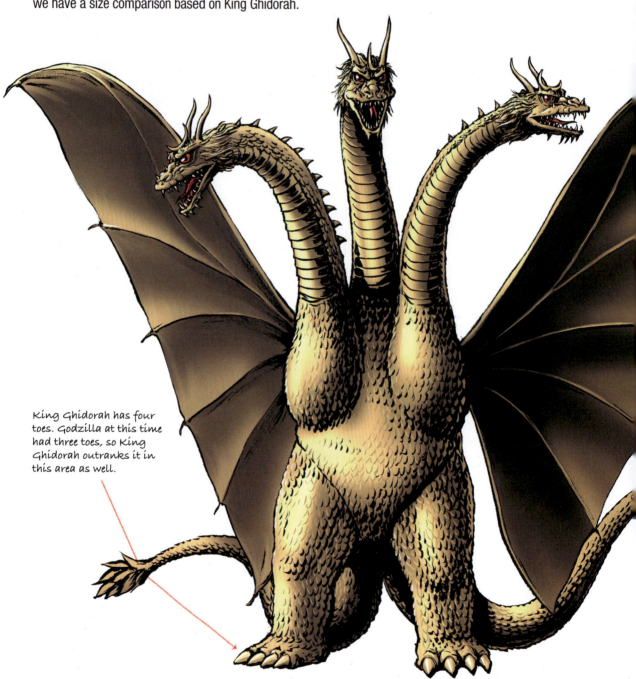

King Ghidorah has four toes. Godzilla at this time had three toes, so King Ghidorah outranks it in this area as well.

King Ghidorah

1964

Godzilla and Rodan are both 50 m tall and the Mothra larva is 40 m, while King Ghidorah ranks in at 100 m. If these figures were accurate, the difference in height would be represented by the blue silhouette. However, the suit actually has a ratio similar to that of the yellow shape, and is smaller than expected when placed alongside Godzilla and the other creatures. Still, King Ghidorah, shown alone, has an intimidating presence that makes the 100 meter figure perfectly logical.

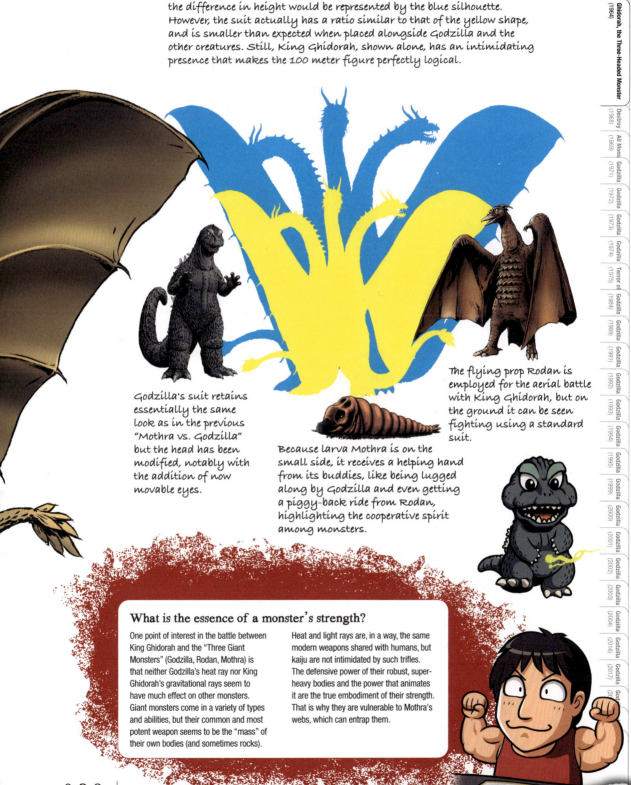

Godzilla's suit retains essentially the same look as in the previous "Mothra vs. Godzilla" but the head has been modified, notably with the addition of now movable eyes.

Because larva Mothra is on the small side, it receives a helping hand from its buddies, like being lugged along by Godzilla and even getting a piggy-back ride from Rodan, highlighting the cooperative spirit among monsters.

The flying prop Rodan is employed for the aerial battle with King Ghidorah, but on the ground it can be seen fighting using a standard suit.

What is the essence of a monster's strength?

One point of interest in the battle between King Ghidorah and the "Three Giant Monsters" (Godzilla, Rodan, Mothra) is that neither Godzilla's heat ray nor King Ghidorah's gravitational rays seem to have much effect on other monsters. Giant monsters come in a variety of types and abilities, but their common and most potent weapon seems to be the "mass" of their own bodies (and sometimes rocks).

Heat and light rays are, in a way, the same modern weapons shared with humans, but kaiju are not intimidated by such trifles. The defensive power of their robust, super-heavy bodies and the power that animates it are the true embodiment of their strength. That is why they are vulnerable to Mothra's webs, which can entrap them.

029

Showa Godzilla Series
GODZILLA 1965

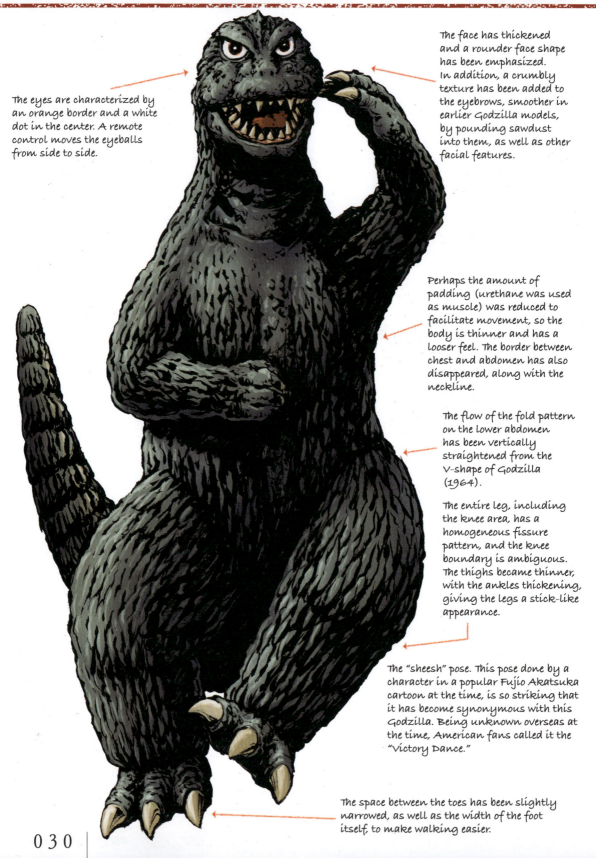

The eyes are characterized by an orange border and a white dot in the center. A remote control moves the eyeballs from side to side.

The face has thickened and a rounder face shape has been emphasized. In addition, a crumbly texture has been added to the eyebrows, smoother in earlier Godzilla models, by pounding sawdust into them, as well as other facial features.

Perhaps the amount of padding (urethane was used as muscle) was reduced to facilitate movement, so the body is thinner and has a looser feel. The border between chest and abdomen has also disappeared, along with the neckline.

The flow of the fold pattern on the lower abdomen has been vertically straightened from the V-shape of Godzilla (1964).

The entire leg, including the knee area, has a homogeneous fissure pattern, and the knee boundary is ambiguous. The thighs became thinner, with the ankles thickening, giving the legs a stick-like appearance.

The "sheesh" pose. This pose done by a character in a popular Fujio Akatsuka cartoon at the time, is so striking that it has become synonymous with this Godzilla. Being unknown overseas at the time, American fans called it the "Victory Dance."

The space between the toes has been slightly narrowed, as well as the width of the foot itself, to make walking easier.

GODZILLA

1965

"Invasion of Astro-Monster"

Explanation

Godzilla finally ventures into space! At first glance, this new suit for "Invasion of Astro-Monster" may not differ greatly from that of the previous 1964 iteration, but there are alterations in the face and the flow of folds on the lower half of the body, and it seems more fluid. Taking advantage of this, Godzilla also performs many comical movements, including the famous "Victory Dance."

Several puppets were made use of in this film, and they are put into action to great effect in several memorable scenes.

A large scale miniature of a house was created just for Godzilla to trample, and a giant foot made to scale. These feet were later modified and applied in "Godzilla, Mothra and King Ghidorah: Giant Monsters All-Out Attack" (2001).

Godzilla, a real charmer for non-monsters

Following the tale of resistance against King Ghidorah in the previous film, this marks the debut of a Godzilla that doesn't just spark fear in the hearts of men, but rather a creature that has the potential to be an ally to mankind. As Godzilla's antagonists were aliens, it was either manipulated by humans as a negotiation tool or controlled by aliens to do their bidding. No longer an untouchable terror, it was growing on us, with people offering words of affection and even pity towards it on occasion. The suit shape also seems to have evolved to prioritize ease of movement over a feeling of monstrosity, but it still attracted the viewer with the help of Haruo Nakajima's superlative acting, director Eiji Tsuburaya's special effects technique and dynamic screen composition, all of which are packed full of visual challenges and mature charm.

Showa Godzilla Series
GODZILLA 1966

"Ebirah, Horror of the Deep"

Explanation
This is a reimagining of Godzilla from the previous "Invasion of Astro-Monster," with a distinct face and a more draped body skin with reduced padding, perhaps to accommodate filming in water. Human-like gestures are also noticeable, perhaps because the story was originally a vehicle for King Kong.

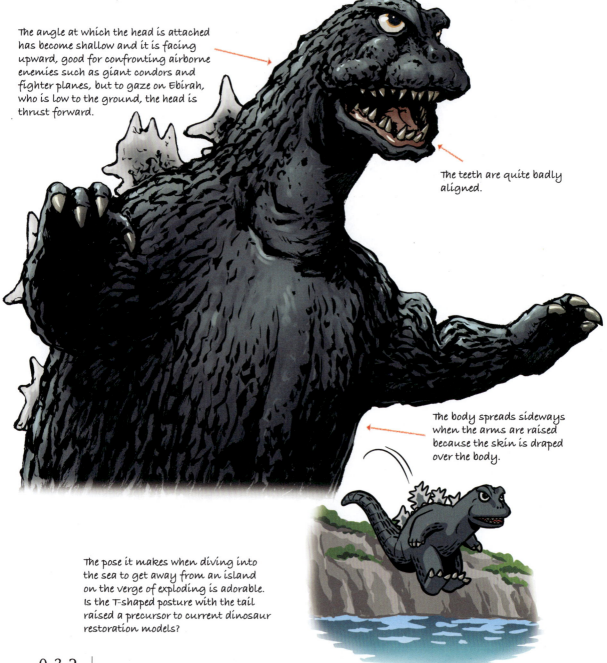

The angle at which the head is attached has become shallow and it is facing upward, good for confronting airborne enemies such as giant condors and fighter planes, but to gaze on Ebirah, who is low to the ground, the head is thrust forward.

The teeth are quite badly aligned.

The body spreads sideways when the arms are raised because the skin is draped over the body.

The pose it makes when diving into the sea to get away from an island on the verge of exploding is adorable. Is the T-shaped posture with the tail raised a precursor to current dinosaur restoration models?

032

Showa Godzilla Series

GIANT CONDOR 1966

"Ebirah, Horror of the Deep"

Explanation

Letchi Island, where "Ebirah, Horror of the Deep" takes place, is not only home to Ebirah, but to Giant Condor as well. Both challenge it to single combat, but Godzilla, enjoying an enormous size advantage, emerges the ultimate victor.

Legend has it that the flying Rodan prop from "Ghidorah, the Three-Headed Monster" was converted into Litra for the TV series "Ultra Q" and then was finally turned into Giant Condor.

It could be said it's just a bird, but it clearly is out of the ordinary, with a raised eyebrow and other distinctive features that permit facial expressions unique to Toho special effects favorites like Godzilla.

It is covered with feathers from head to toe, and the head is newly sculpted, leaving behind scant trace of Rodan.

The molding of scales seen on its neck may be a remnant of the Litra*.

It puts up a decent fight against a sleeping Godzilla by pecking and biting its tail and hands with its sharp beak. In close-up, the head appears quite different in the face, probably due to use of a puppet.

* A monster from another Toho film series, Ultraman, which became the basis for the Giant Condor design.

It put up a good fight by chomping on Godzilla's tail, but was taken down by heat rays and sank ignominiously into the sea.

Modified Godzilla suit

Godzilla in this outing is arrayed in the same suit as the previous "Invasion of Astro-Monster," but in the meantime the head was detached and transplanted onto the body of Godzilla from "Mothra vs. Godzilla," when it appeared on TV's "Ultraman" as the monster Jirass, only with a frill attached to its neck. The head was later returned to the original body, and legend has it the angle of the head was altered in this process. In 1965, along with Daiei (creator of Gamera), Shochiku, Nikkatsu, and other film productions began producing monster movies, and the Ultraman series started broadcasting the same year, marking the end of the era in which monsters were synonymous with Toho. Godzilla films could no longer be discussed without mentioning their relationship with other monster films and TV special effects, especially those produced by Tsuburaya Productions.

Godzilla: The Encyclopedia

033

Showa Godzilla Series
EBIRAH
1966

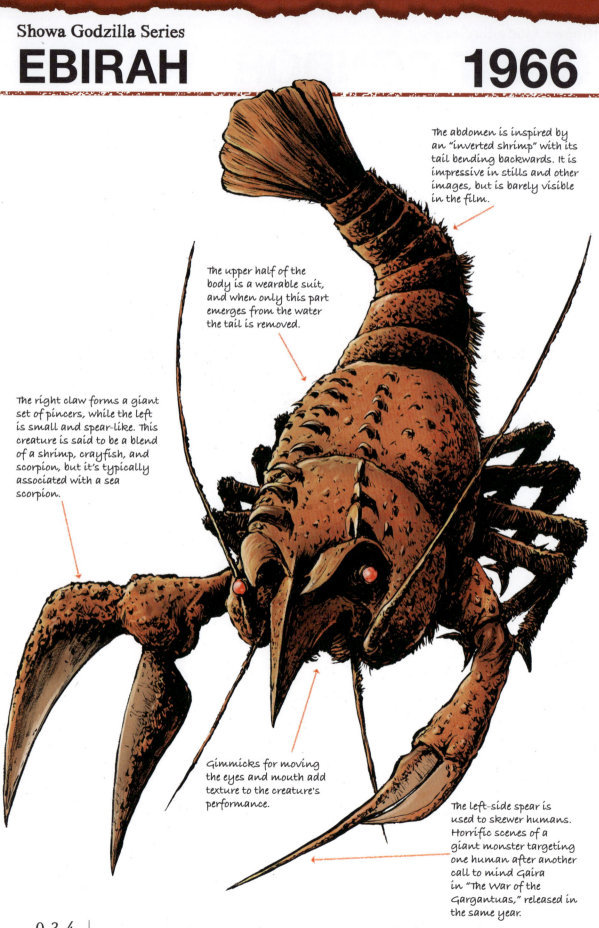

The abdomen is inspired by an "inverted shrimp" with its tail bending backwards. It is impressive in stills and other images, but is barely visible in the film.

The upper half of the body is a wearable suit, and when only this part emerges from the water the tail is removed.

The right claw forms a giant set of pincers, while the left is small and spear-like. This creature is said to be a blend of a shrimp, crayfish, and scorpion, but it's typically associated with a sea scorpion.

Gimmicks for moving the eyes and mouth add texture to the creature's performance.

The left-side spear is used to skewer humans. Horrific scenes of a giant monster targeting one human after another call to mind Gaira in "The War of the Gargantuas," released in the same year.

034

Ebirah

1966

"Ebirah, Horror of the Deep"

Explanation

In the seventh film in the Godzilla series, our hero faces off against a sea monster for the first time. As its name suggests ("ebi" means shrimp in Japanese), Ebirah is an underwater denizen that never leaves the ocean. Godzilla is widely considered a land-based monster, but as its original territory is the sea, it cannot be defeated there.

In the battle with Godzilla, Ebirah's pincers are ripped off, effectively defeating it. What happened to it after that is not depicted, but it likely survived its wounds, and like a crayfish, may have regenerated the lost pincers and is now living somewhere at sea.

For the scene where Ebirah first appears, giant pincers were made, and the rain and waves combine to create an incredible scale image.

A realistic modeling of a real creature

Ebirah was designed by Yasuyuki Inoue, a well-known special effects artist. Like Kamacuras and Kumonga in the next film, Ebirah was designed and sculpted to look like a realistic, gigantic version of an actual living creature, differing greatly from the suited monsters of the past. Although Eiji Tsuburaya is credited as special effects director, Sadamasa Arikawa, a cameraman who became special effects director on "Son of Godzilla" the following year, is said to have handled effects. The film features sickening close-ups of mouth movements of these exoskeletal creatures that diverge from vertebrates, such as Ebirah, Kamacuras in "Son of Godzilla" and Ganimes in "Yog: Monster from Space."

The wrong opponent?

Monsters in Godzilla films have attacked Japan and relished destroying its cities in every outing so far, but in this film the story unfolds on an isolated island in the South Sea, far from the mainland. Originally planned as a vehicle for King Kong, Godzilla stepped in to replace the giant ape and Ebirah, with its sharp pincers, hard exoskeleton and mastery of the underwater environment, might have been a bit too much for King Kong to bite off. With "Ultra Q" and "Ultraman" already airing on TV, the realism of Ebirah's modeling may have been a point of pride in the production, but especially after King Ghidorah, it is hard to deny that it left a subdued impression.

035

Showa Godzilla Series

GODZILLA

1967

The shape of the dorsal plate has also changed significantly from that of the previous version. It seems to be a throwback to the first Godzilla.

The face is long and narrow, and the eyebrows rise higher than the top of the head.

The skin of the legs is flabby, and there are constricted parts on the thighs.

A formidable weapon in the past, in this film the tail becomes a childcare accessory for carrying Minilla, jumping rope, and so on.

036

Godzilla

1967

"Son of Godzilla"

Explanation

Godzilla finally gets a son. To emphasize the difference in size between Godzilla and Minilla, a larger suit was made for the proud new parent, and mainstay Haruo Nakajima was replaced by a taller actor. In terms of both face and body flesh, this suit leaves a distinct impression, unlike previous versions.

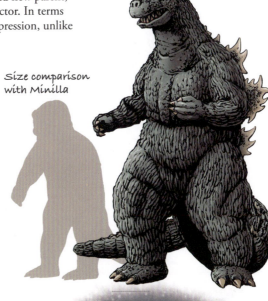

Size comparison with Minilla

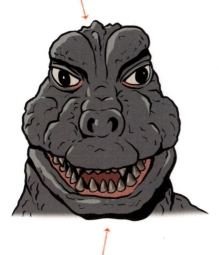

The eyes with upper lids are more human-like, giving Papa Godzilla a gentler expression.

The mouth is wide and teeth are long and black.

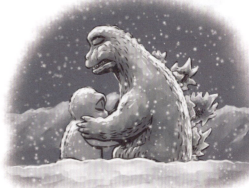

In the last scene of the film, Godzilla and son fall asleep while embracing each other on Sollgel Island, where the air turns chill and snow begins to fall. An emotional scene indeed.

Godzilla's odd face: due to a size change?

I believe that every Japanese person has a childhood memory of seeing a strange-looking Godzilla in a book or other media, and later learning that it was the "Son of Godzilla" version. At least, I certainly have. It's obvious they attempted to make Godzilla seem bigger by presenting a smaller Minilla. It is not a great leap to assume even the face was lengthened for that very purpose.

However, I wonder if this is sufficient reason to account for such a radical change. Most important are the eyes, which may have been altered to match Minilla's. Both it and this Godzilla share rather odd faces, but it may have the effect of imparting a father-son vibe. It is, after all, Godzilla who is most suited to stand next to Minilla.

Showa Godzilla Series
MINILLA
1967

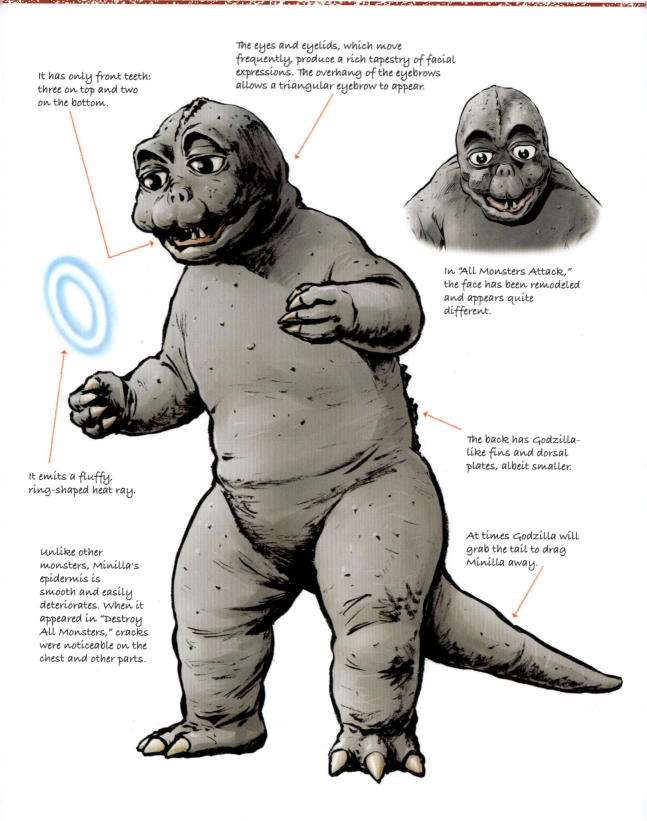

It has only front teeth: three on top and two on the bottom.

The eyes and eyelids, which move frequently, produce a rich tapestry of facial expressions. The overhang of the eyebrows allows a triangular eyebrow to appear.

In "All Monsters Attack," the face has been remodeled and appears quite different.

It emits a fluffy, ring-shaped heat ray.

Unlike other monsters, Minilla's epidermis is smooth and easily deteriorates. When it appeared in "Destroy All Monsters," cracks were noticeable on the chest and other parts.

The back has Godzilla-like fins and dorsal plates, albeit smaller.

At times Godzilla will grab the tail to drag Minilla away.

038

Minilla

1967

"Son of Godzilla"

Explanation

Godzilla's child makes its debut in the eighth movie. Its telepathic brain wave calls to guardian Godzilla are so powerful they disrupt telecommunications. After hatching from an egg, it is unable to walk and is as helpless as a human baby. The face and body shape are also human-like, and at first glance bears little resemblance to its creator. After a closer look common elements reveal themselves.

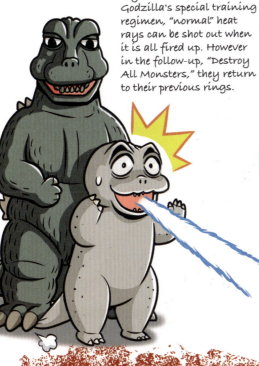

At first, Minilla could only spit rings of heat rays, but thanks to Godzilla's special training regimen, "normal" heat rays can be shot out when it is all fired up. However in the follow-up, "Destroy All Monsters," they return to their previous rings.

Newborn Minilla was depicted with a puppet. It wags its tail to show happiness.

The egg is a yellow and brown oval, somewhat elongated and strong enough to withstand the sickle attacks of three Kamacuras.

Cute Minilla a big hit among overseas fans

While sometimes called "ugly" or "disgusting" in Japan, Minilla enjoys much popularity among American fans, especially women, seemingly due to the "cute factor". In fact, the movements of Minilla, expertly played by dwarf actor Ma-chan, are undeniably adorable. Minilla also starred alongside Godzilla in the next film, "Destroy All Monsters," but the Godzilla (1968), performed by Haruo Nakajima, is smaller than the larger Godzilla 1967 version due to the new suit. Since Minilla's suit is unchanged in both films, one can't help but compare the two and come to the conclusion that "Godzilla has shrunk" (a true statement). However, if we look at it as "Godzilla has remained the same," we may be able to see Minilla as having grown up!

039

Showa Godzilla Series
KAMACURAS 1967

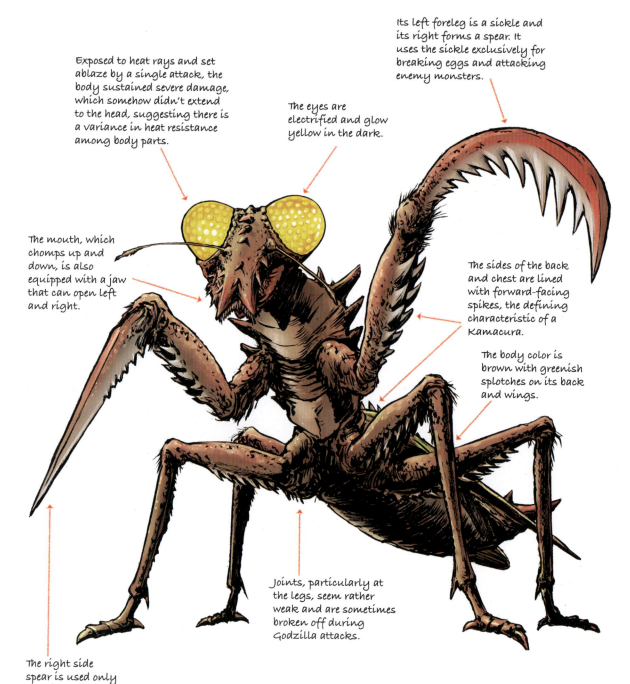

Exposed to heat rays and set ablaze by a single attack, the body sustained severe damage, which somehow didn't extend to the head, suggesting there is a variance in heat resistance among body parts.

The eyes are electrified and glow yellow in the dark.

Its left foreleg is a sickle and its right forms a spear. It uses the sickle exclusively for breaking eggs and attacking enemy monsters.

The mouth, which chomps up and down, is also equipped with a jaw that can open left and right.

The sides of the back and chest are lined with forward-facing spikes, the defining characteristic of a Kamacura.

The body color is brown with greenish splotches on its back and wings.

Joints, particularly at the legs, seem rather weak and are sometimes broken off during Godzilla attacks.

The right side spear is used only occasionally against smaller opponents like humans.

Kamacuras

1967

"Son of Godzilla"

Explanation

Kamacuras are human-sized praying mantises native to Sollgel Island, which grew to enormous size after a failed weather control experiment. Three of them gang up and attack a newborn Minilla, but two are beaten down on the spot by Godzilla, who shows up just in time. The survivor is later defeated by Kumonga.

The wing flaps open when flying, but even with the wings closed, their leaping ability is quite impressive.

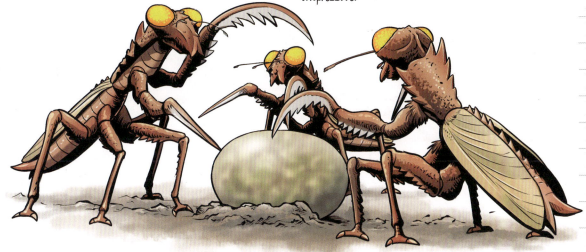

Each model was made to slightly different scale (large, medium, and small), which helped to emphasize perspective.

An odd feat of balance in a not-especially-strong monster

A fully manipulated kaiju with six limbs. To have three of them appear at the same time means that, on the screen there are more piano wires than even Kumonga required (see next page). As a monster, the slender, hand-manipulated Kamacura is a minor character for a Godzilla film, but it is in fact a well-balanced foe that doesn't overwhelm little Minilla. Two costumed creatures attacking would give off a "bullying" vibe, as in later Gabara, but use of a manipulated monster which is non-humanoid and not overly large communicates a survival of the fittest feeling, and succeeds in creating an atmosphere that is not unappealing to children.

041

Showa Godzilla Series
KUMONGA
1967

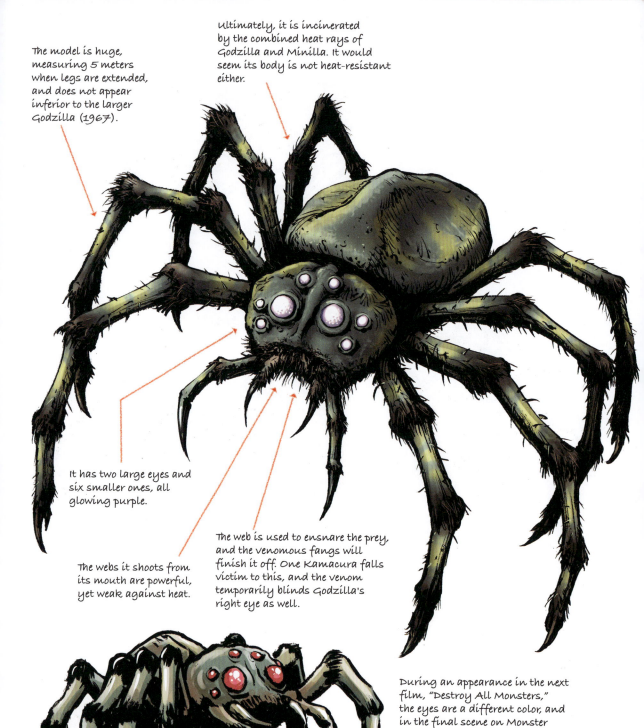

The model is huge, measuring 5 meters when legs are extended, and does not appear inferior to the larger Godzilla (1967).

Ultimately, it is incinerated by the combined heat rays of Godzilla and Minilla. It would seem its body is not heat-resistant either.

It has two large eyes and six smaller ones, all glowing purple.

The webs it shoots from its mouth are powerful, yet weak against heat.

The web is used to ensnare the prey, and the venomous fangs will finish it off. One Kamacura falls victim to this, and the venom temporarily blinds Godzilla's right eye as well.

During an appearance in the next film, "Destroy All Monsters," the eyes are a different color, and in the final scene on Monster Island, they glow red. However, they appear purple while battling at the foot of Mt. Fuji. This may be attributed to the amount of light put through the device.

042

Kumonga

1967

"Son of Godzilla"

Explanation

A giant spider that lives in "Kumonga Valley" on Sollgel Island. It is unknown whether it was originally a giant of its species, like Kamacuras, or if it grew to its enormous size as a result of the infamous weather-control experiments. Although it appears to be simply a giant version of a spider, it remains a formidable foe, unilaterally defeating Kamacuras and putting Godzilla in a tight spot.

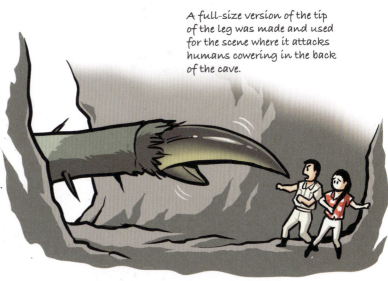

A full-size version of the tip of the leg was made and used for the scene where it attacks humans cowering in the back of the cave.

It curls up to play dead.

"Kumonga," the most challenging hand-manipulated kaiju

It possesses a body shape typical of a household spider, but its gigantic size showcases a powerful enemy. Kumonga requires 16 piano wires to manipulate, two per leg, and all must be able to move in concert. As a stand-alone monster, it requires by far the most skill to operate. Like Kamacuras, it demonstrates the high technical level of the Toho special effects team and their spirit of challenge during this period.

The so-called "Godzilla body shape" is considered the gold standard of monster types, but Kumonga is the result of the search for an antagonist for the big guy that would avoid any similarity to it. Following this, for the "Toho Champion Festival," a movie program aimed at kids, the focus shifted to Godzilla-shaped monsters due to the time and effort required for filming, as well as their strong characterization.

043

Showa Godzilla Series
GODZILLA 1968

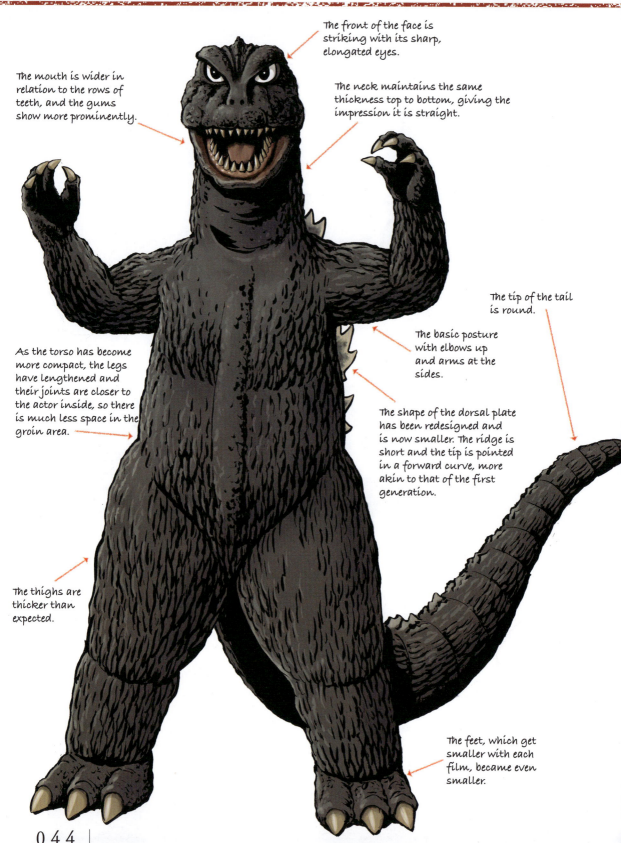

- The front of the face is striking with its sharp, elongated eyes.
- The mouth is wider in relation to the rows of teeth, and the gums show more prominently.
- The neck maintains the same thickness top to bottom, giving the impression it is straight.
- As the torso has become more compact, the legs have lengthened and their joints are closer to the actor inside, so there is much less space in the groin area.
- The tip of the tail is round.
- The basic posture with elbows up and arms at the sides.
- The shape of the dorsal plate has been redesigned and is now smaller. The ridge is short and the tip is pointed in a forward curve, more akin to that of the first generation.
- The thighs are thicker than expected.
- The feet, which get smaller with each film, became even smaller.

044

Godzilla: The Encyclopedia

Godzilla

1968

"Destroy All Monsters"

Explanation

Godzilla's suit, newly designed for "Destroy All Monsters," in which a great number of large monsters appear, has a clear expression created by its strong-willed eyes and a nimble body shape that emphasizes ease of movement, creating a dynamic energy befitting the leader of Earth's monsters.

In the battle with Hedorah, it loses an eye and its right hand is burned to the bone. Its face is a little rounded, as if bloated.

It also co-stars with Minilla in "All Monsters Attack" (1969). Since Godzilla (1967) had a larger suit, the height difference between Godzilla and Minilla has diminished, but it would be more fun to think of it not as "Godzilla getting smaller" but as "Minilla growing up."

Following the tussle with Hedorah, it locks horns with Gigan, as its shoulder is cut by a rotary cutter and forehead cracked open by a massive hammer. The damage to the suit is painful to see.

Suit appearing in four consecutive films

"Destroy All Monsters" was planned as the conclusion to the Godzilla series, but due to strong audience numbers, a decision was made to keep it going. The Godzilla suit in this film, supposedly the last, went on to play an active role in the series, appearing in four films over the course of five years (as the main suit), the longest streak in the franchise. And while it was gradually battered and bruised in mortal combat against powerful enemies such as Hedorah and Gigan, it left an indelible impression on generations of viewers as the classic face of the hero Godzilla. Haruo Nakajima, who had brought Godzilla to life from the beginning, retired when this suit did.

045

Showa Godzilla Series
ANGUIRUS
1968

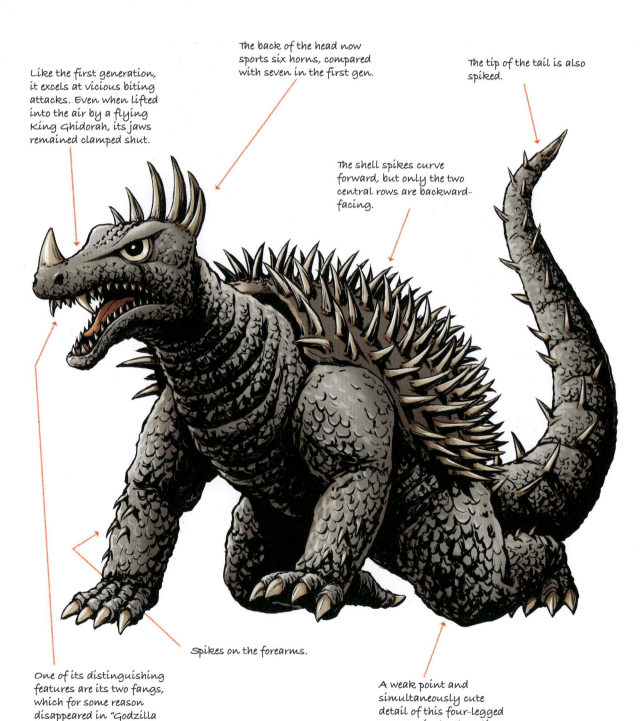

Like the first generation, it excels at vicious biting attacks. Even when lifted into the air by a flying King Ghidorah, its jaws remained clamped shut.

The back of the head now sports six horns, compared with seven in the first gen.

The tip of the tail is also spiked.

The shell spikes curve forward, but only the two central rows are backward-facing.

Spikes on the forearms.

One of its distinguishing features are its two fangs, which for some reason disappeared in "Godzilla vs. Mechagodzilla."

A weak point and simultaneously cute detail of this four-legged monster is the "kneeling pose."

046

Anguirus

1968

"Destroy All Monsters"

Explanation

The second generation Anguirus made its appearance 13 years after its debut as Godzilla's first monster antagonist in "Godzilla Raids Again" (1955). Compared to the first generation, it appeared cuter with its big, dark eyes and small shell, and it became quite popular in the late Showa period.

The spiky carapace can play both offense and defense. It turns its back to the enemy and leaps backwards, skewering them on its spikes.

Second gen Anguirus has frequently played the role of companion to Godzilla since this film, but its outings have not always been pleasant. In particular, the scene in "Godzilla vs. Mechagodzilla" (1974) in which it gets its mouth ripped open by a Mechagodzilla masquerading as Godzilla is shockingly brutal.

The transformation of Anguirus into a beloved character

After a dramatic reappearance, Anguirus neatly replaced Rodan as Godzilla's companion and partner of choice. However, while Rodan is viewed as Godzilla's "rival" and "partner," Anguirus is considered more of a "minion" of lower rank. This may be due in part to the fact that Anguirus was treated as a frontrunner in the "Destroy All Monsters," only to be challenged and defeated by a fake Godzilla during a recon mission. Also in this role it is dropped from the sky, trampled on, and let's not forget has its mouth savagely ripped open, all of which look rather painful. However, all this abuse garnered sympathy from viewers and Anguirus' position as a beloved character was strengthened.

047

Godzilla: The Encyclopedia

Showa Godzilla Series
GOROSAURUS　　　　1968

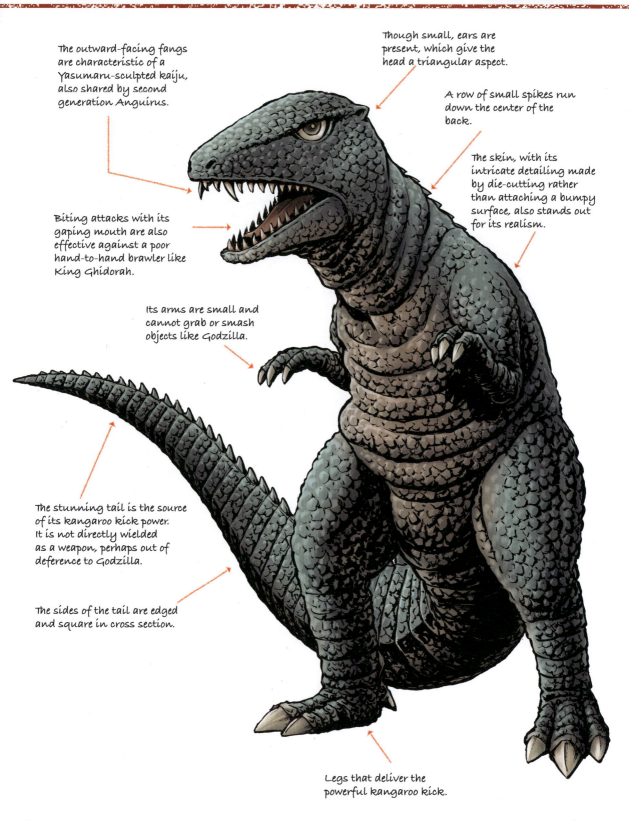

The outward-facing fangs are characteristic of a Yasumaru-sculpted kaiju, also shared by second generation Anguirus.

Though small, ears are present, which give the head a triangular aspect.

A row of small spikes run down the center of the back.

The skin, with its intricate detailing made by die-cutting rather than attaching a bumpy surface, also stands out for its realism.

Biting attacks with its gaping mouth are also effective against a poor hand-to-hand brawler like King Ghidorah.

Its arms are small and cannot grab or smash objects like Godzilla.

The stunning tail is the source of its kangaroo kick power. It is not directly wielded as a weapon, perhaps out of deference to Godzilla.

The sides of the tail are edged and square in cross section.

Legs that deliver the powerful kangaroo kick.

Gorosaurus

1968

"Destroy All Monsters"

Explanation

In "King Kong Escapes" (1967), Gorosaurus makes an appearance not as a kaiju but simply a dinosaur. It was 35 meters tall in this film, but in "Destroy All Monsters," a specimen as large as Godzilla is introduced. In addition to its memorable role in the film as Baragon's stand-in, it also played a major role in the climactic battle against King Ghidorah.

In the battle with King Ghidorah, it savages its neck and takes it down, kicks it in the back, and forces it onto its knees twice.

In "King Kong Escapes" (1967), it clashes with King Kong, but after being repeatedly bested, its mouth is finally ripped apart and it dies.

Gorosaurus, a realistic dinosaur

The body shape and tiny details help create an incredibly true-to-life monster, a marked departure from the suited behemoths that came before. It blended seamlessly into the realistic world constructed for "King Kong Escapes," but when stacked up alongside the other creatures of "Destroy All Monsters," I felt perhaps they came off a bit fake in comparison. However, as there may be some overlap among kaiju fans and dinosaur buffs, Gorosaurus enjoyed a certain popularity despite its modest presence. Unfortunately, when later Anguirus took its place as Godzilla's sidekick, Gorosaurus was only seen again in a degraded form on a children's TV show, "Go, Godman!"

Showa Godzilla Series
MANDA

1968

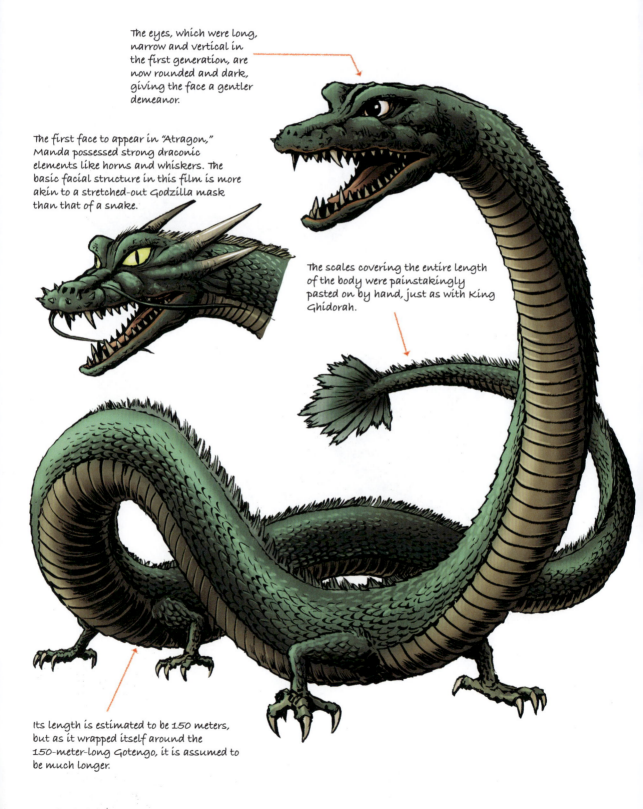

The eyes, which were long, narrow and vertical in the first generation, are now rounded and dark, giving the face a gentler demeanor.

The first face to appear in "Atragon," Manda possessed strong draconic elements like horns and whiskers. The basic facial structure in this film is more akin to a stretched-out Godzilla mask than that of a snake.

The scales covering the entire length of the body were painstakingly pasted on by hand, just as with King Ghidorah.

Its length is estimated to be 150 meters, but as it wrapped itself around the 150-meter-long Gotengo, it is assumed to be much longer.

Godzilla: The Encyclopedia

Manda

1968

"Destroy All Monsters"

Explanation

Manda, guardian god of the Mu Empire who debuted in "Atragon" (1963), makes an appearance as a resident of Monster Island. A different individual from the first generation, it has lost its horns and its head has altered dramatically. It assaulted Tokyo along with Godzilla and others, and was also seen at Mt. Fuji, but was not present for the final battle against King Ghidorah.

Four monsters attacked Tokyo: Rodan, Godzilla, Manda, and Mothra (in order of appearance). Each monster acted separately, but Godzilla and Manda were often shown together on screen. A viewing of the unused outtakes reveals them directly clashing with each other. It may have ended up on the cutting room floor because it would have appeared incongruous to have two Kilaak-controlled beings quarreling amongst themselves.

Manda seems to enjoy entwining itself around objects: the first generation attached itself to the Gotengo and the second went for the monorail.

The impressive movement of Manda

It is unclear how the guardian deity of the Mu Empire came to be housed on the Ogasawara Monster Island, but one theory hypothesizes that the extensive modification to its head indicates it is a separate entity, with the purpose to remove its "divinity" as a guardian deity by making it appear less dragon-like. In "Atragon," the dragon appears only on land, rather than underwater, and its ground-crawling form is a far cry from the image of a dragon soaring through the sky. The small legs were thought unusable for walking, and it was probably deemed impossible to move them, even as a model. The monorail clinch was probably an attempt to show the legs in dynamic movement, without actually using them.

051

Showa Godzilla Series
BARAGON
1968

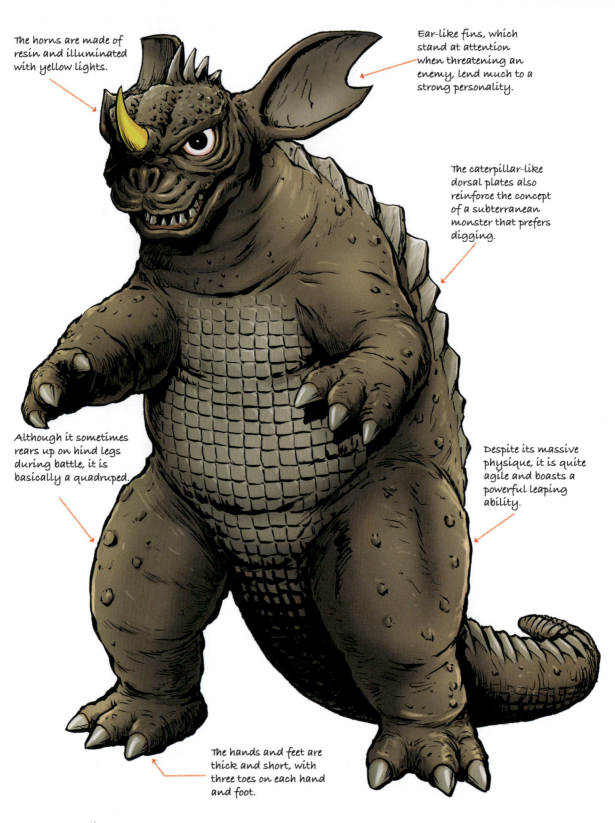

The horns are made of resin and illuminated with yellow lights.

Ear-like fins, which stand at attention when threatening an enemy, lend much to a strong personality.

The caterpillar-like dorsal plates also reinforce the concept of a subterranean monster that prefers digging.

Although it sometimes rears up on hind legs during battle, it is basically a quadruped.

Despite its massive physique, it is quite agile and boasts a powerful leaping ability.

The hands and feet are thick and short, with three toes on each hand and foot.

Baragon

1968

"Destroy All Monsters"

Explanation

A subterranean reptile that first appeared in "Frankenstein Conquers the World" (1965). The first version was 25 meters tall, half the height of Godzilla. The follow-up in "Destroy All Monsters" is said to be the same, but there are no images to compare size as it revealed its face only briefly and was never placed alongside other kaiju like Godzilla.

The first generation fired red hot heat rays from its mouth; it is not known if the second could do the same.

In the scene, the creature destroying the Arc de Triomphe in Paris is called "Baragon" on the radio, but in actuality it was Gorosaurus that popped up. Baragon, an underground denizen, was originally slated to appear, but due to unforeseen circumstances the plan was changed. I therefore took it upon myself to give Baragon the chance for a comeback in an illustration, hopefully making it up to the monster who missed its big day.

For someone born in 1964 like me, Baragon is a somewhat unique figure. When "Frankenstein Conquers the World" was released only in theaters in 1965, Baragon was just a creature that made a brief appearance in "Destroy All Monsters" and was more widely-known for its remote-controlled toy and giant soft vinyl figures, which were every bit as popular as Godzilla.

A suit with numerous modifications

The first Baragon was a well-known character where the design, modeling, and Haruo Nakajima's performance were all top notch, but its lasting impact was through its successful commercialization as a soft vinyl figure, remote-controlled toy, and other sundry products. It was also widely recognized for being loaned to Tsuburaya Productions, from whose template emerged Ultra monsters such as Pagos, Neronga, Magular, and Gabora. The "Destroy All Monsters" version of the Baragon suit was returned by Tsuburaya Productions after alterations, only for it to be further remodeled. In the film, it is only shown in one shot in Monster Island, and only a miniature appears in the King Ghidorah battle. Rumor has it the destructor of the Arc de Triomphe was switched to Gorosaurus was because "the ears got in the way," but the explanation given that the mods just weren't completed in time is still a reasonable. But what is the real story?

Showa Godzilla Series
VARAN
1968

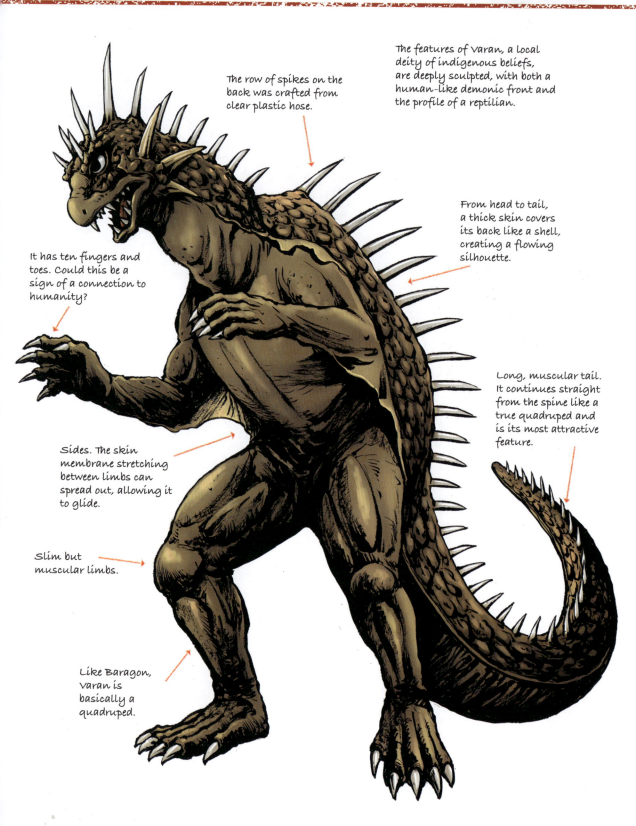

The row of spikes on the back was crafted from clear plastic hose.

The features of Varan, a local deity of indigenous beliefs, are deeply sculpted, with both a human-like demonic front and the profile of a reptilian.

From head to tail, a thick skin covers its back like a shell, creating a flowing silhouette.

It has ten fingers and toes. Could this be a sign of a connection to humanity?

Sides. The skin membrane stretching between limbs can spread out, allowing it to glide.

Long, muscular tail. It continues straight from the spine like a true quadruped and is its most attractive feature.

Slim but muscular limbs.

Like Baragon, Varan is basically a quadruped.

054

Varan

1968

"Destroy All Monsters"

Explanation

Varan appeared in "Varan the Unbelievable" (1958) as the third headlining monster (after Godzilla and Rodan), but perhaps because it was in black and white, it did not receive much attention and wouldn't appear again until "Destroy All Monsters" 10 years later. However, only a small flying model was filmed and it did not aid in the battle against King Ghidorah. The original suit will be explained here.

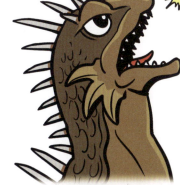

With its cool look and ability to dominate on land, sea, and air, Varan should have been a bigger hit. Perhaps the lack of success can be chalked up to its ignominious defeat by swallowing an explosive flare.

The magic of Varan's suit is particularly apparent in the scene in which it lays waste to the settlement while on all fours. The dynamic moving line from head to tail is brought to life by Haruo Nakajima's masterful performance in the greatest scene of this four-legged kaiju.

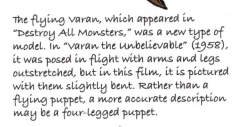

The flying Varan, which appeared in "Destroy All Monsters," was a new type of model. In "Varan the Unbelievable" (1958), it was posed in flight with arms and legs outstretched, but in this film, it is pictured with them slightly bent. Rather than a flying puppet, a more accurate description may be a four-legged puppet.

A suit with two sides

Varan is a creature long worshipped as the "Baradagi Mountain God" in a hidden village deep in the mountains of northeastern Japan. Among Toho monsters, the four-legged side view is the most reptilian, while the standing frontal is more human-(or demon) like. The design and modeling of this monster is truly amazing, encapsulating both the ancient reptile and the raging god in a single suit. Once almighty, it is now relegated to Monster Island, similar to the fate of Mothra and Manda. Viewed as gods of the Earth intercepting King Ghidorah from outer space, we may be able to regard the film on a more awe-inspiring scale.

055

Showa Godzilla Series
GABARA
1969

The basic facial structure is similar to Godzilla, but doesn't protrude as much.

The number of digits is the equal of Godzilla's: four for each hand and three per foot.

Gabara's back has neither dorsal plate nor carapace that would serve as a so-called "zipper hider," being simply covered with uniformly designed warts. Despite this, the suit is so well sculpted that the seams are barely discernible.

The horns on the head run down to the nape of the neck.

It has a long neck and is taller than Godzilla.

Warts covering its body are reminiscent of the rejected prototype of first generation Godzilla. Gabara's face also bears a resemblance to the big lizard. It's interesting to imagine this is how Godzilla may have turned out if they went with the warty look.

The lighthearted, tail-less getups were seen on TV's "Go! Godman" and "Go! Green Man."

All fingers and toes have sharp claws, another point which distinguishes it from frogs.

056

Gabara

1969

"All Monsters Attack"

Explanation

As a "bully monster" that lives on Monster Island in Ichiro's imaginary world, "Gabara" also just happens to be the nickname of the boy tormenting him in real life. Taller than Godzilla, it might seem like an adult monster is bullying child Minilla. However, the word for "bully" in Japanese is ambiguous and leaves the possibility that despite its appearance Gabara is also a child. That would, in turn, mean that Godzilla has gotten involved in a child's spat...

After the horns glow pink, electric current flows from the back through the arms to the prey, paralyzing it.

Scenes where Gabara's suit, without interior actors, flies through the air when Minilla knocks it off a seesaw or is tossed over Godzilla's back are memorable, and seem to contribute to Gabara's somewhat pitiful image.

No need for practical effects!

For monsters from the "Toho Champion Film Festival" that came out following Gabara, it is obvious at a glance that while they are upright and bipedal, they have no tail or a short tail and a suit that doesn't require manipulation.

The first Godzilla-like monster

Gabara, said to have mutated from a toad, is frog-like with its warty skin and lack of tail, but also has noticeable mammalian elements, such as ears and hair. This may be an anthropomorphic expression of the "bully monster" of Ichiro's dream. Or perhaps it is the image of a "demon," including the horns. Gabara is a monster without a tail, but otherwise quite similar in form to Godzilla. In general, this so-called "Godzilla type" design was avoided, being reserved for the big guy alone. However, it was a hit with kids, easy (or unnecessary) to manipulate, and suited for action, which led to the style going mainstream as low budgets and short production runs became the norm.

057

Godzilla: The Encyclopedia

Showa Godzilla Series
HEDORAH
1971

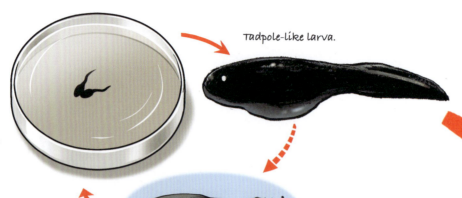

The animated depiction of two larvae merging into a single creature effectively foreshadows the threat of Hedorah.

Tadpole-like larva.

The larva has dried and crumbled. When placed in sewage, it quickly regenerates.

What form of monster will appear next?

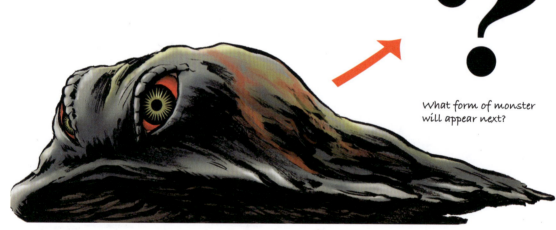

A disc-shaped Hedorah in flying mode.

Releasing sulfuric acid mist to devastate wide swaths of the country.

A radically new kaiju on a different level from Earth creatures

In "Godzilla vs. Hedorah," filmmakers went all in on portraying the individuality of Hedorah, as evidenced by the multitude of models and techniques utilized in its development. The initial tadpoles alone are truly diverse, ranging from a small puppet, to a 30-centimeter specimen caught by a fisherman, to a dried out version, to a loach with a round head, and then to an animated creature. Hedorah's development seems to trace the history of biological evolution, both as an individual and the whole. It embodies a grand picture of anti-organic life that, all by itself, encompasses an ecosystem of alien origin vastly different from those on Earth.

Hedorah

1971

"Godzilla vs. Hedorah"

Explanation

This enigmatic creature appeared in "Godzilla vs. Hedorah," a cult favorite with its avant-garde take on the themes of pollution, a societal concern at the time. The design, embodying a living nightmare, combined with its ability to grow and mutate, directly ties in to the theme of the film and makes a powerful impression.

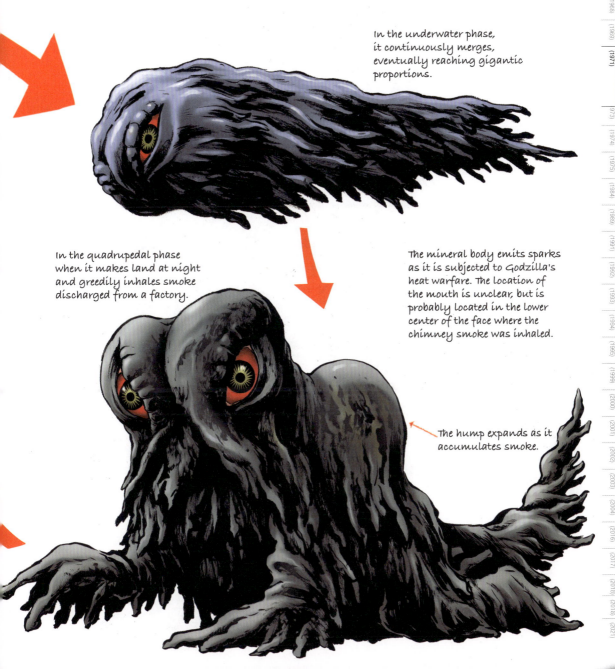

In the underwater phase, it continuously merges, eventually reaching gigantic proportions.

In the quadrupedal phase when it makes land at night and greedily inhales smoke discharged from a factory.

The mineral body emits sparks as it is subjected to Godzilla's heat warfare. The location of the mouth is unclear, but is probably located in the lower center of the face where the chimney smoke was inhaled.

The hump expands as it accumulates smoke.

Showa Godzilla Series

Hedorah

1971

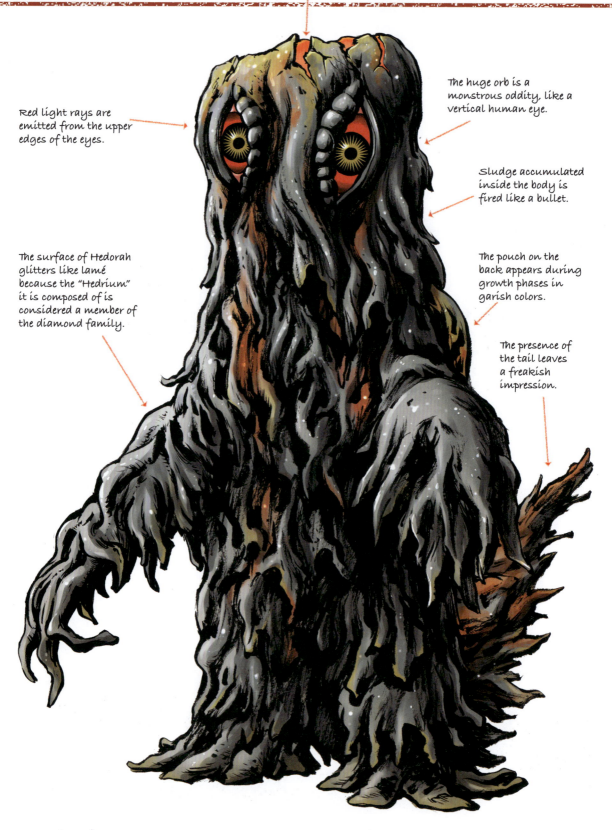

- As the head grows, the fissure in the head widens and emits red light.
- The huge orb is a monstrous oddity, like a vertical human eye.
- Red light rays are emitted from the upper edges of the eyes.
- Sludge accumulated inside the body is fired like a bullet.
- The surface of Hedorah glitters like lamé because the "Hedrium" it is composed of is considered a member of the diamond family.
- The pouch on the back appears during growth phases in garish colors.
- The presence of the tail leaves a freakish impression.

HEDORAH 1971

Explanation

As it grows, Hedorah eventually morphs into an upright, two-legged monster larger than Godzilla. However, it possesses none of the beauty or grace of a living creature, even a trace of functionality or natural order like that of other kaiju. When giant eyes were added to its elusive form, an impressive entity was born, one whose character is chaos itself.

Hedorah's growth is not irreversible, and it can transform into a flying creature at will. When it loses mass, it regresses to its land roving or underwater forms.

Unlike when it dries naturally, it loses its regenerative capacity when baked at high temperatures.

One more?

Hedorah, embodying the horror of pollution

"Godzilla vs. Hedorah," produced under the new regime after the passing of Eiji Tsuburaya, frequently depicts human death in a direct manner rarely seen in previous Godzilla films. This is due to director Yoshimitsu Banno's strong awareness of the blight of pollution. Thus Godzilla faces an unprecedentedly deadly foe in Hedorah that results in massive trauma to its body.

Typically, the kaiju is responsible for the damage it causes, but Hedorah is not what it seems to be. The being is simply transmuted pollution, which causes damage whether it exists or not. The final form of Hedorah, which has developed via biological evolution, is rather human-like and may be seen as a metaphor for the monstrousness of human society.

Showa Godzilla Series
GIGAN
1972

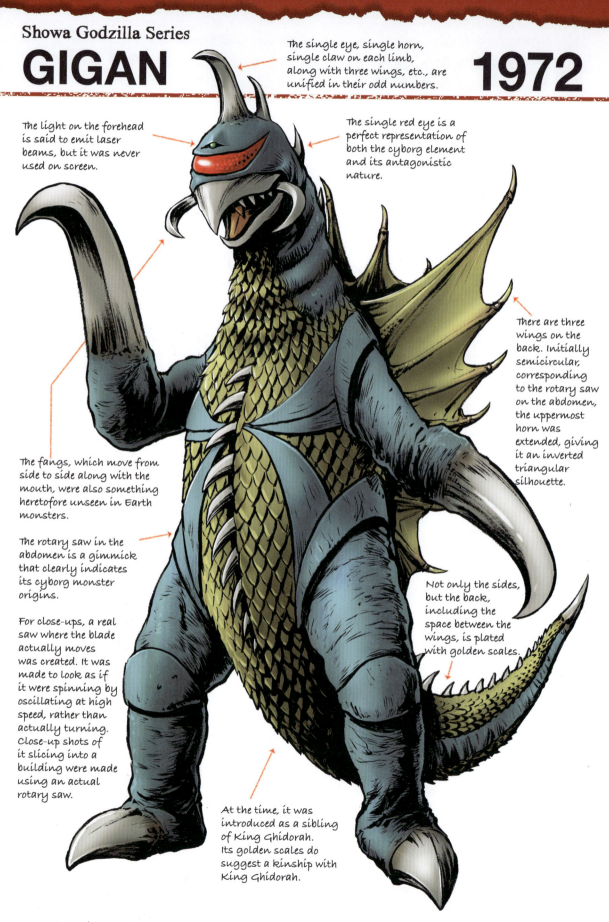

The single eye, single horn, single claw on each limb, along with three wings, etc., are unified in their odd numbers.

The light on the forehead is said to emit laser beams, but it was never used on screen.

The single red eye is a perfect representation of both the cyborg element and its antagonistic nature.

The fangs, which move from side to side along with the mouth, were also something heretofore unseen in Earth monsters.

The rotary saw in the abdomen is a gimmick that clearly indicates its cyborg monster origins.

For close-ups, a real saw where the blade actually moves was created. It was made to look as if it were spinning by oscillating at high speed, rather than actually turning. Close-up shots of it slicing into a building were made using an actual rotary saw.

There are three wings on the back. Initially semicircular, corresponding to the rotary saw on the abdomen, the uppermost horn was extended, giving it an inverted triangular silhouette.

Not only the sides, but the back, including the space between the wings, is plated with golden scales.

At the time, it was introduced as a sibling of King Ghidorah. Its golden scales do suggest a kinship with King Ghidorah.

062

Gigan

1972

"Godzilla vs. Gigan"

Explanation

The sharp and innovative design of this "futuristic monster," as it was also known, was an instant update of the classic old-fashioned kaiju that had been so strongly associated with Toho. The Cyborg Monster, another alias, accurately depicted it as an alien invasion weapon and led to the introduction of Mechagodzilla. The monster became so popular that it would appear next in "Godzilla vs. Megalon" as well as the TV show "Zone Fighter."

When flying, the wings fold backward rather than open. They may be more like dorsal plates than wings.

Even though only one year had passed since the previous version, a new suit was made for the encounter with Megalon. In addition to the overall darker body color, the face and body are quite different. The face has slightly drooping eyes, and the beak is thicker and shorter, giving a blunter impression. The angle of the head is also facing upwards.

The attraction of the cyborg monster Gigan

When we think of cyborgs, we tend to imagine a fusion of organism and machine, but in fact there is nothing overtly mechanical about Gigan. The red single eye is striking, but it also has a biological feel, like the compound eye of an insect. Fangs that open from side to side are also seen in insects. The mechanical impression one gets from Gigan is in fact more insect related. However, by introducing these insect-like elements to a reptilian monster, the artist has succeeded in suggesting a "creature that defies the rules of nature = cyborg," while at the same time lending it the unified, elegant aspect of a living organism. When the saw in the belly rotated, the insect and mechanical elements meshed perfectly.

063

Showa Godzilla Series
GODZILLA
1973

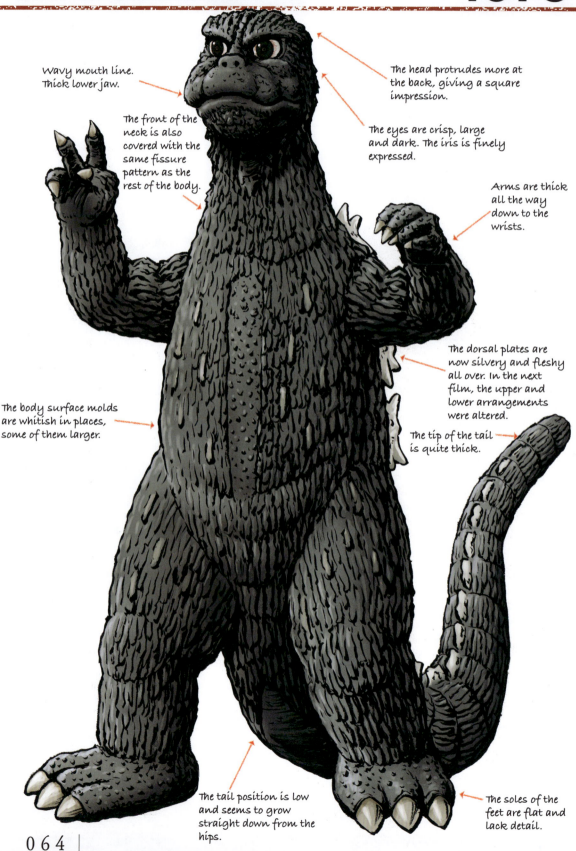

Wavy mouth line. Thick lower jaw.

The front of the neck is also covered with the same fissure pattern as the rest of the body.

The head protrudes more at the back, giving a square impression.

The eyes are crisp, large and dark. The iris is finely expressed.

Arms are thick all the way down to the wrists.

The body surface molds are whitish in places, some of them larger.

The dorsal plates are now silvery and fleshy all over. In the next film, the upper and lower arrangements were altered.

The tip of the tail is quite thick.

The tail position is low and seems to grow straight down from the hips.

The soles of the feet are flat and lack detail.

Godzilla

1973

"Godzilla vs. Megalon"

Explanation

The new Godzilla suit, the first new suit in five years since "Destroy All Monsters" (1968), makes a cute impression with large eyes and a round body shape, perhaps because it was revealed during the "Champion Film Festival" for kids, and the action has a human, easy-to-understand, comical feel. The head has been modified for each of the three films, and the changes are significant.

"Godzilla vs. Mechagodzilla" (1974)

"Terror of Mechagodzilla" (1975)

Besides the face, the arrangement of the dorsal plates in 1974 is different from that of the previous film. The reason is uncertain, but it may be due to the damage caused in the "Zone Fighter" appearance.

Drop-kicking while sliding its tail on the ground! Once you suspend disbelief and go with the flow, you'll find yourself hooked on this movie.

This Godzilla as it appeared in "Zone Fighter." It was a great fit for co-starring with other heroes.

A Hero for Justice? Godzilla

Haruo Nakajima retired, having played Godzilla since the first generation, and the sculpting was handed over from the duo of Toshimitsu and Yagi to Yasumaru, resulting in a Godzilla with a very different presence from the previous ones.
Because Godzilla films of this period were aimed at children and had low budgets, they were not well received when Toho Tokusatsu was reevaluated in the '80s, and the form of this Godzilla was criticized quite harshly. Now that diverse Godzilla forms have become the norm, it comes across as a lovable version of some importance. In addition, many fans in the U.S. feel that this is the "correct" Godzilla. The fact that it has become the ultimate heroic monster of justice is undoubtedly a unique aspect of Godzilla that has guaranteed its popularity.

065

Showa Godzilla Series
MEGALON
1973

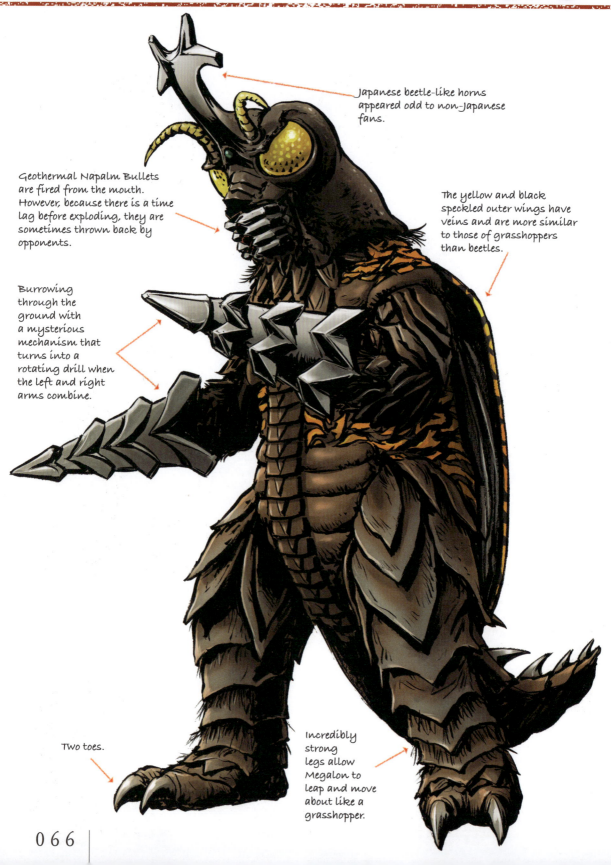

- Japanese beetle-like horns appeared odd to non-Japanese fans.
- Geothermal Napalm Bullets are fired from the mouth. However, because there is a time lag before exploding, they are sometimes thrown back by opponents.
- Burrowing through the ground with a mysterious mechanism that turns into a rotating drill when the left and right arms combine.
- The yellow and black speckled outer wings have veins and are more similar to those of grasshoppers than beetles.
- Two toes.
- Incredibly strong legs allow Megalon to leap and move about like a grasshopper.

Megalon

1973

"Godzilla vs. Megalon"

Explanation

A guardian beast of the underground kingdom of Seatopia, it was angered by the nuclear tests of humans aboveground and was sent to seek revenge. It has beetle-like horns and jumps like a grasshopper. Perhaps because of its ability to dig its way through the ground, its design also evokes the image of a mole cricket.

It fires yellow lightning-like beams similar to King Ghidorah's gravitational rays from its horns. It also emits yellow light when firing Geothermal Napalm Bullets.

When flying, the arms come together, outer wings spread open, and the two center wings rise up like a vertical tail and take on a jet-like form.

One contributing factor for Jet Jaguar's popularity in the U.S. was the frequent rebroadcasts of "Godzilla vs. Megalon" on cable TV. Consequently, the "Gigan and Megalon duo" seem to have become the definitive villainous monsters.

The first insectoid creature in the Godzilla series

Insect monsters in Toho Tokusatsu movies to date, such as Mothra, Kamacuras, and Kumonga, were basically just giant insects, and thus represented only by hand manipulation. This style has already become a standard in TV special effects, but in comparison, the Megalon design is probably one of the best.

Personally my own special preference is the way the eyes are expressed. I don't like to make insects' eyes anthropomorphic just because they are villains, but Megalon's eyes have an insect-like hemispherical shape with an eyelid-like halo that lend it the unmistakable expression of something evil. That is what makes it cool.

067

Showa Godzilla Series
JET JAGUAR

1973

The eyes are video cameras that can also act as lights that emit blue beams.

The face is similar to a Hannya (Japanese female demon), but that's part of its charm.

The accordion structure of the entire body has succeeded in virtually eliminating wrinkles, always a challenge for hero suits.

Arms powerful enough to lift Gigan and heave it into the air.

In the abdominal accordion structure, the fourth ring is thickest.

While the luminescent eyes of many robots are merely lamps indicating activation, the eyes of Jet Jaguar function as a genuine light source for searching out and dazzling the enemy.

Rocket jets for flight are located in the toes.

068

Jet Jaguar

1973

"Godzilla vs. Megalon"

Explanation

The first giant robot in the Godzilla series is also the first humanoid robot in the Toho Tokusatsu series. Although it has no weapon to wield, it grows into a giant at will and teams up with Godzilla, an ally of mankind, to fight against the Megalon & Gigan duo.

When flying, the antenna on the head open up.

The flying model is posed with its arms open in a C-shape and extended forward. The principle of flight is unknown.

The shape of Jet Jaguar's head is similar to other Toho heroes of the time, such as Godman and Zone Fighter.

Robots of justice with legions of international fans

With the introduction of Jet Jaguar, the company was no doubt aware of the popularity of giant heroes like Ultraman and their robot counterparts such as Mazinger Z. However, Jet Jaguar's design and characterization have a unique individuality that does not simply settle for being second best.

To say that Jet Jaguar's sense of style is off would be an understatement, but it still exudes a different presence in a world overflowing with successors to heroes and robots. It is beloved by younger fans, and has even been reevaluated by the generation of the time, not to mention has caught on with many overseas as well. It may not be a bad idea to take a fresh look at its appeal.

069

Showa Godzilla Series
MECHAGODZILLA 1974

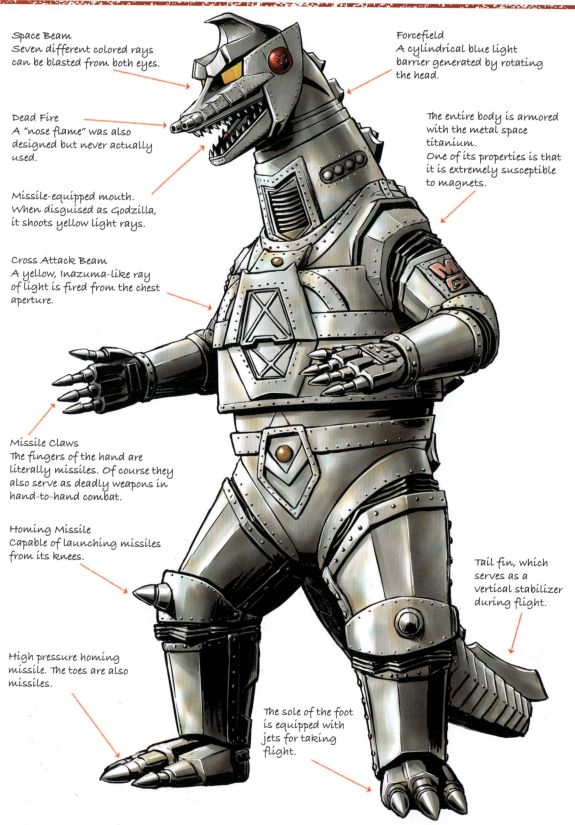

Space Beam
Seven different colored rays can be blasted from both eyes.

Dead Fire
A "nose flame" was also designed but never actually used.

Missile-equipped mouth. When disguised as Godzilla, it shoots yellow light rays.

Cross Attack Beam
A yellow, Inazuma-like ray of light is fired from the chest aperture.

Missile Claws
The fingers of the hand are literally missiles. Of course they also serve as deadly weapons in hand-to-hand combat.

Homing Missile
Capable of launching missiles from its knees.

High pressure homing missile. The toes are also missiles.

Forcefield
A cylindrical blue light barrier generated by rotating the head.

The entire body is armored with the metal space titanium.
One of its properties is that it is extremely susceptible to magnets.

Tail fin, which serves as a vertical stabilizer during flight.

The sole of the foot is equipped with jets for taking flight.

070

Mechagodzilla

1974

"Godzilla vs. Mechagodzilla"

Explanation

Has Godzilla vs. Godzilla finally been realized? Here, a mechanical Godzilla created by a being from Planet 3 of the Great Cosmic Black Hole wants to invade Earth! This new "Mechagodzilla" is a celebrated character that knocks out the fans with its vivid debut scene, overwhelming firepower, and captivating design.

It first took the stage by impersonating Godzilla with a false exterior. The shape of Godzilla is unmistakable. Still, there was also not much point in disguising itself.

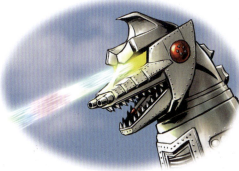

Space beams fired from the eyes.

Cross-attack beams fired by opening the chest hatch.

In flight position with its head facing forward and its arms slightly open behind it. While flying, its sole weapons of attack are the space beams from its eyes.

Mechagodzilla captivates the crowd with an overwhelming aura

Considering children's shifting interest to TV-based heroes and robots, combined with the gradual decline in popularity of the Godzilla series, the introduction of Mechagodzilla was perhaps inevitable. The highly stylized design and modeling, however, demonstrated solid characterization and a realism that could not be matched by either anime or TV special effects. Even I, a fourth grader at the time, was blown away by the image I saw on a magazine cover, and returned to the theater for another chance to see Godzilla, having skipped it the previous year. Mechagodzilla certainly had that much appeal. And as a perennial favorite on par with King Ghidorah and Mothra, Mechagodzilla would return in a new form in each new series.

071

Showa Godzilla Series
KING CAESAR 1974

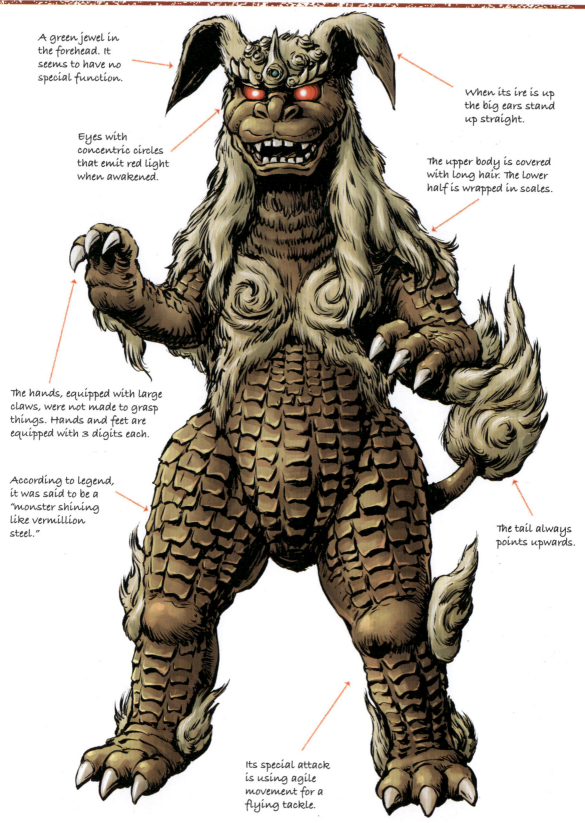

- A green jewel in the forehead. It seems to have no special function.
- Eyes with concentric circles that emit red light when awakened.
- When its ire is up the big ears stand up straight.
- The upper body is covered with long hair. The lower half is wrapped in scales.
- The hands, equipped with large claws, were not made to grasp things. Hands and feet are equipped with 3 digits each.
- According to legend, it was said to be a "monster shining like vermillion steel."
- The tail always points upwards.
- Its special attack is using agile movement for a flying tackle.

King Caesar

1974

"Godzilla vs. Mechagodzilla"

Explanation

King Caesar, the legendary guardian of Okinawa. This lion-like Shisa creature is a non-humanoid mammalian monster, rare in Toho Tokusatsu films. Its beast-like fighting style provides a good contrast to the mechanical Mechagodzilla.

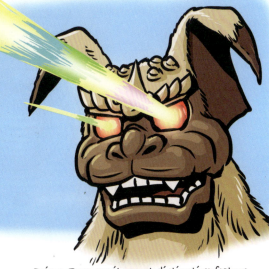

Prism Eyes are its most distinctive feature. Energy beams are captured in one eye and shot back at the attacker through the other. This unique ability is unseen in nature.

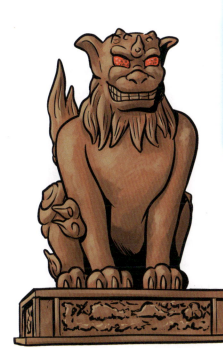

This statue is key to King Caesar's revival. According to the hieroglyphics on the pedestal, when set on the shrine, beams will shine from its eyes and it will arise. The model is equipped with special eyes that emit a red glow.

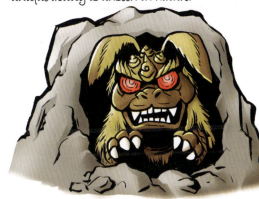

King Caesar, the "guardian god" awakened by song

The film focuses less on Mechagodzilla and more on the suspense of solving the mystery surrounding Caesar's resurrection and the final struggle for the statue. King Caesar is at last awakened after "Miyarabi's Prayer" is sung, but for all the screen time it received, I got the feeling that it didn't play an important role. Even Black Hole Planet 3 Alien, who tried so hard to prevent its resurrection, says, "Take down King Caesar for now," casually dismissing it. Apologies to King Caesar, but I feel as if Godzilla alone could have defeated Mechagodzilla. But perhaps this is because King Caesar was caught between Mechagodzilla, an over-powered character, and a Godzilla that couldn't afford to appear weak in contrast.

073

Showa Godzilla Series
MECHAGODZILLA　1975

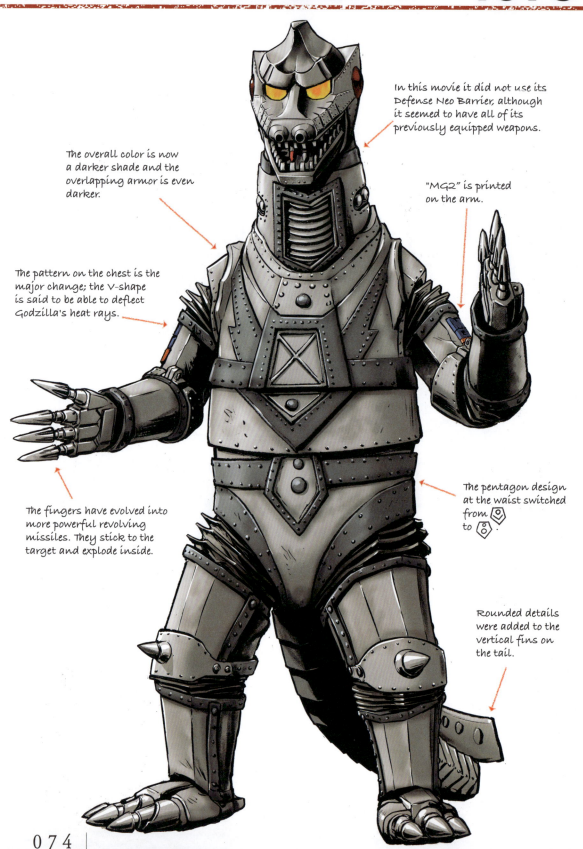

The overall color is now a darker shade and the overlapping armor is even darker.

In this movie it did not use its Defense Neo Barrier, although it seemed to have all of its previously equipped weapons.

"MG2" is printed on the arm.

The pattern on the chest is the major change; the V-shape is said to be able to deflect Godzilla's heat rays.

The fingers have evolved into more powerful revolving missiles. They stick to the target and explode inside.

The pentagon design at the waist switched from ⬠ to ⬠.

Rounded details were added to the vertical fins on the tail.

074

Mechagodzilla

1975

"Terror of Mechagodzilla"

Explanation

The wreckage of Mechagodzilla, destroyed by Godzilla in the previous film, was recovered, regenerated, and further strengthened. It linked to the cyborg girl's brain, turning it into a more perfect cyborg monster.

Cyborg girl

Katsura is the only daughter of Dr. Mafune. She died in an experiment, but was resurrected as a cyborg at the hands of the Black Hole Planet 3 Aliens. She emits an eerie light from her eyes. In later surgery, a Mechagodzilla control device is implanted into her brain.

A second head was created inside as a safety measure following Mechagodzilla's previous defeat when Godzilla crushed its head. It fires a powerful beam.

In Katsura's refitting scene, her breasts are exposed. Even if fake, it was shocking for children's film program "Champion Festival," as it might have proven awkward for both kids and their parents. The fact that the internal mechanisms were shown was important, and would have contributed to highlighting Katsura's tragic nature by making the viewer realize visually as well as verbally that she is a cyborg.

Mechagodzilla seen in different light after mind linking with a girl

Mechagodzilla itself seems to have been upgraded only slightly, but the existence of a link with a cyborg girl allows us to view it in a very different light. This may be considered a forerunner to the "mecha and beautiful girl" concept that has now become common in anime and other entertainment. Titling this sequel merely "Mechagodzilla", a character so popular from the previous film, is seen as a marketing strategy to rely on the marquee name to attract audiences when monsters like Godzilla no longer had similar drawing power. However, the current trend proved too hard to buck, and following this film the Godzilla series went into hibernation for some time. This formula would be repeated in the follow-up series. Mechagodzilla may be seen as a terminator that brings about the end of each Godzilla series.

075

Godzilla: The Encyclopedia

Showa Godzilla Series
TITANOSAURUS 1975

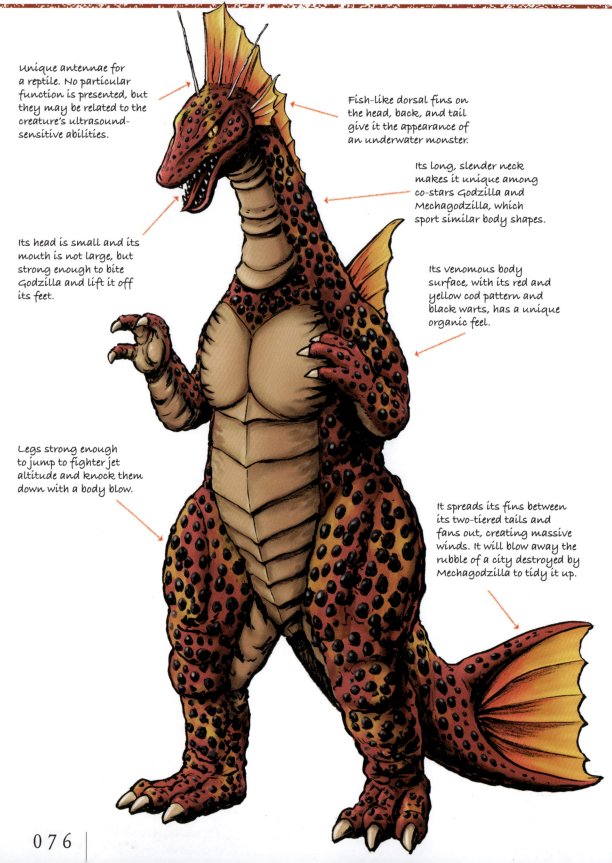

Unique antennae for a reptile. No particular function is presented, but they may be related to the creature's ultrasound-sensitive abilities.

Fish-like dorsal fins on the head, back, and tail give it the appearance of an underwater monster.

Its long, slender neck makes it unique among co-stars Godzilla and Mechagodzilla, which sport similar body shapes.

Its head is small and its mouth is not large, but strong enough to bite Godzilla and lift it off its feet.

Its venomous body surface, with its red and yellow cod pattern and black warts, has a unique organic feel.

Legs strong enough to jump to fighter jet altitude and knock them down with a body blow.

It spreads its fins between its two-tiered tails and fans out, creating massive winds. It will blow away the rubble of a city destroyed by Mechagodzilla to tidy it up.

Godzilla: The Encyclopedia

Titanosaurus

1975

"Terror of Mechagodzilla"

Explanation

The first dinosaur-type kaiju to make an appearance in the Godzilla series in a while. In fact, it is treated as a genuine dinosaur in the film. However, with its fish-like fins and insect-like antennae, it can hardly be called simply a dinosaur, and is given special features to make it more monster-like. It is controlled by cyborg girl Katsura using a device invented by Dr. Mafune.

A swimming model instead of a flying prop was used for the underwater scene. The fins of the tail also spread out while swimming, and it can be argued that Godzilla was ahead of its time in depicting a bipedal monster swimming on its side.

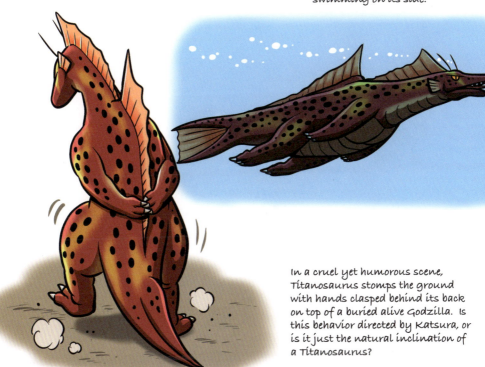

In a cruel yet humorous scene, Titanosaurus stomps the ground with hands clasped behind its back on top of a buried alive Godzilla. Is this behavior directed by Katsura, or is it just the natural inclination of a Titanosaurus?

A second monster involved in the drama on the human side

Even though Mechagodzilla is in monster form, it is in essence an alien weapon, so it is the second monster involved in the drama on the human side. The same is true of King Caesar and this Titanosaurus. In "Terror of Mechagodzilla," Titanosaurus is the only monster to star in the movie until Mechagodzilla begins its attack an hour after the movie starts. When more than one kaiju make an appearance in a film, they typically try to mix in the different monster styles as much as possible, but all three kaiju in this film are Godzilla (upright dinosaur)-type. On the other hand, the three monster traits are clearly divided, with the slender Titanosaurus being ranked in a slightly lower weight class.

I thought it would be interesting to have futuristic robot Mechagodzilla controlled by aliens and the primitive dinosaurs controlled by Earthlings and have the two go at it. But in the end, both were governed by a female cyborg.

0 7 7

GODZILLA ANATOMICAL FILE

Godzilla Heisei Era (1984-1995)

Godzilla
1984 "The Return of Godzilla"

The YAHATA MARU No.5 encounters Godzilla for the first time at the west end of Daikoku Island. Later, a Soviet nuclear submarine is attacked south of Hachijojima. Godzilla heads to Japan in search of nuclear material for an energy source. After absorbing all radioactive materials from the Mihama Nuclear Power Plant in Shizuoka, it comes ashore in Tokyo Bay.

Godzilla
1989 "Godzilla vs. Biollante"

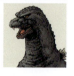

Godzilla, buried in Mt. Mihara in the previous film, is revived by explosives planted in the volcano. It appears in Tokyo Bay but is intercepted by Super X2, and a battle ensues. Perhaps sensing the presence of Biollante, Godzilla then comes ashore from Odawara and proceeds to Lake Ashi, where it confronts the monster. It is tormented by Biollante's many tentacles.

Biollante
1989 "Godzilla vs. Biollante"

A monster created by the fusion of roses, humans, and G-cells. After attacking an industrial spy that had infiltrated Shirakami Laboratory, it grew to giant size in Lake Ashi. Because a human mind resides within, it is named Biollante after the plant spirit from Norse mythology.

Godzilla
1991 "Godzilla vs. King Ghidorah"

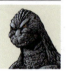

A dying Godzillasaurus, warped into the Bering Sea by a Futurian, is transformed into Godzilla by radiation emitted from a sunken Soviet nuclear sub. It later absorbs the core of submarine MUSASHI-2, growing to a gigantic size, and lands in Hokkaido. It faces off against King Ghidorah in the town of Bihoro.

Godzillasaurus
1991 "Godzilla vs. King Ghidorah"

A dinosaur that inhabited Lagos Island. In 1944, it supported the Japanese military. Originally destined to be transformed into Godzilla by the effects of nuclear testing at Bikini Atoll in 1954, it was warped into the Bering Sea by people from the future to prevent this from happening.

Dorats
1991 "Godzilla vs. King Ghidorah"

Creatures genetically engineered as pets in the world of the 23rd century. They can only be controlled by their owners through special sound waves. However, these three animals were designed to eventually merge together to form King Ghidorah when subjected to the effects of a nuclear explosion.

King Ghidorah
1991 "Godzilla vs. King Ghidorah"

Three Dorats left behind by Emmy in 1944 are transformed by the 1954 nuclear tests on Bikini Atoll. They are controlled by the same sound waves as the Dorats, and attack Fukuoka City in the present day, though under power of agents in the future. They fight Godzilla in Hokkaido.

Mecha-King Ghidorah
1991 "Godzilla vs. King Ghidorah"

King Ghidorah, whose wings were burned off by Godzilla's heat rays and left to sink into the ocean, was raised from the Sea of Okhotsk in the year 2204 and transformed into a cybernetic monster using 23rd century technology. Emmy is the pilot. She time-warped to the present day to confront Godzilla.

Godzilla
1992 "Godzilla vs. Mothra"

A meteorite falling in the Ogasawara Trench causes Godzilla, submerged with Mecha-King Ghidorah, to resurface. It then appears behind transport ship ARIAKE, which is towing Mothra eggs off the coast of the Philippines. It attacks the hatched Mothra larvae.

Mothra
1992 "Godzilla vs. Mothra"

Once the guardian god of Earth, it battled Battra 12,000 years ago in the icy seas of the north.
The eggs were lost to the deep in the late '60s and early '70s. In the modern era, the eggs of Mothra came to light on Infant Island due to a huge typhoon south of Indonesia. With the cooperation of Cosmos, the eggs are transported to Japan.

Battra
1992 "Godzilla vs. Mothra"

Twelve thousand years ago, a scientist from Cosmos developed a device that could manipulate the climate at will, resulting in the birth of the black Mothra Battra. It then began destroying its surroundings, forcing the Earth to retaliate and extinguish it. Later, resurrected Battra lands on the Noto Peninsula and heads underground to Nagoya.

Godzilla
1993 "Godzilla vs. Mechagodzilla II"

Godzilla suddenly appears on Adonoa Island and battles Rodan. Later lands in Yokkaichi, Japan, and destroys an industrial complex as it chases an egg protected by the island's research team. It then confronts Mechagodzilla, who then menaces Babygodzilla, newly hatched from its egg.

Godzilla Heisei Era (1984-1995)

Mechagodzilla
1993 "Godzilla vs. Mechagodzilla II"

Mecha-King Ghidorah, left to the bottom of the sea, was hauled up and thoroughly restored. This new machine for tackling Godzilla was created using technology from the 23rd century. It battles Rodan, who has kidnapped Babygodzilla, and defeats it even though the right eye Laser Cannon has been destroyed.

Super Mechagodzilla
1993 "Godzilla vs. Mechagodzilla II"

Mechagodzilla combines with Garuda, becoming a creature that can fly and has massive firepower. It challenges Godzilla and drives it to the brink of death with its powerful guns and shock anchors, but is repulsed by Godzilla, who receives Fire Rodan's energy.

Rodan
1993 "Godzilla vs. Mechagodzilla II"

This monster lives on Adonoa Island in the Bering Sea. It attacks a research team that was collecting Pteranodon fossils and perfectly formed eggs. Facing off against Godzilla, who emerges from the sea, it violently pecks away, but is defeated in a heated battle. It later goes to Japan to retrieve Babygodzilla.

Babygodzilla
1993 "Godzilla vs. Mechagodzilla II"

Dinosaur Godzillasaurus hatches from an egg found on Adonoa Island. It was a brood parasite in the nest of Rodan. It is called "Baby" by Gojo, a researcher at the National Institute for Life Science. Later kidnapped by Rodan while being transported in an attempt to lure Godzilla.

Godzilla
1994 "Godzilla vs. Spacegodzilla"

It suddenly appears on the shore of Baas Island and fights to protect Babygodzilla from Spacegodzilla, but is out of luck. Following Spacegodzilla, it heads for Fukuoka, lands in Kagoshima, and then to Fukuoka via Kumamoto and Beppu. In Fukuoka, surrounded by crystals, it has it out with Spacegodzilla.

Spacegodzilla
1994 "Godzilla vs. Spacegodzilla"

Spacegodzilla was created when G-cells combined with crystalline organisms and rapidly evolved in outer space. Flying in to defeat Godzilla, it knocks M.O.G.U.E.R.A. out of control and attacks Babygodzilla on Baas Island. After defeating Godzilla, it traps Babygodzilla in its crystalline prison and flies off.

Littlegodzilla
1994 "Godzilla vs. Spacegodzilla"

Babygodzilla grew to a massive size while spending time on Baas Island in the South Pacific, but similar to its predecessor, it has grown accustomed to humans. It was frozen in a crystalline form by Spacegodzilla. After its release, it was able to blow tiny radioactive heat bubbles.

M.O.G.U.E.R.A.
1994 "Godzilla vs. Spacegodzilla"

A weapon designed to defend against Godzilla, the initials standing for Mobile Operation Godzilla Universal Expert Robot Aero-type. It engages in battle with Spacegodzilla, fresh from outer space, but loses control. Later, it is recharged and once again takes up the challenge of defeating the incoming Spacegodzilla.

Godzilla
1995 "Godzilla vs. Destoroyah"

It appeared red-hot in Hong Kong, on the verge of a nuclear meltdown, the result of a fission reaction caused by absorbing the energy of a uranium deposit on Baas Island. It appears in Bungo Channel after passing off the coast of Taiwan and Okinawa, and is hit by Super XIII's freezer bombs and ultra-low temperature lasers.

Destoroyah
1995 "Godzilla vs. Destoroyah"

Microscopic life forms living without oxygen in the geological strata 2.5 billion years ago were revived by the Oxygen Destoroyah device and evolved when exposed to the atmosphere. Multiple human-sized individuals grow and morph out of the microscopic organisms. Exposed to ultra-low temperature laser irradiation and frozen bullets, they fuse and grow into gigantic creatures.

Godzilla Jr.
1995 "Godzilla vs. Destoroyah"

It disappeared in a plume of smoke with Baas Island, but was transformed by the island's nuclear reaction. After appearing in Omaezaki, it headed for Adonoa Island in the Bering Sea, but was guided to Tokyo, where it fought Destoroyah.

Heisei Godzilla Series
GODZILLA
1984

The flat eyebrows and the top of the head are similar to those of Godzilla 1973, also sculpted by Yasumaru.

The prominent canine teeth are another way it pays homage to the first generation.

The lower jaw became square, thicker, and more powerful.

Sharply upward-looking, vicious sanpaku eyes.

The three rows of dorsal plates were larger on both sides in addition to the center row. This was also carried over to subsequent series.

Dorsal plates with the largest peak are below the center.

The surface skin produced by die-cutting is denser than the conventional urethane direct-applied skin, while at the same time it is less rough.

The tail became much longer and its tip thinner.

The toes have returned to the same four as in the first generation, but the big toes are not as far apart.

080

Godzilla

1984

"The Return of Godzilla"

Explanation

Godzilla was resurrected after a long sleep of nine years, and for the first time its history was reset, establishing it as the second appearance since the first Godzilla in 1954. The "Champion Festival" era "friend of mankind" Godzilla was replaced with a throwback to the Godzilla of terror, with ears restored and four toes, the same as the first generation. This form also carried over into the subsequent Heisei series.

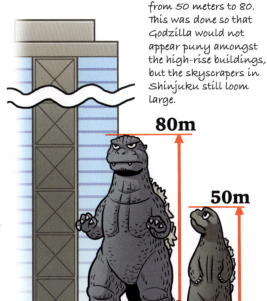

The height was raised from 50 meters to 80. This was done so that Godzilla would not appear puny amongst the high-rise buildings, but the skyscrapers in Shinjuku still loom large.

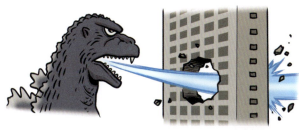

The heat rays have changed from the flame or gas of the Showa period to a more direct and longer range, almost beam-like appearance. The scene where the heat rays penetrate a building is particularly impressive.

A new ploy, in which Godzilla "absorbs radiation," was added to the film, but showcasing invisible radioactivity in a visual work proved challenging. The film uses the simple but somewhat immediate expression "Godzilla holds a reactor core," but this is the starting point for the Heisei VS series, which, while steering toward entertainment, does not forget the issue of radiation until the very end.

Godzilla, foundation of the Heisei series

During the nine years of Godzilla's hibernation, the movie industry had seen the rise of "Star Wars" and other foreign special effects, and new techniques were adopted for Godzilla's modeling to showcase the technological advances that have kept pace. A gimmick to move the muscles in the face was incorporated, and the epidermis was made from a clay prototype of the entire body, with the skin cut from the prototype and pasted on to give it a more lifelike appearance. The same skin and dorsal plates, which could be reproduced from the mold, continued to be used for subsequent works. In terms of setting, the creature was not only a "creature that does not die from radiation," but rather a "living nuclear reactor" that absorbs radiation as direct energy and reacts. In terms of both setting and design, it can be said that this Godzilla formed the basis of the Heisei series that would continue for the next six films.

081

Heisei Godzilla Series

Godzilla

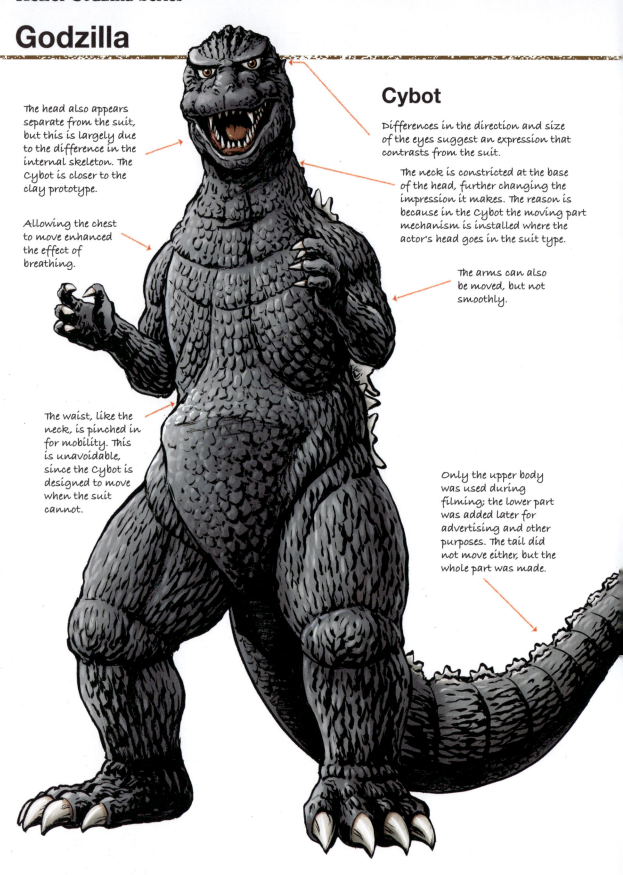

The head also appears separate from the suit, but this is largely due to the difference in the internal skeleton. The Cybot is closer to the clay prototype.

Allowing the chest to move enhanced the effect of breathing.

The waist, like the neck, is pinched in for mobility. This is unavoidable, since the Cybot is designed to move when the suit cannot.

Cybot

Differences in the direction and size of the eyes suggest an expression that contrasts from the suit.

The neck is constricted at the base of the head, further changing the impression it makes. The reason is because in the Cybot the moving part mechanism is installed where the actor's head goes in the suit type.

The arms can also be moved, but not smoothly.

Only the upper body was used during filming; the lower part was added later for advertising and other purposes. The tail did not move either, but the whole part was made.

082

1984

Explanation

In addition to the suit, a giant 4.8-meter-tall "Cybot" was built for the 1984 revival of Godzilla, with an internal mechanism that could depict changes in facial expression and breathing. It was used not only for filming but also for advertising, and became a symbol of the resurrected Godzilla.

In addition to the Cybot, a life-size Godzilla foot sculpture was made.

Shockirus was skewered with a broken harpoon, but moved about without a care in the world.

Shockirus

A giant one-meter-long wharf roach that was living parasitically on Godzilla's body. It attacks humans, sucking their bodily fluids, leaving them dried up husks. Despite its appearance, it can jump quite well. It is possible that when Godzilla landed in Tokyo, they were scattered all over the city, but I wonder if it would come off as American-style to depict that part of the story (in Western kaiju movies, there are often scenes in which the main characters fight human-size monsters).

Just as much screen presence as the suit

At a time when 3D scanners and printers were unavailable, creating objects of identical shape yet different sizes would inevitably involve human hands working from scratch, resulting in variations. This is especially true if the internal mechanisms were also different. In the case of this Cybot, the contrast in facial features is particularly striking, and since they were used for posters and other promotional material, it became hard to tell which was the main focus, the suit or the face. There were some scenes where the relative size of the Cybot could be felt when a bomb landed or smoke was released, but as only the upper half of the body was operational and was moved by a mechanical device, it came off as awkward. Therefore, the cuts used in the film were almost exclusively close-ups of the face, and the entire massive body was never shown. Lessons learned from these issues would be applied in the follow-up "Godzilla vs. Biollante."

0 8 3

Heisei Godzilla Series
GODZILLA 1989

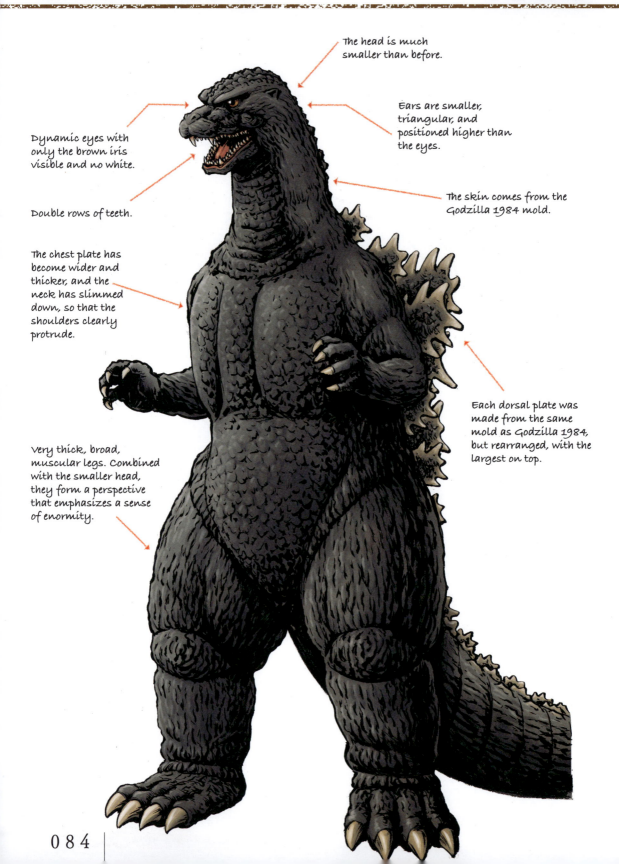

The head is much smaller than before.

Ears are smaller, triangular, and positioned higher than the eyes.

Dynamic eyes with only the brown iris visible and no white.

Double rows of teeth.

The skin comes from the Godzilla 1984 mold.

The chest plate has become wider and thicker, and the neck has slimmed down, so that the shoulders clearly protrude.

Each dorsal plate was made from the same mold as Godzilla 1984, but rearranged, with the largest on top.

Very thick, broad, muscular legs. Combined with the smaller head, they form a perspective that emphasizes a sense of enormity.

Godzilla

1989
"Godzilla vs. Biollante"

Explanation

Coming 5 years after "The Return of Godzilla" (1984), upon which it was based, this version gained tremendous support from fans old and new with innovative concepts throughout the movie and its strong, organic form, making it the new standard.

The first demonstration of a new technique: internal radiation of heat rays. It continued to be used in subsequent films and became a staple Heisei Godzilla technique.

The mechanical (guignol) of the upper body was also quite effective. The Cybot on page 82 had some issues, such as the face appearing different from the suit and the movements being awkward, so it was made from the exact same mold and size as the suit, its movements controlled by wires.

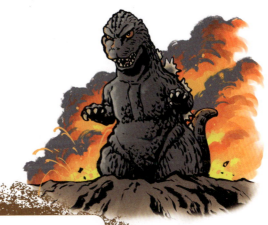

Godzilla, the standard for the Heisei era

"Godzilla" (1989) was the product of special effects director Koichi Kawakita, a showcase for his first time direction of the big lizard and his pursuit of the ideal Godzilla image. Innovations in morphology, such as the creation of eyes, teeth, and other details, lend the creature a more organic feel that gives it the appearance of a massive king of monsters. In addition, many new avenues were explored in production, such as the use of guignol for swimming and the installation of electric lights on the dorsal plates to make it glow. Thanks to these innovations, the new version was received with surprise and a favorable reception by fans. Although minor modifications were made in subsequent films, the basic style remained the same for the six films that followed until "Godzilla vs. Destoroyah" in 1995. The story was also consequently drawn from a continuous worldview, and this Godzilla would remain a major presence in the overall history of Godzilla as the face of the "Heisei VS Series."

085

Heisei Godzilla Series
BIOLLANTE
1989

It has a mouth in the center of its flower.

It can move the huge flower and leaves, albeit slightly.

The body looks like many vines intertwined with each other. A pouch of body fluid is in its center.

Tentacles with mouth and bristling teeth at the tip. In addition to biting attacks, they also spit highly acidic sap.

Vine-like tentacles entwine the opponent, trapping it in place. It is vulnerable to heat rays.

It is rooted to the bottom of the lake and cannot move.

Biollante

1989

"Godzilla vs. Biollante"

Explanation

Biollante, Godzilla's first kaiju antagonist in the Heisei era, is also the first plant monster in the series, created by synthesizing rose, human, and Godzilla cells based on the theme of biotechnology, an idea attracting attention at the time. Beginning to grow abnormally, Biollante attacked humans in the lab and then appeared in the form of a giant rose flower over Lake Ashi.

A huge rose at the top. At first it was a bud, but later bloomed with a mouth with leaves in the center. When it was a bud, it retained its human heart, but gradually became more ferocious.

It tried to block Godzilla's heat rays by building a wall with its tentacles, but this was easily breached and went up in flames.

This was the first battle with Godzilla, who, possessing the same cells as its own, had sensed Biollante's presence and confronted it. At this point, its power was negligible and it was easily defeated, but the life force transformed into spores that rose into the sky to further evolve...

New monster the product of crowd-sourcing

Biollante is the first Heisei kaiju to tussle with Godzilla, as well as the first new monster in 14 years, since the appearance of Titanosaurus in "Terror of Mechagodzilla." The original design was solicited from the public five years previously, immediately after "Godzilla" and dentist Shinichiro Kobayashi's concept was adopted. Pre-production was extensive and design work had been underway for quite some time, but it was a challenging task to come up with a final form for Biollante, which grows and morphs, to the satisfaction of director Kawakita, so this first iteration was sculpted ahead of the others. There are various names for both forms, such as "Biollante A & B" and "Lake Ashi & Wakasa version," but officially they are described as "flower-beast form" and "plant form."

Heisei Godzilla Series

Biollante

Explanation

Incinerated at Lake Ashi, Biollante turned into a spore and escaped into space. It later turns up in Wakasa in a gigantic and monstrously evolved form to again be confronted by Godzilla. This unprecedented massive, realistic shape, together with a "Super Godzilla," heralded the arrival of a new era for Godzilla.

White eyes lacking pupils.

Tentacles equipped with a mouth are the same as the Lake Ashi version.

The mouth is packed with teeth. This is a form not found in ordinary animals.

It has a luminous nuclear core in its abdomen that stores radioactive materials.

The head has become animal-like, but the plant's vitality is such that it does not sense damage even when blasted with heat rays.

The huge and peculiar shape of the sculpture was difficult to store and reproduce, so there were no opportunities to see it again, and it was never commercialized. The rarity of such a one-of-a-kind figure may have contributed to its popularity.

Tentacles with mouths grow in all directions like legs.

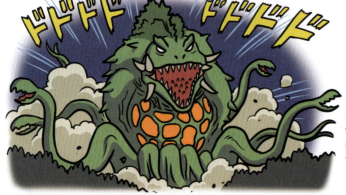

It was originally intended to be motionless, but a scene where it is mobile was hastily filmed. The charge of this giant, requiring more crew than King Ghidorah to maneuver, is very powerful.

Godzilla: The Encyclopedia

1989

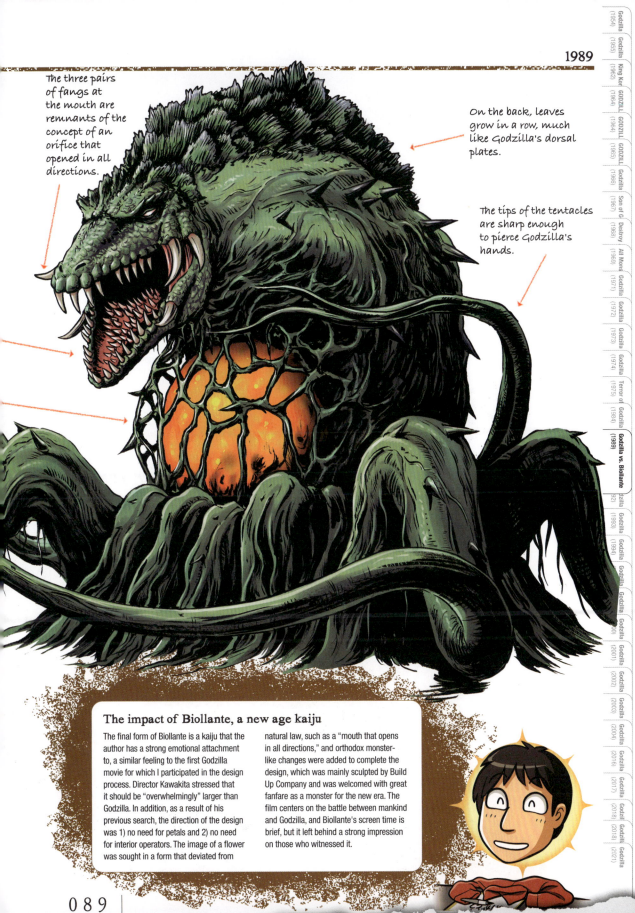

The three pairs of fangs at the mouth are remnants of the concept of an orifice that opened in all directions.

On the back, leaves grow in a row, much like Godzilla's dorsal plates.

The tips of the tentacles are sharp enough to pierce Godzilla's hands.

The impact of Biollante, a new age kaiju

The final form of Biollante is a kaiju that the author has a strong emotional attachment to, a similar feeling to the first Godzilla movie for which I participated in the design process. Director Kawakita stressed that it should be "overwhelmingly" larger than Godzilla. In addition, as a result of his previous search, the direction of the design was 1) no need for petals and 2) no need for interior operators. The image of a flower was sought in a form that deviated from natural law, such as a "mouth that opens in all directions," and orthodox monster-like changes were added to complete the design, which was mainly sculpted by Build Up Company and was welcomed with great fanfare as a monster for the new era. The film centers on the battle between mankind and Godzilla, and Biollante's screen time is brief, but it left behind a strong impression on those who witnessed it.

089

Heisei Godzilla Series
GODZILLA
1991

The eyes are the same brown as in the previous film, but a bit brighter.

The heat ray has been upgraded and is now a "spiral heat ray." It is powerful enough to blow King Ghidorah's head off.

The chest is thicker and more voluminous than in the previous work.

The ankles have become thicker and more muscular.

The newly designed head has rounded cheeks and a clear expression.

Dorsal plates are arranged in the same manner as Godzilla 1989, but the overall position has been lowered due to sagging.

090

Godzilla
1991

"Godzilla vs. King Ghidorah"

Explanation
The Godzilla's suit from "Godzilla vs. Biollante" was modified, and although it is not a new model, the chest plate is thicker and more raised, giving this Godzilla the "toughest" form of all the Godzillas in the VS series.

The upper body mechanisms are also from the previous iteration, but the skin material swapped foam rubber for latex, the same as the suit, eliminating any textural difference. In the reunion scene with Chairman Shindo, a masterful performance of facial expressions was showcased.

The maneuver in which it grabs King Ghidorah and swings it around was also used in the follow-up "Godzilla vs. Mothra" in the scene battling the undersea Battra larva. It looks great swinging.

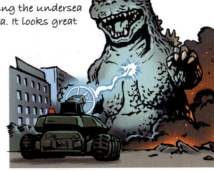

Godzilla steps "through" Sapporo's underground shopping center. In "The Return of Godzilla" (1984), it also dipped one foot into Yurakucho (near Ginza), but sank down to waist. Whether Sapporo's shopping center is deeper or Godzilla is heavier, we'll never know.

A mighty and powerful new Godzilla

In this film the circumstances of Godzilla's birth are revealed, particularly that history has been altered by the intervening Futurians, resulting in a height increase of 80 meters to a truly massive 100 meters. The suit itself is a modification from previous films with only partial changes. The most eye-catching feature is the excessively built-up chest, but the head has also been modified to give a more robust impression. Other parts of the suit have noticeably deteriorated, such as sagging, but overall the powerful, heavy suit has a divergent appeal from the previous model. One might argue that Godzilla has grown to truly heroic heights and is worthy of winning a one-on-one battle with King Ghidorah. It was also the first Godzilla in the Heisei era to get soft vinyl dolls released by Bandai. In recent years, human-sized 2 meter tall figure has been produced. Our hero is also a hot topic in the world of figurines.

Heisei Godzilla Series
GODZILLASAURUS 1991

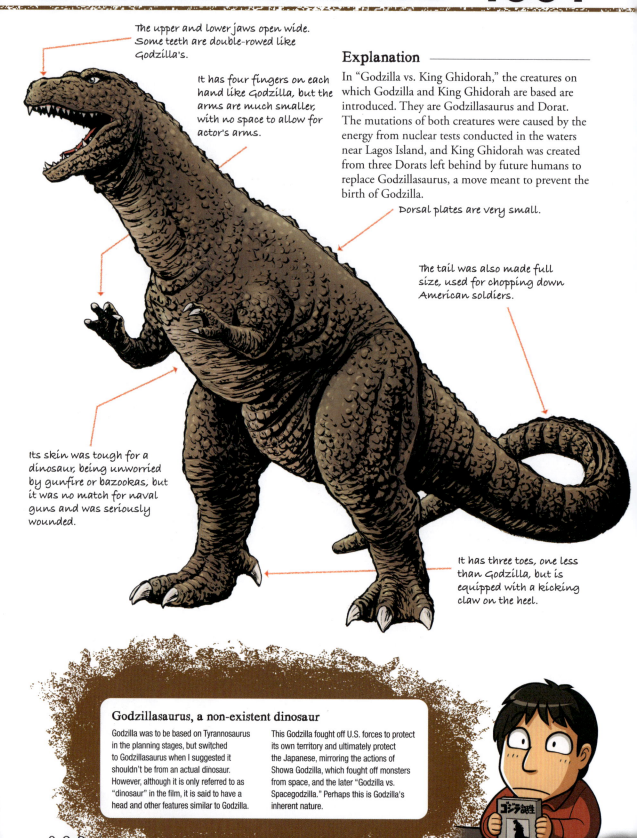

The upper and lower jaws open wide. Some teeth are double-rowed like Godzilla's.

It has four fingers on each hand like Godzilla, but the arms are much smaller, with no space to allow for actor's arms.

Explanation

In "Godzilla vs. King Ghidorah," the creatures on which Godzilla and King Ghidorah are based are introduced. They are Godzillasaurus and Dorat. The mutations of both creatures were caused by the energy from nuclear tests conducted in the waters near Lagos Island, and King Ghidorah was created from three Dorats left behind by future humans to replace Godzillasaurus, a move meant to prevent the birth of Godzilla.

Dorsal plates are very small.

The tail was also made full size, used for chopping down American soldiers.

Its skin was tough for a dinosaur, being unworried by gunfire or bazookas, but it was no match for naval guns and was seriously wounded.

It has three toes, one less than Godzilla, but is equipped with a kicking claw on the heel.

Godzillasaurus, a non-existent dinosaur

Godzilla was to be based on Tyrannosaurus in the planning stages, but switched to Godzillasaurus when I suggested it shouldn't be from an actual dinosaur. However, although it is only referred to as "dinosaur" in the film, it is said to have a head and other features similar to Godzilla.

This Godzilla fought off U.S. forces to protect its own territory and ultimately protect the Japanese, mirroring the actions of Showa Godzilla, which fought off monsters from space, and the later "Godzilla vs. Spacegodzilla." Perhaps this is Godzilla's inherent nature.

Heisei Godzilla Series
DORAT

1991

Explanation

Dorat is presented as a genetically engineered pet from the future, but in reality it was programmed to react with nuclear energy and mutate into the being known as King Ghidorah. It was controlled by special sound waves, and its characteristics were inherited even after it mutated into its final form.

It has a green head of hair.

Ears like a cat instead of horns.

Futurian Emmy Kano explains that Dorat is controlled by the sound of her whistle, revealing she can convey her emotions through certain frequencies. It is believed that this mechanism was used to control it even when it took the form of King Ghidorah.

A close-up upper body model with moving eyes and mouth was also made.

Trial and error to achieve "optimal cute"

Dorat is a case in which the difficulty of determining what is "cute" and what is "realistic" in the modeling of fictional creatures was clearly demonstrated. Cartoon-like distorted designs may seem nice on paper, but when introduced to the real world as a three-dimensional creature, they often come off as strange and creepy. This is especially true when they are brought to life by flesh-and-blood humans. This trial-and-error process was carried over to Babygodzilla and Littlegodzilla.

093

Heisei Godzilla Series
KING GHIDORAH 1991

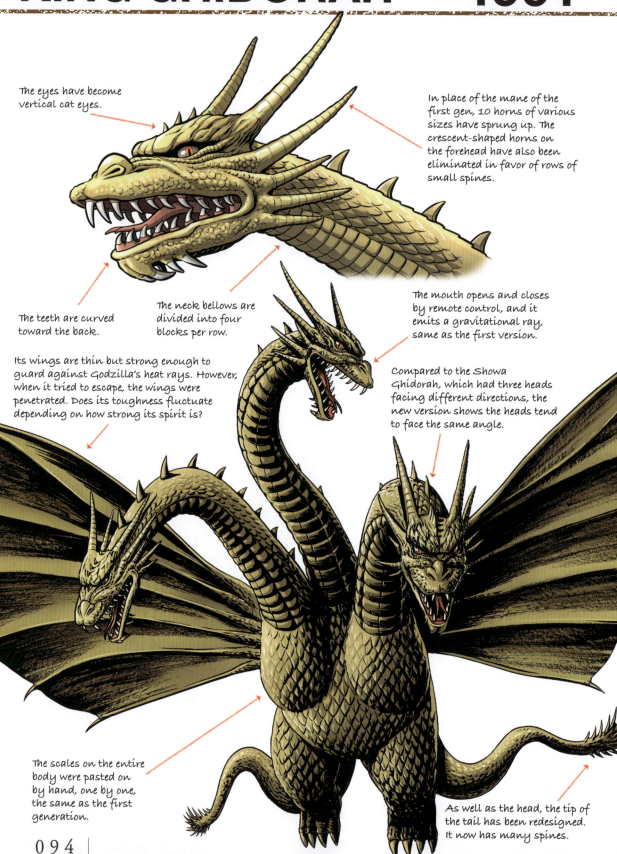

The eyes have become vertical cat eyes.

In place of the mane of the first gen, 10 horns of various sizes have sprung up. The crescent-shaped horns on the forehead have also been eliminated in favor of rows of small spines.

The teeth are curved toward the back.

The neck bellows are divided into four blocks per row.

The mouth opens and closes by remote control, and it emits a gravitational ray, same as the first version.

Its wings are thin but strong enough to guard against Godzilla's heat rays. However, when it tried to escape, the wings were penetrated. Does its toughness fluctuate depending on how strong its spirit is?

Compared to the Showa Ghidorah, which had three heads facing different directions, the new version shows the heads tend to face the same angle.

The scales on the entire body were pasted on by hand, one by one, the same as the first generation.

As well as the head, the tip of the tail has been redesigned. It now has many spines.

094

King Ghidorah

1991

"Godzilla vs. King Ghidorah"

Explanation

In this second film since the Heisei era began, the Godzilla series has taken a new course in reviving once popular monsters, and King Ghidorah, Godzilla's greatest rival, is the first to make an appearance.

Unlike the Showa version, which originated from space, here King Ghidorah is an Earth-born monster created by people from the future (mutated from a dorat), but its abilities seem to essentially mimic the original.

A flying prop one-third the size of the suit was also created. In an aerial battle with a fighter plane, it showed unprecedented maneuverability.

It also debuted a unique attack in which it wrapped its long neck around Godzilla's to strangle it.

It was controlled by a Futurian and was able to overpower Godzilla, but when command was lost, it could no longer make use of its flying ability and gravitational rays, and was summarily defeated. Torn off by Godzilla heat rays, gold dust erupted from the neck stump.

King Ghidorah rebranded into a Western style

Having not been remade for 26 years since its first appearance in "Ghidorah, the Three-Headed Monster," the suit basically follows the design of the first version, with only the head depicted in the design illustrations. The head was reimagined to resemble a Western dragon instead of Showa Ghidorah's oriental draconic face through elimination of the mane and replacing it with numerous horns. The crescent horns depicted in the designs were also removed from the suit, which seems to have strongly reflected the image of the poster illustration by Noriyoshi Orai. Its nickname also went from Showa era "Space Super Monster" to "Super Dragon Monster." Following Biollante, which claimed to be a "super-Godzilla," Godzilla was fighting "super monsters," but after this outing, it will be fighting gods, referred to as "guardian gods" and "gods of destruction."

Heisei Godzilla Series
MECHA-KING GHIDORAH 1991

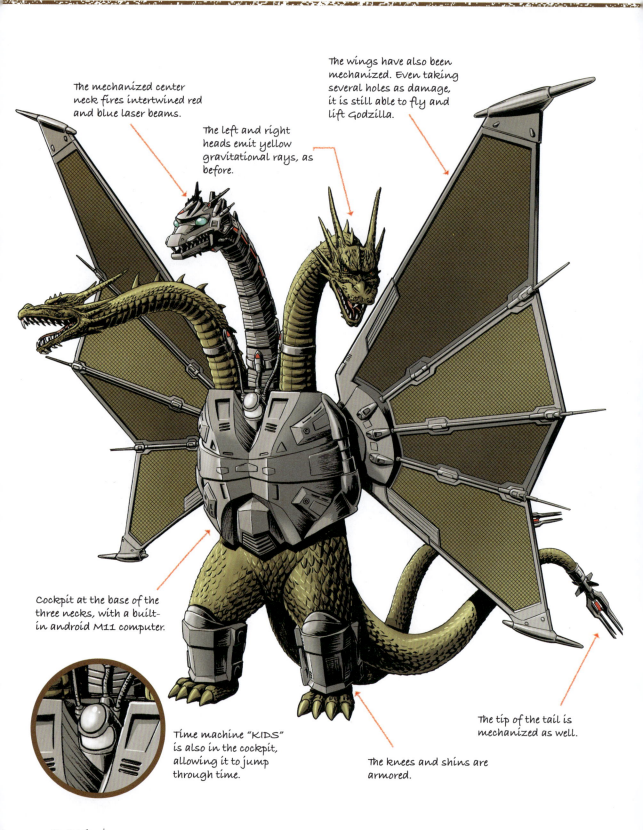

The mechanized center neck fires intertwined red and blue laser beams.

The left and right heads emit yellow gravitational rays, as before.

The wings have also been mechanized. Even taking several holes as damage, it is still able to fly and lift Godzilla.

Cockpit at the base of the three necks, with a built-in android M11 computer.

Time machine "KIDS" is also in the cockpit, allowing it to jump through time.

The knees and shins are armored.

The tip of the tail is mechanized as well.

Mecha-King Ghidorah

1991

"Godzilla vs. King Ghidorah"

Explanation

Roundly defeated by Godzilla and sunk in the Sea of Okhotsk, King Ghidorah was repurposed into a cyborg using 23rd century technology and once again came to challenge the big lizard. The suit was designed with mechanical parts at the crotch and ankles but was removed because actors couldn't walk with them. It was eventually filmed without performers for safety reasons.

Green round eyes. According to director Koichi Kawakita, "The eyes are round because it is a good guy."

The antenna on top of the head is a remnant of the crescent horn motif.

The laser launcher is affixed to the upper jaw. The nozzle on the side of the head was designed to have verniers installed to move the head and laser gun quickly and accurately. The neck is composed of nine segments.

The capture device entails wires that shoot out from four hatches on the body and a claw hand that extends from the center of the body to grab Godzilla.

Mecha-King Ghidorah, for which many settings were explored.

Still a rookie designer, I came up with a variety of settings for this character, but wasn't able to successfully convey them to an audience. I would like to take this opportunity to introduce some of these designs. First, the mesh on the wings, sometimes referred to as "solar panels," would provide shade during flight. I imagined it would be an anti-gravity levitation system. Incidentally, the modeling was covered with wire mesh, which weighed 50 kg on one side. The red part at the center of the tail was a laser cannon, same as the mouth laser, and it could fire five beams of light from the neck and tail simultaneously, an upgrade that was visually quite obvious. If it ever makes another appearance, I would like to see it in action.

097

Heisei Godzilla Series
GODZILLA 1992

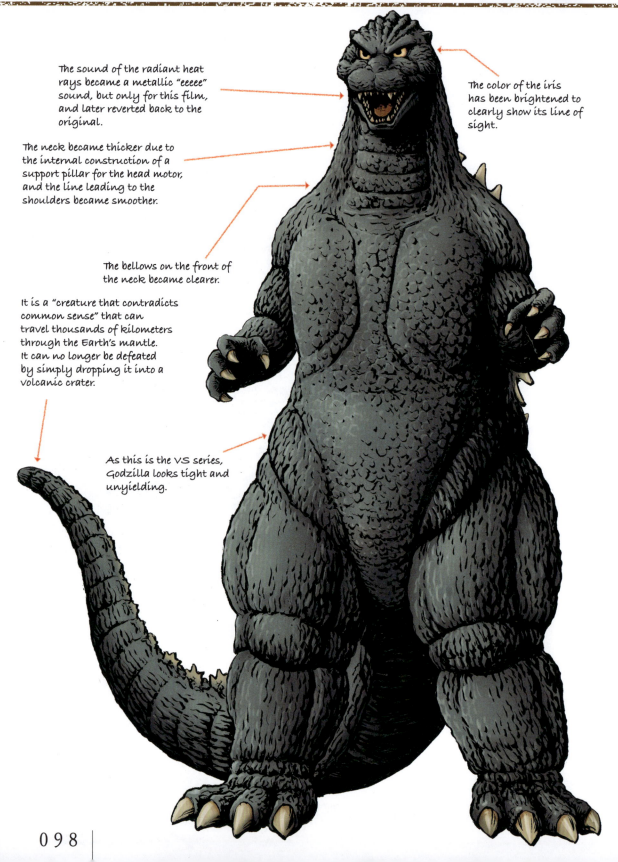

The sound of the radiant heat rays became a metallic "eeeee" sound, but only for this film, and later reverted back to the original.

The neck became thicker due to the internal construction of a support pillar for the head motor, and the line leading to the shoulders became smoother.

The bellows on the front of the neck became clearer.

It is a "creature that contradicts common sense" that can travel thousands of kilometers through the Earth's mantle. It can no longer be defeated by simply dropping it into a volcanic crater.

As this is the VS series, Godzilla looks tight and unyielding.

The color of the iris has been brightened to clearly show its line of sight.

Godzilla

1992

"Godzilla vs. Mothra"

Explanation

In this film, a completely new suit was produced for the first time in three years. The most significant improvement is that the suit could now move its head up and down. In addition, the sharp, rigid body gives a more youthful impression than before, and Godzilla's movements are more nimble, perhaps due to the fact that the opposing monster is lighter than in the past.

The head can now pivot up and down, which previously was only possible with the upper body model. This feature was to accommodate the two major flying monsters, Mothra and Battra, but from this point on, it became a standard gimmick and evolved further.

The giant Godzilla head that peeks out from the top of the Toho Building in Shinjuku's Kabukicho was modeled after this one.

In the scene where Godzilla emerges from Mt. Fuji, the suit from the previous film is used, just as in the undersea scene.

Godzilla during the heyday of the Heisei Godzilla era.

The most striking change from the previous film with this suit is the eye color, which now clearly shows the gaze, as director Kawakita was dissatisfied with the white parts added to Godzilla's eyes in the poster of the previous "Godzilla vs. King Ghidorah." Other elements that have carried over to subsequent suits, such as the neck movement and accompanying changes in form, complete the standard style that will be remembered as the Godzilla that enjoyed the heyday of the Heisei Godzilla era. This was the biggest model change among the VS series Godzillas, with the exception of Burning Godzilla, and the soft vinyl dolls Bandai made at this time were sold in the same form for three years until "Godzilla vs. Spacegodzilla" was released. If this Godzilla had been adopted for the previous film, it would have been interesting to see how its appearance was altered by the historical change.

099

Heisei Godzilla Series
MOTHRA
1992

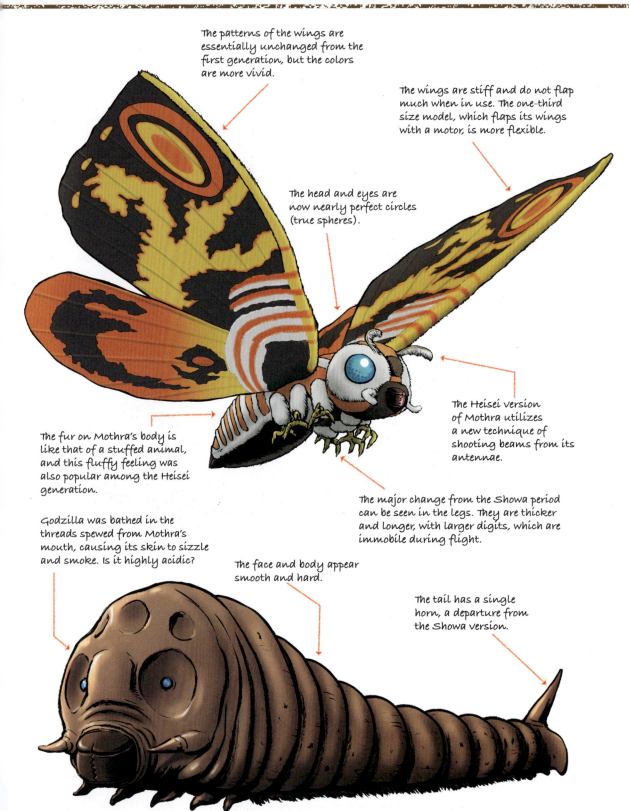

The patterns of the wings are essentially unchanged from the first generation, but the colors are more vivid.

The wings are stiff and do not flap much when in use. The one-third size model, which flaps its wings with a motor, is more flexible.

The head and eyes are now nearly perfect circles (true spheres).

The Heisei version of Mothra utilizes a new technique of shooting beams from its antennae.

The fur on Mothra's body is like that of a stuffed animal, and this fluffy feeling was also popular among the Heisei generation.

The major change from the Showa period can be seen in the legs. They are thicker and longer, with larger digits, which are immobile during flight.

Godzilla was bathed in the threads spewed from Mothra's mouth, causing its skin to sizzle and smoke. Is it highly acidic?

The face and body appear smooth and hard.

The tail has a single horn, a departure from the Showa version.

100

Mothra

1992

"Godzilla vs. Mothra"

Explanation

Mothra is back, coming after King Ghidorah the previous year. It has been 26 years since the first adult Mothra was seen in "Ebirah, Horror of the Deep" in 1966. The transformation from egg to larva to cocoon and finally to adult was well presented, and Shobijin (Japanese for "small beauties"), essential to the Mothra story, appeared as "Cosmos."

The scales have the ability to reflect beams and Godzilla's heat rays. Both beams from outside and heat rays from inside are deflected and attack enemies in the vicinity.

In "Mothra" (1961), Tokyo Tower was used for the cocoon, but this time the National Diet Building takes its place.

Shobijin of Heisei were given the name "Cosmos," the name of their race. The actors, unlike previous generations, are not twins, yet they do not display any individuality, nor even have their own names. This may be called a transitional point for Elias in the later "Heisei Mothra" series. The height of these dwarf fairies is also around 18 cm, which is between Showa Shobijin's 30 cm and Elias' 12 cm.

Mothra stands out with its fluffiness and bright colors.

I also drew designs of Mothra at this time, but the adult insect was left the same from the Showa era, and the goal was to enhance the sense it was a living creature. However, what Kawakita envisioned for Mothra this time was a fantastically beautiful and cute version, probably in consideration of its popularity among women. The yellow of the wings, the orange of the body, and the blue of the eyes are all highly saturated hues, as the catchphrase "The Great Battle of Colors" suggests. The larvae were created as something quite distinct from Showa, with a horn projecting from their tails. It was my personal preference that when a past monster is reintroduced with reimagined origins and abilities, I think a commensurate reimagining of the appearance is warranted, but these characteristics have been carried over to the Mothra larvae in subsequent years.

101

Heisei Godzilla Series
BATTRA
1992

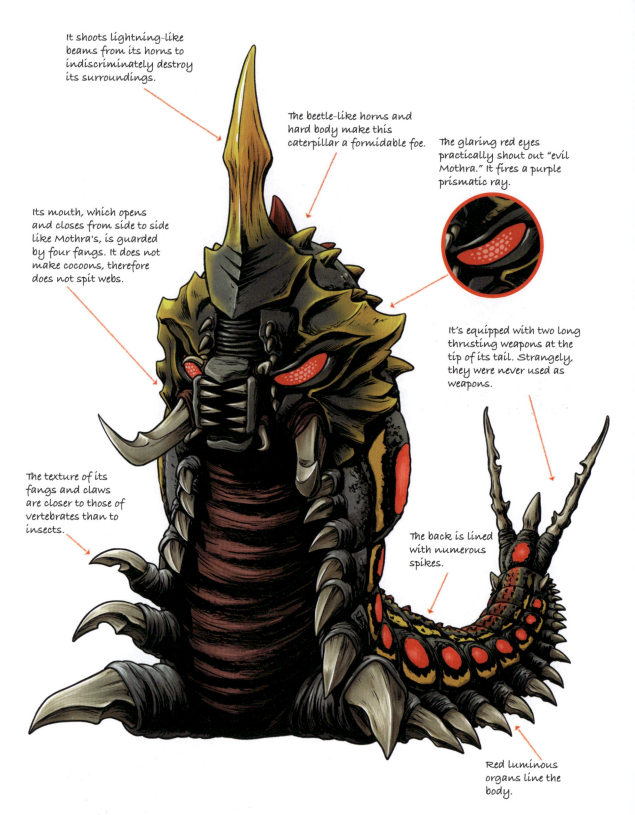

It shoots lightning-like beams from its horns to indiscriminately destroy its surroundings.

The beetle-like horns and hard body make this caterpillar a formidable foe.

The glaring red eyes practically shout out "evil Mothra." It fires a purple prismatic ray.

Its mouth, which opens and closes from side to side like Mothra's, is guarded by four fangs. It does not make cocoons, therefore does not spit webs.

It's equipped with two long thrusting weapons at the tip of its tail. Strangely, they were never used as weapons.

The texture of its fangs and claws are closer to those of vertebrates than to insects.

The back is lined with numerous spikes.

Red luminous organs line the body.

102

Battra (larva)

1992

"Godzilla vs. Mothra"

Explanation

Battra, burrowing its way underground from the Sea of Japan, pops up in Nagoya and destroys the local castle and TV tower. Under attack from a squad of tanks, it blasts beams from horns and eyes, further devastating the city before again withdrawing below the surface. Later, it appears off the coast of the Philippines and intervenes in the battle between Godzilla and the Mothra larvae. "Battle Mothra/Battra" is a black Mothra that is said to come into existence upon sensing that life on Earth is in danger. In its larval form, it differs greatly from Mothra in that it is a venomous, colorful caterpillar with its upper body elevated, represented by a suit in which an actor can enter.

Like the larva of Mothra, it is also an excellent swimmer. In addition, it can drill its way through the earth at high speeds.

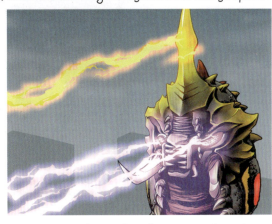

It shoots yellow beams from its horns and purple lightning-like rays from the eyes.

An unexpected appearance from a new monster, Battra.

The original idea of good Mothra fighting the evil Mothra can be glimpsed at in "Mothra vs. Shadorah," which was deliberated on before "Godzilla vs. King Ghidorah." An early proposal was that one of the twin larvae born from a single egg would become the evil Mothra due to the effects of radiation, and the poster illustration depicts traces of this idea. Battra was a new monster that caught fans by surprise, as they had expected only Mothra to appear, and was also a favorite among males at the time because it presented a masculine counterpart to the feminine Mothra. Like Mecha-King Ghidorah, this is an entertaining twist in the Heisei VS series that not only resurrects popular monsters from the past, but likewise puts a new spin on them.

103

Heisei Godzilla Series
BATTRA
1992

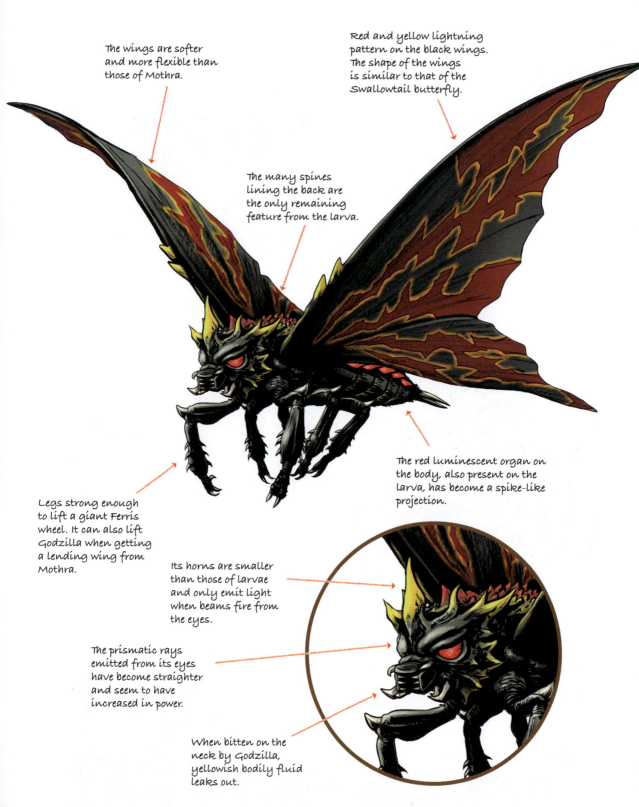

The wings are softer and more flexible than those of Mothra.

Red and yellow lightning pattern on the black wings. The shape of the wings is similar to that of the Swallowtail butterfly.

The many spines lining the back are the only remaining feature from the larva.

The red luminescent organ on the body, also present on the larva, has become a spike-like projection.

Legs strong enough to lift a giant Ferris wheel. It can also lift Godzilla when getting a lending wing from Mothra.

Its horns are smaller than those of larvae and only emit light when beams fire from the eyes.

The prismatic rays emitted from its eyes have become straighter and seem to have increased in power.

When bitten on the neck by Godzilla, yellowish bodily fluid leaks out.

104

Godzilla: The Encyclopedia

Battra (imago)

1992

"Godzilla vs. Mothra"

Explanation

As an adult, Battra is truly a "black Mothra." Originally a kaiju simply bent on destruction, after exchanging energy and spiritual energy with Mothra, it aided in defeating Godzilla. Although its beams are more powerful than those of its larvae, its defenses seem somewhat lacking.

Given that its original mission was to destroy a meteorite approaching Earth, Battra, like Mothra, is believed to have the ability to travel through space.

Battra does not weave a cocoon like Mothra, but emits light and metamorphoses from larva to adult in an instant. Despite its insect-like appearance, this unique being is undoubtedly a remarkable creation of life on our planet.

Battra probably never intended on fighting Godzilla

Since the story upon which "Godzilla vs. Mothra" was based never originally included Godzilla, it is just an interloper who happens to show up and engage Battra and Mothra in battle. Battra always appears to fight only Mothra. In other films of the VS series, the foes tend to have some kind of bad blood with Godzilla and actively take it on, but "Godzilla vs. Mothra" and Battra are a bit of a special case. In other words, Mothra is a monster who carries more than enough weight to deserve its own franchise, and this film may be seen as the Mothra series taking a business trip to the Godzilla franchise.

105

Heisei Godzilla Series
GODZILLA
1993

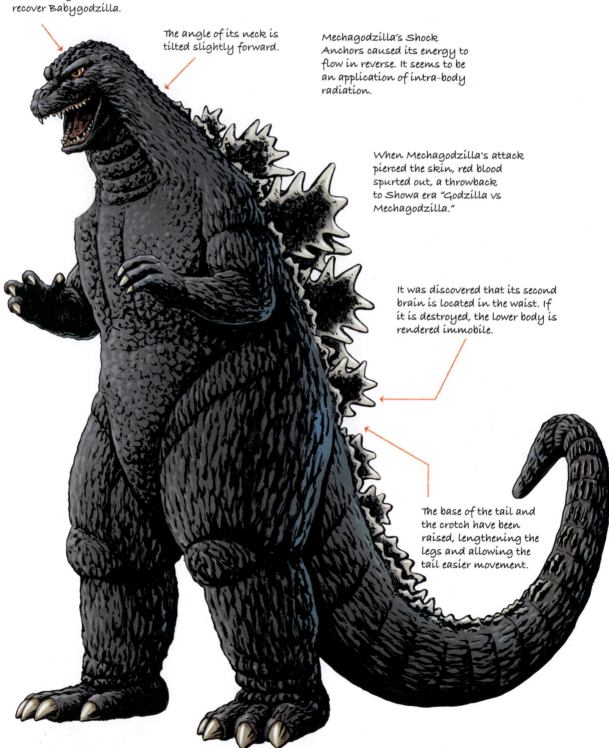

The eyes peer straight ahead. They reflect its burning desire to recover Babygodzilla.

The angle of its neck is tilted slightly forward.

Mechagodzilla's Shock Anchors caused its energy to flow in reverse. It seems to be an application of intra-body radiation.

When Mechagodzilla's attack pierced the skin, red blood spurted out, a throwback to Showa era "Godzilla vs Mechagodzilla."

It was discovered that its second brain is located in the waist. If it is destroyed, the lower body is rendered immobile.

The base of the tail and the crotch have been raised, lengthening the legs and allowing the tail easier movement.

Godzilla

1993

"Godzilla vs. Mechagodzilla II"

Explanation

Another new suit was introduced in this film, but by this time the modeling had achieved a new level of sophistication, and any differences from the previous iteration are at a level where they can't be detected at a mere glance. However, due to a delay in its fabrication, the suit from the previous movie was called into service for the first half, such as scenes on Adonoa Island.

The upper body mechanism presents a slightly different impression from the full suit, with a sloping mouth and slanted eyes, but offers a gentle expression when interacting with Babygodzilla.

This Godzilla was also featured in amusement park Sanrio Puroland's "Monster Planet of Godzilla," a 3D attraction. This means it destroyed Tokyo Station before "SHIN GODZILLA."

Once revived by the life energy of Fire Rodan, it blasted a red "Hyper Uranium Heat Ray."

"Godzilla vs. Mechagodzilla II" further expands Godzilla's narrative

The importance of this film lies not so much in the change in Godzilla's suit itself, but rather it represents a single narrative turning point in the Heisei VS series. Broadly considering the structure of the series, the first three films, including "The Return of Godzilla" (1984), established the new elements of Godzilla itself: "use of nuclear energy," "Godzilla cells," and "birth of Godzilla." After "VS Mothra," in which Godzilla was treated as a guest star, this film expands on these ideas and builds a narrative with "G-Force" and "Godzilla's (same genus) children," which became the basis for subsequent films.

The Heisei Godzilla series was originally scheduled to conclude with this film, but production delays in the TriStar Pictures version of Godzilla led to an extension. As a result, the ideas established here were further expanded, and the Heisei VS series has come to hold a significant position in the history of Godzilla.

Heisei Godzilla Series
MECHAGODZILLA 1993

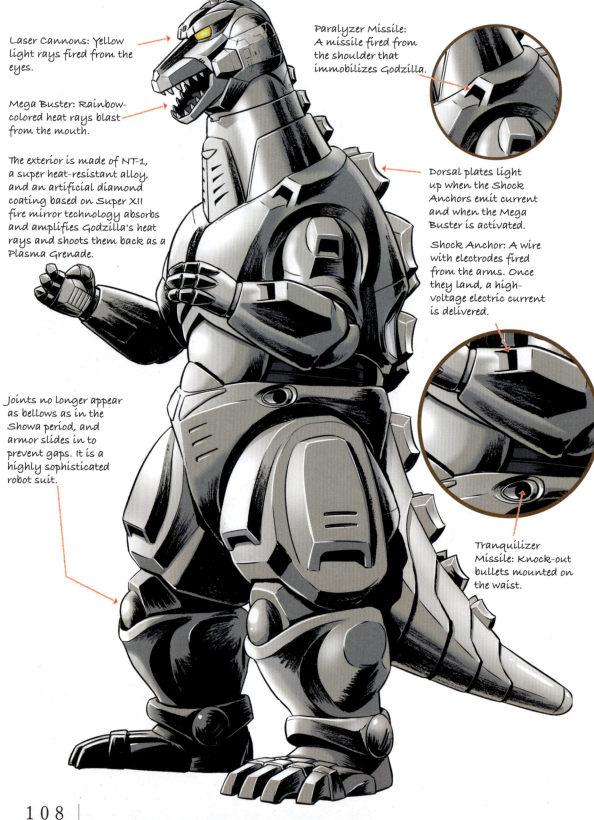

Laser Cannons: Yellow light rays fired from the eyes.

Mega Buster: Rainbow-colored heat rays blast from the mouth.

The exterior is made of NT-1, a super heat-resistant alloy, and an artificial diamond coating based on Super XII fire mirror technology absorbs and amplifies Godzilla's heat rays and shoots them back as a Plasma Grenade.

Joints no longer appear as bellows as in the Showa period, and armor slides in to prevent gaps. It is a highly sophisticated robot suit.

Paralyzer Missile: A missile fired from the shoulder that immobilizes Godzilla.

Dorsal plates light up when the Shock Anchors emit current and when the Mega Buster is activated.

Shock Anchor: A wire with electrodes fired from the arms. Once they land, a high-voltage electric current is delivered.

Tranquilizer Missile: Knock-out bullets mounted on the waist.

108

Mechagodzilla

1993

"Godzilla vs. Mechagodzilla II"

Explanation

Mechagodzilla, revived in the Heisei era, has undergone a major change in both story and appearance from its Showa era counterpart. No longer a weapon of alien invasion, it is a simple, heavy robot developed by mankind as the ultimate countermeasure against Godzilla.

It has the ability to fly on its own power. The face-forward flight posture is reminiscent of Showa period Mechagodzilla, but the ankles are angled upward as there is no jet from the soles of its feet.

Plasma Grenade: Mechagodzilla's most devastating ray, fired when the port on its abdomen opens. It is powerful enough to send massive Godzilla flying. When it attacked Fire Rodan, it is believed to have absorbed the uranium heat ray.

Mechagodzilla corners Godzilla, but is rendered inoperable by energy feedback from the Shock Anchor attack. The resulting body blow it receives demolishes it beyond repair. This forced the need for further upgrades.

Mechagodzilla, mankind's most powerful weapon against Godzilla

At the beginning of the film, the head of Mecha-King Ghidorah is dredged up from the bottom of the ocean, the explanation given that it was created with 23rd century technology, drawing us into a new narrative that "humans created Mechagodzilla." We then are presented with Akira Ifukube's exciting opening, which starts things off with a bang. Mechagodzilla, presumably a "good guy," continues its relentless attack on a bleeding and suffering Godzilla, and as the audience witnesses this unyielding onslaught, a face that initially appeared gentler than that of Showa Mechagodzilla begins to look ruthless and terrifying. This feeling of a reversal of good and evil is the thematic heart of the film, and I believe the key to this exquisite expression comes to life in the sinister "lower eyelid" added at the behest of director Kawakita.

109

Heisei Godzilla Series
SUPER MECHAGODZILLA 1993

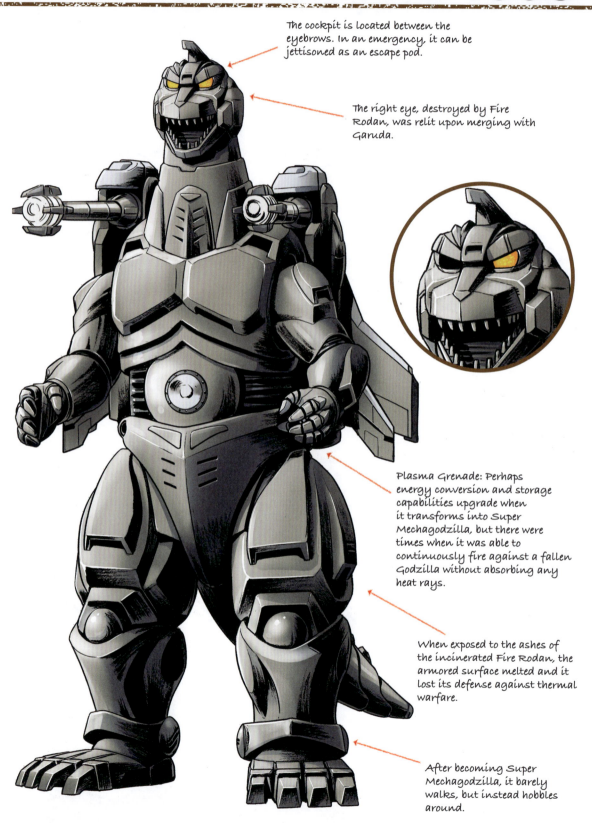

The cockpit is located between the eyebrows. In an emergency, it can be jettisoned as an escape pod.

The right eye, destroyed by Fire Rodan, was relit upon merging with Garuda.

Plasma Grenade: Perhaps energy conversion and storage capabilities upgrade when it transforms into Super Mechagodzilla, but there were times when it was able to continuously fire against a fallen Godzilla without absorbing any heat rays.

When exposed to the ashes of the incinerated Fire Rodan, the armored surface melted and it lost its defense against thermal warfare.

After becoming Super Mechagodzilla, it barely walks, but instead hobbles around.

Super Mechagodzilla

1993

"Godzilla vs. Mechagodzilla II"

Explanation

Defeated in its first bout despite being able to corner Godzilla, Mechagodzilla was modified to maximize firepower and mobility, enabling it to combine with the first battle machine set against Godzilla, Garuda. Thus "Super Mechagodzilla" was born, equipped with the G-Crusher, a special killing machine.

Mechagodzilla weighs 150,000 tons, while Garuda weighs a mere 482 tons in the story, but the actual sculpture of Garuda is far heavier than the Mechagodzilla suit.

When merged, the nose section slides backward.

Maser Beam Cannon: Two large beam cannons mounted on Garuda.

G-Crusher: Replaced the Shock Anchors during the second sortie. Specialized for destroying Godzilla's second brain, this is Super Mechagodzilla's secret weapon.

Mechagodzilla seen in a different light from the poster illustration

Fans of Mechagodzilla must be aware many twists and turns were taken in the design process of bringing it back to the Heisei era. The poster illustration for Mechagodzilla by Noriyoshi Orai left a particularly strong impression, as it looked nothing like the one that appeared in the movie. That version was based on my initial design proposal and reflected the setting in which multiple mecha would transform and merge to become Mechagodzilla. For a variety of reasons, in the end Mechagodzilla was limited to merging with only Garuda, and the design direction was changed to a curved surface-based design, but the original plan was carried over to the next M.O.G.U.E.R.A..

111

Heisei Godzilla Series
RODAN
1993

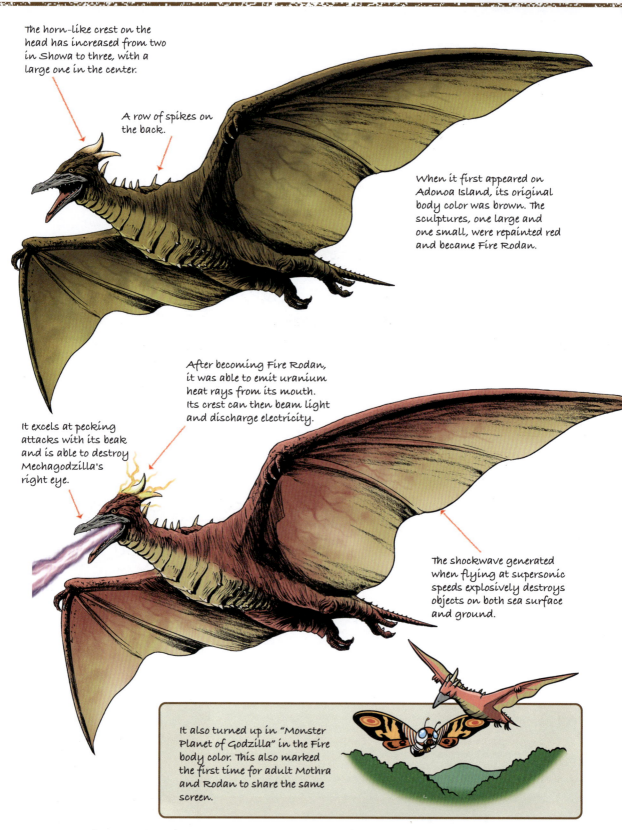

The horn-like crest on the head has increased from two in Showa to three, with a large one in the center.

A row of spikes on the back.

When it first appeared on Adonoa Island, its original body color was brown. The sculptures, one large and one small, were repainted red and became Fire Rodan.

It excels at pecking attacks with its beak and is able to destroy Mechagodzilla's right eye.

After becoming Fire Rodan, it was able to emit uranium heat rays from its mouth. Its crest can then beam light and discharge electricity.

The shockwave generated when flying at supersonic speeds explosively destroys objects on both sea surface and ground.

It also turned up in "Monster Planet of Godzilla" in the Fire body color. This also marked the first time for adult Mothra and Rodan to share the same screen.

Rodan

1993
"Godzilla vs. Mechagodzilla II"

Explanation

Rodan, who had stayed out of sight since "Destroy All Monsters" (1968) 25 years earlier, was depicted only with a flying model, not a suit. Although it was significantly inferior to Godzilla in terms of size, Rodan's speedy movement allowed it to toy with the big lizard. After a resounding defeat at Godzilla's hands, it was resurrected to become the red Fire Rodan.

The battle with Godzilla on Adonoa Island marks an early highlight in the film, with a speedy, out-of-control, physical fight, a contrast to the VS series which focused on trading heavy beam strikes.

Bodily fluids that appear to be blood oozing from wounds are yellowish brown, not red.

Mortally wounded by a direct hit from Super Mechagodzilla's Plasma Grenade, Rodan disappeared after its life force revived Godzilla, whose second brain had been destroyed.

A monster mutated by radiation from a Pteranodon. Pteranodon bones (fossils) were left behind on Adonoa Island, its birthplace.

Resurrected on Adonoa Island, it transformed into Fire Rodan, and headed for Babygodzilla. On its way, it destroyed the cities of Aomori and Sendai.

Rodan: a bridge connecting Babygodzilla and Godzilla

In the Showa era, Rodan was a "rival" or "sidekick" to Godzilla, more or less an equal, yet now that it has evolved past the suit, the Heisei era Rodan has clearly been taken down a few pegs. However, as its alias "Pteranodon Monster" suggests, the Rodan of this film is closer to an actual Pteranodon, indirectly serving to bridge the gap between dinosaur Babygodzilla and kaiju Godzilla. In the latter half, Rodan becomes a heat ray-shooting kaiju as big as Godzilla, but if this is a device enabling it to give life to Godzilla and wither away, it may be said to be a healthy yet sympathetic monster that supports the film's theme from the sidelines and becomes a willing martyr.

Heisei Godzilla Series
BABYGODZILLA 1993

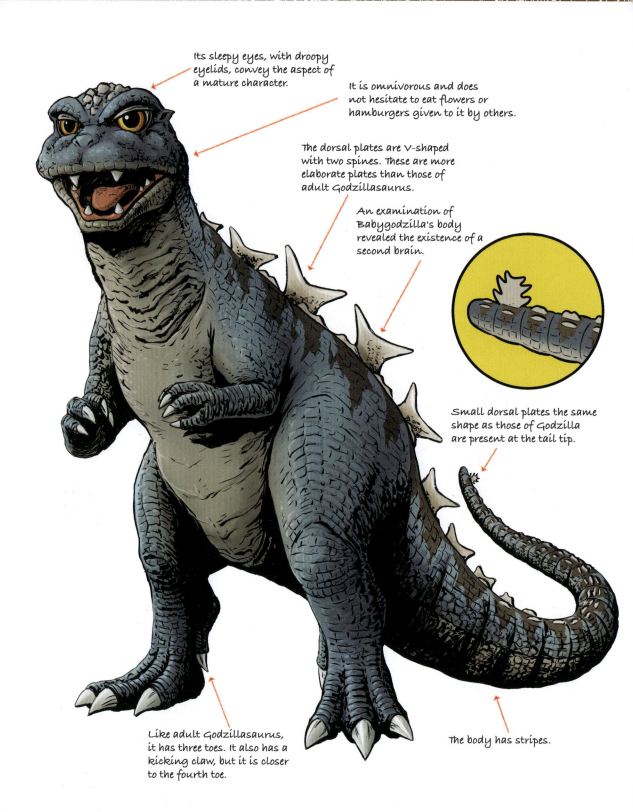

Its sleepy eyes, with droopy eyelids, convey the aspect of a mature character.

It is omnivorous and does not hesitate to eat flowers or hamburgers given to it by others.

The dorsal plates are V-shaped with two spines. These are more elaborate plates than those of adult Godzillasaurus.

An examination of Babygodzilla's body revealed the existence of a second brain.

Small dorsal plates the same shape as those of Godzilla are present at the tail tip.

Like adult Godzillasaurus, it has three toes. It also has a kicking claw, but it is closer to the fourth toe.

The body has stripes.

Babygodzilla

1993

"Godzilla vs. Mechagodzilla II"

Explanation

Godzilla's child finally appears in the Heisei series. Babygodzilla is not its offspring, but rather a juvenile form of Godzillasaurus, the original Godzilla. However, as they are only two of a kind, Godzilla feels an attachment and mothering instinct towards Babygodzilla as if it was its own. Another important role it serves is research into Babygodzilla reveals more about Godzilla's habits and body structure.

A mechanical upper body was created to be able to show detailed facial expressions. Other separate parts, such as the ankles and tail, were devised to emphasize the "living creature" vibe.

When anxious or fearful, the eyes glow red. This red luminescence was observed even when still in the egg.

Godzilla and Babygodzilla are linked by a form of telepathy, and are able to know where they are even when separated. However, it seems that they cannot sense each other's presence when behind walls that shield them from electromagnetic waves, perhaps similar to Minilla's powerful mind link with Godzilla.

The scene in which Babygodzilla hatches from the egg was carefully depicted in several shots, using parts of the legs and tail. The ankle parts with movable toes were made exclusively for this scene.

Babygodzilla, a life-size dinosaur child

Babygodzilla is the central character in a story in which Godzilla, Rodan, and mankind are at odds over its existence. In order to interact with life-size actors, the feature film team (Okawara group) took over from special effects (Kawakita group). I was dispatched to the feature film team to work on the design at the behest of FX director Kawakita. Although there were many possible directions for the design, a decision was made to focus on a realistic living creature, as the dinosaur was a child and collaboration with the actors required a level of realism which set it apart from that of the FX set, but this wasn't what Kawakita had in mind.
As a result, the next film was led by the special effects team and Babygodzilla would grow up to look very unlike the same kaiju.

Heisei Godzilla Series
GODZILLA 1994

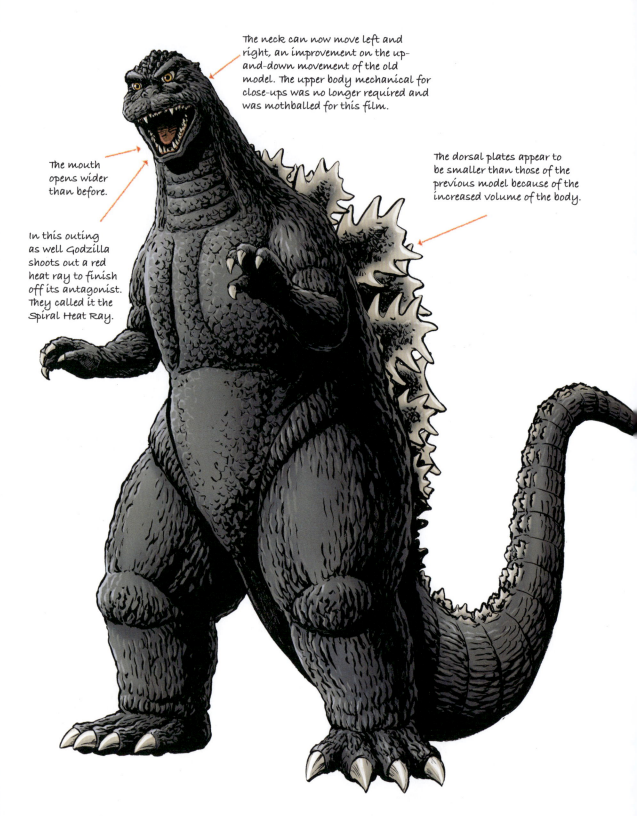

The neck can now move left and right, an improvement on the up-and-down movement of the old model. The upper body mechanical for close-ups was no longer required and was mothballed for this film.

The mouth opens wider than before.

In this outing as well Godzilla shoots out a red heat ray to finish off its antagonist. They called it the Spiral Heat Ray.

The dorsal plates appear to be smaller than those of the previous model because of the increased volume of the body.

Godzilla

1994

"Godzilla vs. Spacegodzilla"

Explanation

The suit, designed to be more voluminous to contrast with Littlegodzilla, makes full use of their previous experience in both modeling and gimmickry. Thanks to this, even in situations where mechanical or marine suits had previously been used, a single main suit proved sufficient. This suit is considered to be the pinnacle of perfection of the Heisei VS series of Godzilla suits.

This Godzilla is featured in the giant mural at Toho Studios.

Size of Littlegodzilla as a comparison.

Actual size of the suit.

Supposed 30 meter height.

TOHO STUDIOS

Godzilla in this film is like a protector of Littlegodzilla, and displays fatherly affection by protecting Littlegodzilla from Spacegodzilla's attack by putting himself in harm's way.

"Godzilla vs. Spacegodzilla" moved forward based on a solid foundation

The Heisei Godzilla series has always hatched new story developments, but in this film, "G-Force," "Littlegodzilla," and second Mechagodzilla unit "M.O.G.U.E.R.A.," are all ideas developed in the previous film. Rather than lacking in originality, this film should be seen as the completion of a solid foundation. Although I would have liked to have seen a few more films set within this universe, this combination could be seen as replacing King Ghidorah of "Destroy All Monsters" (1968) with Spacegodzilla and Earth monsters with M.O.G.U.E.R.A., etc., and beyond that, the only road left might have been to plunge into the "Heisei Champion Festival." As if refusing to do so, Godzilla was to meet a shocking end in the next film.

Heisei Godzilla Series
SPACEGODZILLA 1994

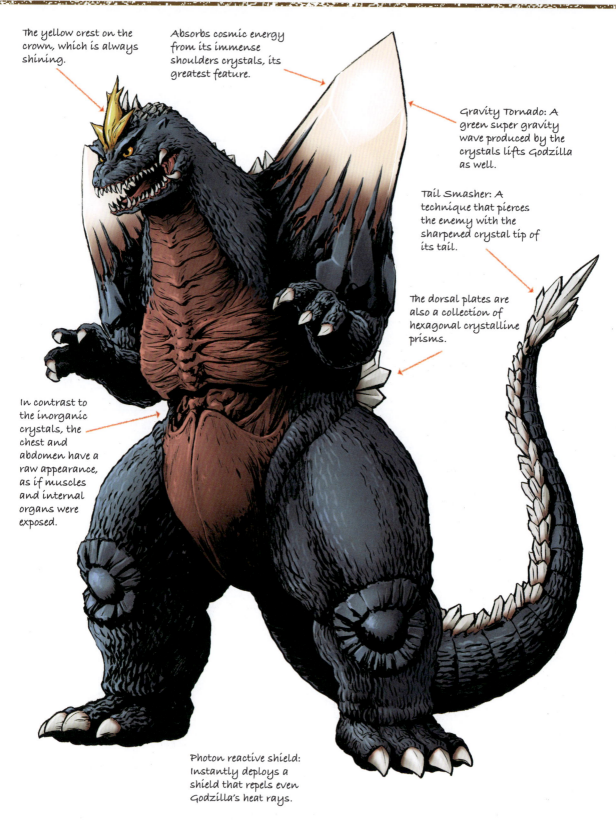

The yellow crest on the crown, which is always shining.

Absorbs cosmic energy from its immense shoulders crystals, its greatest feature.

Gravity Tornado: A green super gravity wave produced by the crystals lifts Godzilla as well.

Tail Smasher: A technique that pierces the enemy with the sharpened crystal tip of its tail.

The dorsal plates are also a collection of hexagonal crystalline prisms.

In contrast to the inorganic crystals, the chest and abdomen have a raw appearance, as if muscles and internal organs were exposed.

Photon reactive shield: Instantly deploys a shield that repels even Godzilla's heat rays.

Spacegodzilla

1994

"Godzilla vs. Spacegodzilla"

Explanation

The first monster other than Mechagodzilla to bear the name "Godzilla" has finally been introduced. Spacegodzilla, the first space kaiju in the Heisei era, also manipulates gravity in the same way as King Ghidorah, and also uses a variety of psychic-like techniques to toy with its nemesis. As a result of this appearance, Godzilla is finally able to fight together on the side of mankind.

Homing Ghost: Levitate crystals that shoot like a missile.

Corona Beam: An orange beam of light from the mouth that flies in a sweeping curve.

Lipless, bare teeth. The fangs around the mouth remind one of Biollante.

It can create many crystals to form a field that collects cosmic energy.

It can greatly expand the crystals on its back to enable it to fly in outer space.

Spacegodzilla powered through the sky toward Fukuoka, destroying the cities of Sapporo, Yamagata, and Kobe on the way.

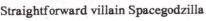

Straightforward villain Spacegodzilla

Spacegodzilla is the one who strikes out on its own against the framework completed in the previous film: Godzilla, Little, and the G-Force. Its strength and viciousness are appealing as a straightforward villain, and it is often lauded as the "No. 1 enemy monster of the VS series" by fans of the past generation. Spacegodzilla, like Mechagodzilla, is a "similar yet distinct Godzilla," with diverse weapons, shields and flying abilities, making it a sort of "overpowered Mechagodzilla." In this light, director Kawakita's desire to have Godzilla fire crystals, a detail not in his original plan, may be because he felt the lack of live ammo attacks lacked action.

119

Heisei Godzilla Series
LITTLEGODZILLA 1994

Cartoonishly large eyes stripped of eyelids glow red when frightened, just as when it was a baby.

In the Babygodzilla days it was raised by humans, so it has a friendly disposition.

Rounded hump-like dorsal plates.

Teeth have grown in much more fully than its infant days, but remain a single row.

Scales on the body changed to skin similar to Godzilla.

The color of the body is green with a yellowish two-tone side.

The legs have thickened and become shorter, achieving a fully erect posture. It has four toes like Godzilla.

The tail is now extremely short, so performer manipulation is no longer required.

Littlegodzilla

1994

"Godzilla vs. Spacegodzilla"

Explanation

This is a grown-up version of Babygodzilla, who headed into the sea with Godzilla at the conclusion of the previous film. While living with Godzilla on Baas Island, it was irradiated and metamorphosed from a dinosaur into a full-fledged kaiju. Its size went from human-scale to 30 meters in height, and its appearance has transformed to an even greater extent.

Being extremely curious but lacking in caution, it ends up in traps or wandering too close to Spacegodzilla.

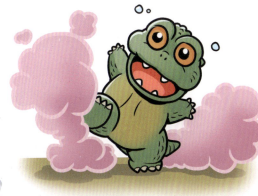

It was trapped in the crystal prison by Spacegodzilla.

In the last part of the movie, Miki Saegusa telepathically displays an image of it in which it blows soap bubble-like radiant heat rays.

Littlegodzilla, the ultimate "cute kaiju"

Godzilla films are multifaceted: science fiction, war, drama, and more are present but one aspect that must not be forgotten is that they remain "character driven" films. Some may dislike the overemphasis on this element in the belief it "infantilizes" the characters, but it is key to the entertainment value of a film, and I think it greatly succeeds in this respect. For the VS series generation who were children at the time, "Godzilla vs. Spacegodzilla" boasts the strongest foe, the coolest robot, and the most adorable monster, with Littlegodzilla in particular being a symbol of the direction this work took, with its cartoonishly cute image.

121

Heisei Godzilla Series
M.O.G.U.E.R.A. 1994

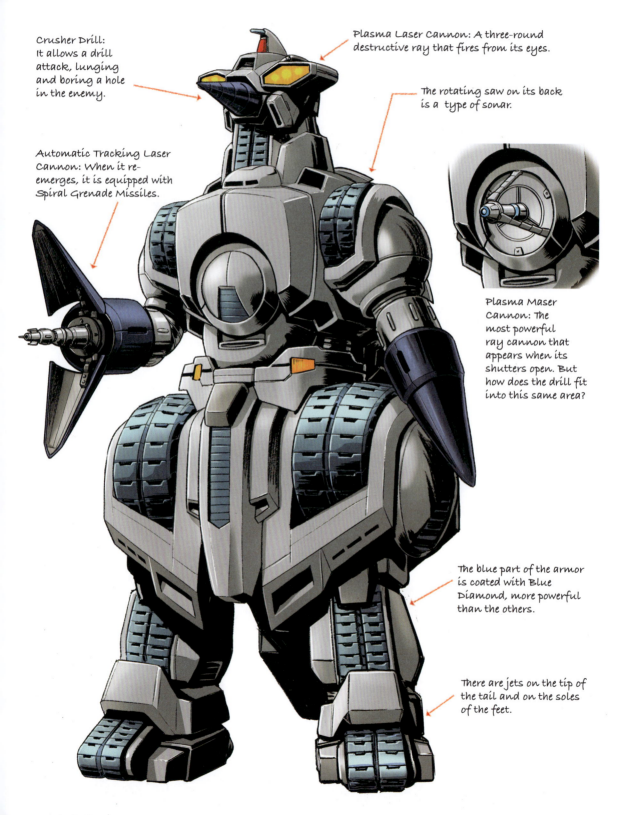

Crusher Drill: It allows a drill attack, lunging and boring a hole in the enemy.

Plasma Laser Cannon: A three-round destructive ray that fires from its eyes.

The rotating saw on its back is a type of sonar.

Automatic Tracking Laser Cannon: When it re-emerges, it is equipped with Spiral Grenade Missiles.

Plasma Maser Cannon: The most powerful ray cannon that appears when its shutters open. But how does the drill fit into this same area?

The blue part of the armor is coated with Blue Diamond, more powerful than the others.

There are jets on the tip of the tail and on the soles of the feet.

Godzilla: The Encyclopedia

M.O.G.U.E.R.A.

1994

"Godzilla vs. Spacegodzilla"

Explanation

M.O.G.U.E.R.A., whose initial appearance was in the 1957 film "Defense Force of Earth," is back after a 36-year absence. Like Mechagodzilla, the evil robot that struck mankind as an alien minion has been revived into a G-force anti-Godzilla weapon with a new storyline.

Star Falcon

Land M.O.G.U.E.R.A.

M.O.G.U.E.R.A.'s most notable feature is that it can separate and recombine into two distinct mecha. The upper body transforms into the underground tank "Land M.O.G.U.E.R.A." and the lower body morphs into the all-purpose fighter "Star Falcon."

The drill details display concentric lines, but a spiral pattern was added to make it easier to notice its rotating movement.

The Spiral Grenade Missiles destroy Spacegodzilla's shoulder crystals. This systematic destruction of the kaiju's body reinforced M.O.G.U.E.R.A.'s rank as a strong character.

M.O.G.U.E.R.A. was accepted by fans both old and new

M.O.G.U.E.R.A.'s appearance owes a debt to the influence of director Koichi Kawakita, who was drawn into the world of special effects by "Defense Force of Earth." However, this isn't merely a rehashing of old characters. Understanding the essence of the character's appeal allows for a bold, accurate rejuvenation involving significant updates while retaining essential elements of the series icons. The result is a remake that tickles the old fans, but is also adopted by younger fans for their generation, a key to the success of the Heisei VS series. If M.O.G.U.E.R.A. had made an appearance as Mechagodzilla II, it would have turned into an epic battle between Godzilla, Littlegodzilla, Spacegodzilla, and Mechagodzilla, something I would have given anything to have witnessed.

123

Heisei Godzilla Series
GODZILLA
1995

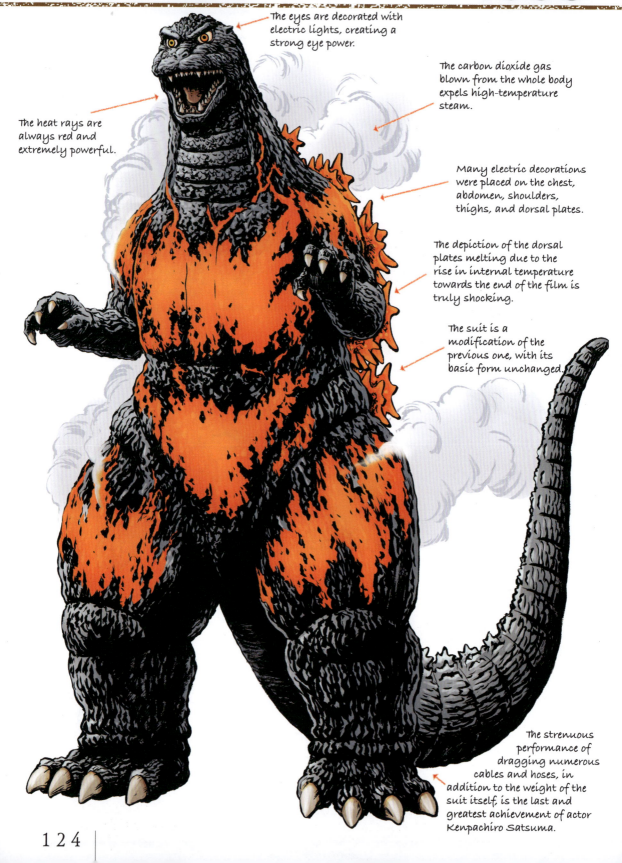

- The eyes are decorated with electric lights, creating a strong eye power.
- The carbon dioxide gas blown from the whole body expels high-temperature steam.
- The heat rays are always red and extremely powerful.
- Many electric decorations were placed on the chest, abdomen, shoulders, thighs, and dorsal plates.
- The depiction of the dorsal plates melting due to the rise in internal temperature towards the end of the film is truly shocking.
- The suit is a modification of the previous one, with its basic form unchanged.
- The strenuous performance of dragging numerous cables and hoses, in addition to the weight of the suit itself is the last and greatest achievement of actor Kenpachiro Satsuma.

Godzilla

1995

"Godzilla vs. Destoroyah"

Explanation

"Godzilla vs. Destoroyah" (1995) was the subject of much attention for its shocking catchphrase, "Godzilla is dead." Its appearance also underwent an unprecedented change, and "Burning Godzilla," with its entire body aglow in red, had a huge impact on viewers. The suit was also a large, heavy device with numerous light bulbs and a carbon dioxide gas injection mechanism built in.

Godzilla's final moments as it melts away. A head for close-ups with a waxed skin was prepared.

The formidable mission of the humans in this film is to halt Godzilla's meltdown, and Super X III plays a major role. It freezes Godzilla in the sea and stops it in its tracks.

The entire body melting scene was brought to life with CGI.

The Impact of Analog Special Effects

The impact of burning Godzilla was immense, and it is fair to say that it surpassed all other elements to become the iconic visual image of this film. Initially, the idea was to add layers of synthetic luminescence, but when director Kawakita saw the finished suit, he decided that the raw power of the suit would prevail and decided to forego any further unnecessary modification.

The convincing power of expressing an unrealistic image using solely the item itself, in this case the suit, is the true appeal of analog special effects.
This image of Godzilla's entire body scorched by heat was cited in subsequent works, including the anime "Godzilla: City on the Edge of Battle" and Legendary's "King of The Monsters," as the ultimate enhanced form of Godzilla.

125

Heisei Godzilla Series
DESTOROYAH 1995

Crawling Form
It grew to a size visible to the naked eye. At this time it melted the fish in the tank, leaving only the bones.

Microscopic body
This creature began life on the seafloor, which had been sucked dry of oxygen by the Oxygen Destroyer. Although too small to be seen by the naked eye, it acquired the destructive power of micro-oxygen, melting a hole in a lab flask and spreading.

Juvenile Form
Merges and grows to human size. The micro-oxygen spewing from the mouths can destroy humans, concrete, and even metallic material.

The face has undergone a significant change from that of the aggregate form and is closer to that of the final form.

Flying Form
The aggregate form further transforms and acquires the ability to fly. It can change its form between the flying form and the aggregate in both directions at will.

Destoroyah

1995

"Godzilla vs. Destoroyah"

Explanation

The Oxygen Destroyer is the only known weapon that has been able to destroy Godzilla. Godzilla's enemy finally found its way to the monster that harbored its power. The creature from a time when there was no oxygen on the earth is resurrected at the bottom of the ocean, an oxygen-free environment, and transforms into a giant beast that clashes with Godzilla Jr.

A second mouth extends from inside its massive maw to pierce the opponent and suck energy or inject micro-oxygen.

It has a special body shape, but still hides a performer within.

Aggregate Form

A large number of juveniles come together and merge to form one huge body. The rays of light emitted from the mouth became an oxygen destroyer with destructive power exceeding that of micro-oxygen.

The extended tentacles and pincer-like arms sprouting from its back distinguish it from the juvenile form.

Numerous large and small legs support the body. The sculpture utilized casters at the ends of its central legs to facilitate movement.

Destoroyah, the ultimate enemy never before seen

Many of the enemy kaiju in the VS series, including Biollante, were connected in some way to Godzilla. In this sense, the appearance of Spacegodzilla was inevitable, and a "Godzilla vs. Godzilla" plan was prepared as the ultimate conclusion of the series, but the monster they went with was an incarnation of the "Oxygen Destroyer," a being more terrifying than Godzilla itself. The Oxygen Destroyer is born in an environment where life is untenable, and it grows in any environment, be it underwater, or in the air. When it walks on two legs, Hedorah comes to mind. The unique body shape of the Destoroyah's aggregate form may have given new flavor to the visual and fighting style of kaiju, after the parade of orthodox monsters such as Mechagodzilla and Space Godzilla.

127

Heisei Godzilla Series
Destoroyah

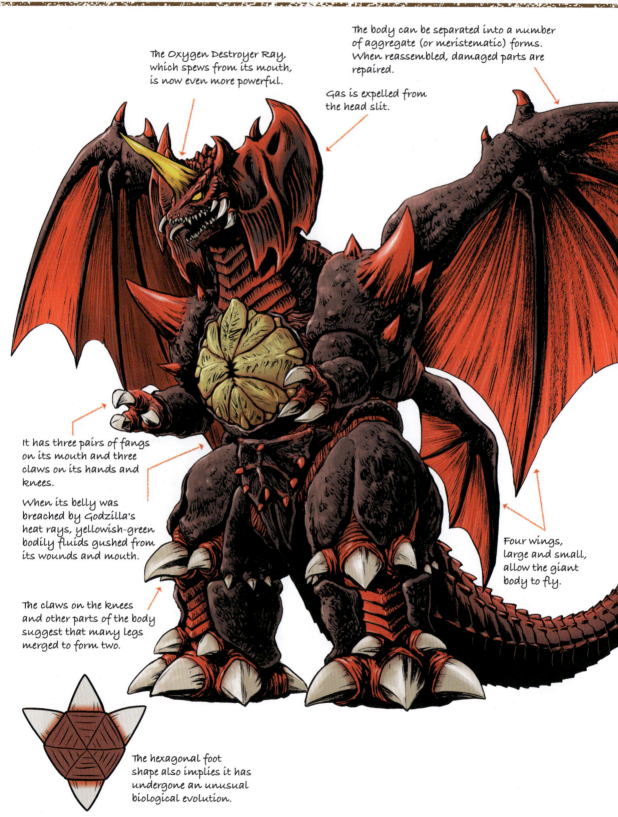

The Oxygen Destroyer Ray, which spews from its mouth, is now even more powerful.

The body can be separated into a number of aggregate (or meristematic) forms. When reassembled, damaged parts are repaired.

Gas is expelled from the head slit.

It has three pairs of fangs on its mouth and three claws on its hands and knees.

When its belly was breached by Godzilla's heat rays, yellowish-green bodily fluids gushed from its wounds and mouth.

The claws on the knees and other parts of the body suggest that many legs merged to form two.

Four wings, large and small, allow the giant body to fly.

The hexagonal foot shape also implies it has undergone an unusual biological evolution.

Godzilla: The Encyclopedia

1995

Explanation

Destoroyah, which continues to expand, has finally transformed into a gigantic, full-fledged kaiju that surpasses even Godzilla in size. Its appearance is reminiscent of a demon out of hell, with a suitably vicious personality, as when it taunts Godzilla Jr., much smaller in comparison.

A tail that combines dexterity and power, such as wrapping around an enemy or grabbing and dragging with its claw-tips.

Its huge wings fold in upon descent to earth.

The "Variable Slicer," which carves through enemies with an energy blade from its single luminous horn.

The most powerful monster to be destroyed by mankind

Destoroyah, armed with an Oxygen Destroyer, appeared as Godzilla's natural enemy. Its full form, with the power and appearance of a demon, is worthy of the label as the most powerful monster, but its treatment in the film is actually a bit underwhelming considering its background and presentation. Despite tricky surprise air assaults and splitting attacks, Destoroyah comes across as a push-over against big G's heat rays, perhaps unavoidable as Godzilla is overpowered this time. Above all, it is quite humiliating for it to be utilized as a mere tool by the human race to prevent Godzilla's meltdown, and then be carelessly tossed aside when unsuccessful. To be fair, as the main point of this film is to depict Godzilla's final days, enemy monsters are presented as accessories to the story, and one could say this kaiju gave it its best shot in the face of such a fate.

129

Heisei Godzilla Series
GODZILLA Jr. 1995

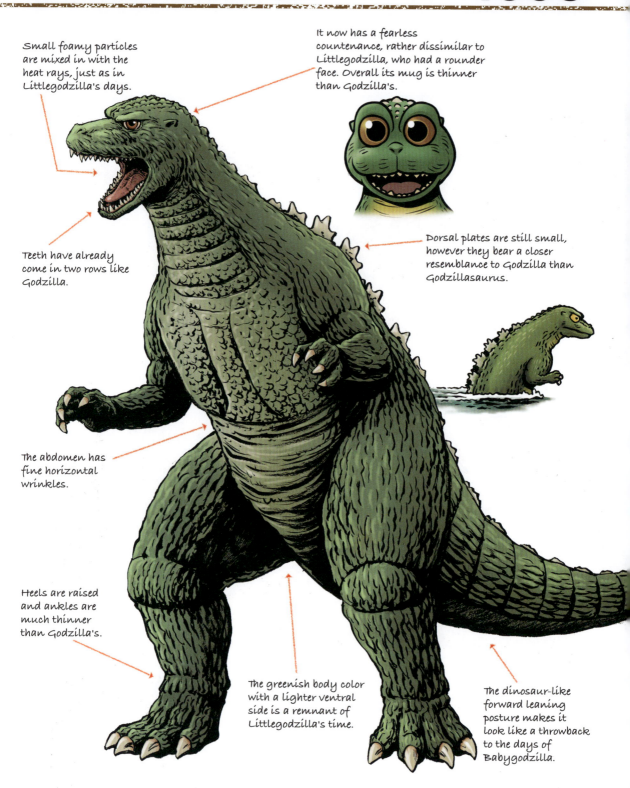

Small foamy particles are mixed in with the heat rays, just as in Littlegodzilla's days.

It now has a fearless countenance, rather dissimilar to Littlegodzilla, who had a rounder face. Overall its mug is thinner than Godzilla's.

Teeth have already come in two rows like Godzilla.

Dorsal plates are still small, however they bear a closer resemblance to Godzilla than Godzillasaurus.

The abdomen has fine horizontal wrinkles.

Heels are raised and ankles are much thinner than Godzilla's.

The greenish body color with a lighter ventral side is a remnant of Littlegodzilla's time.

The dinosaur-like forward leaning posture makes it look like a throwback to the days of Babygodzilla.

Godzilla Jr.
1995
"Godzilla vs. Destoroyah"

Explanation

Godzilla's juvenile form has developed into Baby and Little, but in this outing it has progressed a step further, approaching Godzilla's form and being referred to as Godzilla Jr. However, due to the carnage of Destoroyah, it was thought to have succumbed without succeeding Godzilla.

The silhouette shown at the end of the film. Is this finally the next generation of Godzilla Jr. or …

In the scene where it is shown alongside Godzilla, a miniature sized to fit the setting was employed. From the looks of it, the height difference seems to be greater than that of Littlegodzilla and Godzilla.

Clashing with Destoroyah in Tennozu, Tokyo. It put up a good fight, even with Destoroyah's second mouth being thrust down its throat, and succeeded in fighting it off for a time.

Junior designed to match the job

The explosion at Baas Island not only set Godzilla ablaze, it also stimulated Littlegodzilla's rapid growth. Although it brought Godzilla closer as a kaiju in terms of setting, Littlegodzilla, which stood upright like a kaiju, seems to have reverted to the dinosaur-shaped Babygodzilla as Godzilla Jr. If one were to emphasize the consistency of the series as a whole, it is the design of Littlegodzilla that most disturbs the continuity. But here again we can see that Kawakita's directorial policy placed less emphasis on this, rather giving priority to designs that fit the theme of each film and the role of each character.

Many people would have liked to have seen follow-up films to the VS series in which Junior grew into a fully-fledged Godzilla.

131

GODZILLA ANATOMICAL FILE

Godzilla Millennium (1999-2004)

Godzilla
1999 "Godzilla 2000: Millennium"

Investigating marine anomalies off the coast of Nemuro, the Godzilla Prediction Network finds the big guy. After making landfall in Nemuro, Godzilla maneuvers southward through the Pacific Ocean, engaging Self Defense Forces in Tokai Village, where it is repulsed by Millennian's intervention. It then chases after the Millennian and pops up in Tokyo.

Meganulon
2000 "Godzilla vs. Megaguirus"

This creature hatches from a mass of eggs laid by a giant prehistoric insect, Meganula, which emerged from a space-time chasm as a result of an experiment with the black hole weapon Dimension Tide. It is a larva of Meganula and is extremely carnivorous. It feeds off people in the sewers where it has been dumped.

Godzilla
2001 "Godzilla, Mothra and King Ghidorah: Giant Monsters All-Out Attack"

This entity is said to be an aquatic reptile mutated by atomic bomb testing and then possessed by the spirits of Japanese soldiers who perished in World War II. Due to its nature as a spiritual being, conventional weapons cannot kill it. With a clear intent to kill Japan, it lands in Yaizu and slaughters them indiscriminately on its way to Tokyo.

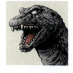

King Ghidorah (Millennium Dragon King)
2001 "Godzilla, Mothra and King Ghidorah: Giant Monsters All-Out Attack"

One of the sacred beasts of the Protectorate that was sealed in the ice pits of Mt. Fuji. It grew slower than the other holy beasts and was not completely formed when it first appeared. It intervened in the battle between Mothra and Godzilla in Yokohama. It later absorbs energy from Mothra and transforms into King Ghidorah.

Multi Purpose-Fighting System Kiryu (High Mobility Type)
2002 "Godzilla against Mechagodzilla"

This is the Multi Purpose-Fighting System Kiryu with its back unit forcibly detached, destroyed by Godzilla during the rematch at Shinagawa. Although equipped with inferior firepower, it has received significant mobility upgrades and can utilize built-in weapons such as the Absolute Zero and maser cannon.

Millennian
1999 "Godzilla 2000: Millennium"

An extraterrestrial life form aboard a UFO discovered in the Japan Trench off the coast of Kashima. After infiltrating the network at Shinjuku and obtaining information about Earth and Godzilla, it declared its intention to conquer all. It was named "Millennian" after its attempt to establish a millennial kingdom.

Meganula
2000 "Godzilla vs. Megaguirus"

The adult form of Meganulon after hatching. In this form, they do not eat prey, but consume life force via a needle in the tail. Sensing Godzilla's enormous energy, they swarm to Kiganjima Island, where Godzilla had landed and attack it to feed off its life force.

Baragon
2001 "Godzilla, Mothra and King Ghidorah: Giant Monsters All-Out Attack"

One of the sacred guardian beasts that were sealed away at the foot of Myoko Mountain in Niigata Prefecture. It is thought to be the origin of the komainu (guardian dogs). To fight Godzilla, an existential threat to the ancient land of Yamato, it crosses Japan underground before confronting it in Hakone, where Godzilla has turned up.

Godzilla
2002 "Godzilla against Mechagodzilla"

Godzilla lands in Tateyama as if compelled by a previous Godzilla skeleton salvaged from the waters there, and engages the Self-Defense Forces in battle. It disappears for a time, but reappears four years later in Tokyo Bay, where it engages Kiryu on Hakkeijima Island. After remaining concealed in the seas around Japan, it lands at Shinagawa.

Modified Multi Purpose-Fighting System Kiryu
2003 "Godzilla : Tokyo S.O.S."

Despite Godzilla destroying 37% of its fuselage, it is refurbished into its current form. As they were worried its skeleton may attract Godzilla, it was scheduled to be scrapped but it sallied forth in its unfinished state on a last ditch effort to save Mothra, who was on the ropes.

Orga
1999 "Godzilla 2000: Millennium"

The Millennian apparently assumes a physical body by obtaining Organizer G1, a substance that imbues Godzilla with extraordinary regenerative abilities and resilience, but is unable to control it and turns into monster Orga. It then attempts to assimilate with Godzilla, aiming to become a perfect copy.

Megaguirus
2000 "Godzilla vs. Megaguirus"

Meganula absorbs energy from Godzilla on the island of Kiganjima and mutates into battle form by sharing energy with their queen in a flooded Shibuya. Recognizing Godzilla as a threat, it confronts the creature in Odaiba with the intention of eliminating it.

Mothra
2001 "Godzilla, Mothra and King Ghidorah: Giant Monsters All-Out Attack"

One of the sacred beasts of protection sealed away in Lake Ikeda. It appears as a larva, later forming a cocoon on the surface of Lake Ikeda and metamorphoses into an adult. After hatching, like Baragon, it heads north directly towards Godzilla and fights it in Yokohama together with the revived Ghidorah.

Multi Purpose-Fighting System Kiryu (Heavily-Armed Type)
2002 "Godzilla against Mechagodzilla"

This is an anti-Godzilla weapon created from the skeleton of Godzilla, salvaged from the bottom of the sea. It incorporates the knowledge and armament gained by the Self-Defense Forces Against Special Organisms from its previous skirmishes against the giant creature. After Godzilla makes landfall on Hakkeijima Island, they are sent out to intercept and engage it.

Kamoebas
2003 "Godzilla : Tokyo S.O.S."

The carcass of a giant creature washes up on Kujukuri Beach in Chiba Prefecture. It turns out to be Kamoebas, a giant mutant of the Matamata turtle, which had not been encountered for 17 years. It had a deep wound on its neck, as if it had been scratched by a giant claw, which turns out to be fatal.

Godzilla Millennium (1999-2004)

Mothra
2003 "Godzilla : Tokyo S.O.S."

Mothra is the guardian god of Infant Island in the South Pacific. It defends the island from Godzilla on the condition that the bones of Godzilla, which form the skeleton of the Kiryu, be returned to the sea. Summoned by the Infant coat of arms, it fights Godzilla on the battlefield of Shinagawa, which was destroyed in the previous battle.

Monster X
2004 "Godzilla Final Wars"

A monster called up by the Xilien to use against Godzilla, it arrives from outer space on a meteorite. It is greeted by Godzilla's heat ray attack and battles it in Tokyo. It displays overwhelming power, such as the Destroyed Thunder blasted from its eyes, forcing Godzilla to its knees.

Ebirah
2004 "Godzilla Final Wars"

Controlled by Xilien, Ebirah appears in the Tokai industrial complex. It engages with members of the M-Force, which has arrived to prevent it from reaching a power plant located 1 km away. Just before being hit by the Maser weapon, it is teleported away by the Xilien.

Rodan
2004 "Godzilla Final Wars"

Controlled by Xilien, it destroys the U.N. Secretary General's plane, then flies to New York to embark on a path of carnage. After that, it is sent to the foot of Mt. Fuji, but is hit by Godzilla's "Anguirus Ball" and crashes.

Kumonga
2004 "Godzilla Final Wars"

Manipulated by Xilien, Kumonga appears in Arizona and demolishes a trailer. After Godzilla's resurrection, it is sent to New Guinea by the Xilien to try and halt Godzilla's progress, but the web it spits out are caught by Godzilla and it is hurled away.

Godzilla
2004 "Godzilla Final Wars"

Godzilla was sealed up in an iceberg in Antarctica by the Gotengo, but was later unthawed as a trump card to stop the Xilien invasion of Earth. After subduing Gigan, Godzilla marches on Tokyo while battling monsters controlled by Xilien in various parts of the world. Finally, it lands in Japan.

Kaizer Ghidorah
2004 "Godzilla Final Wars"

The new metamorphosis of Monster X. In addition to overwhelming Godzilla with destroyed Keizer spewing from its three mouths, it also absorbs energy from opponents through its powerful bite. When Godzilla strikes back, however, it loses two of its heads.

Manda
2004 "Godzilla Final Wars"

A monster encountered by the Gotengo at the bottom of the Normandy Sea. It wrapped itself around the ship and attempted to destroy it, but was plunged into the magma of an undersea volcano, burned, frozen by a cryo-maser gun when it was separated from the Gotengo, and later crushed by a drill.

King Caesar
2004 "Godzilla Final Wars"

Manipulated by Xilien, it appears at an industrial complex in Okinawa and engages in destructive activities. After being temporarily erased by the Xilien, it was sent to the foot of Mt. Fuji to await Godzilla, but Godzilla easily tossed it aside and defeated it.

Hedorah
2004 "Godzilla Final Wars"

It comes ashore in Tokyo Bay only to be blasted by Godzilla's heat ray and smashed into a building. Ebirah is likewise bounced away, its pincers piercing Hedorah. Later, it is knocked down along with Ebirah by a powerful heat ray of Godzilla, who has emerged from the sea.

Minilla
2004 "Godzilla Final Wars"

Initially, Minilla was about the size of a human child, and is discovered by a young boy and its grandfather at Mt. Fuji. At the foot of the mountain, it witnesses Godzilla battling Anguirus and others, growing into a giant. After that, it appears in front of Godzilla in Tokyo.

Gigan
2004 "Godzilla Final Wars"

It is a monster found mummified off the coast of Hokkaido, a fusion of machine and organism. In fact, 12,000 years ago, it was an evil entity on the verge of destroying the planet when Mothra fought to stop it. Activated by Xilien, it became a tool for invading Earth.

Anguirus
2004 "Godzilla Final Wars"

Appears in Shanghai under the control of Xilien. It engages in battle with members of the M-Force, but evades them by turning into its ball form and rolling away. After being temporarily erased by the Xilien, it is later sent to the foot of Mt. Fuji to halt Godzilla's progress.

Kamacuras
2004 "Godzilla Final Wars"

Manipulated by Xilien, Kamacuras appears in Paris. It attaches itself to an airborne battleship and destroys it. After Godzilla's resurrection, it waits for it in Manazuru. It mimics a mountain, but is lured by Godzilla's heat rays and attacks it, only to be tossed away and impaled on a steel tower.

Zilla
2004 "Godzilla Final Wars"

Controlled by Xilien, Zilla appears in Sydney and destroys the city. It was temporarily taken over and put on ice by the Xilien, but was reintroduced after Godzilla's resurrection. It is faster than Godzilla, but is knocked away by its tail and burned by heat rays.

Millennium Series
GODZILLA 1999

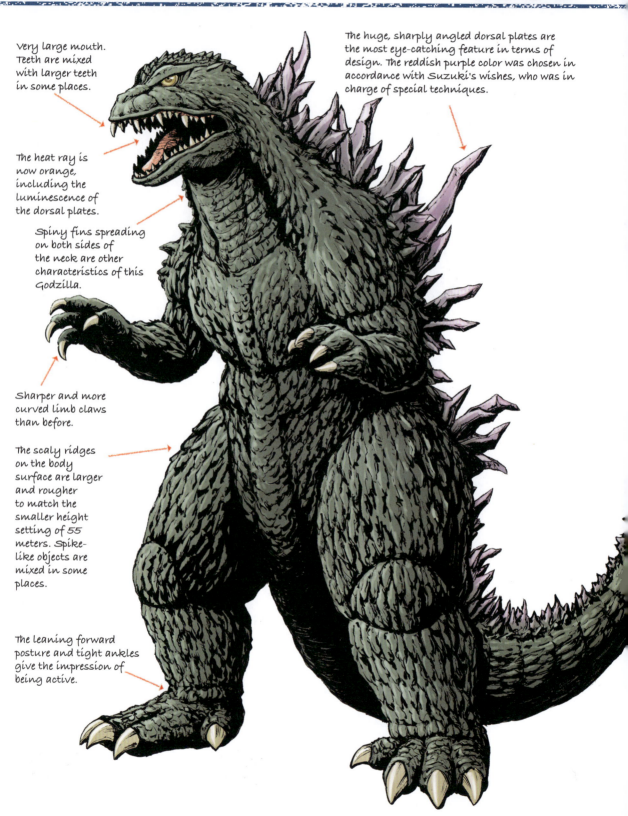

Very large mouth. Teeth are mixed with larger teeth in some places.

The huge, sharply angled dorsal plates are the most eye-catching feature in terms of design. The reddish purple color was chosen in accordance with Suzuki's wishes, who was in charge of special techniques.

The heat ray is now orange, including the luminescence of the dorsal plates.

Spiny fins spreading on both sides of the neck are other characteristics of this Godzilla.

Sharper and more curved limb claws than before.

The scaly ridges on the body surface are larger and rougher to match the smaller height setting of 55 meters. Spike-like objects are mixed in some places.

The leaning forward posture and tight ankles give the impression of being active.

Godzilla

1999

"Godzilla 2000: Millennium"

Explanation

Godzilla was to be resurrected only three years after "Death of Godzilla," so it was important that a major change in the design be made. The final product is clearly a change in direction from the VS series. The skin is now a greenish color, and the height has been reduced from 100 meters to 55 meters, closer to the Showa Godzilla.

The tail tip also differs from the previous versions, being pointed instead of rounded.

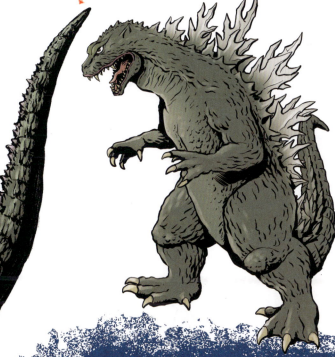

The silhouette was drawn in advance for advertising purposes. This was virtually the first design drawing, which was finalized with input from the director and others.

An image model, also called a template version, created by Yuji Sakai based on the silhouette drawing. It was used in many advertisements prior to the suit creation, and left a strong impression.

Godzilla appears at Cape Nosappu on the eastern tip of Hokkaido, with HOKKAI MARU NO. 3 in its mouth. From the beginning of the film, the horror of the giant monster was depicted.

The first Godzilla created from design drawings

Godzilla's design was brought to life through modeling for the first generation Godzilla, and this marks the first time a design was set in stone from drawings. Usually, the suit model is the first to be seen by fans, but since Sakai's model was announced first, comparisons between the two models were made, which divided fan support into two camps. However, the difference is that Sakai's model was based on a silhouette drawing, while the suit was sculpted by adding information from line drawings made afterwards.

This Godzilla appeared in the next film, "Godzilla vs. Megaguirus," in a completely different form, except for a more vivid green body color. As a suit, however, it was a wholly new creation.

Millennium Series
MILLENNIAN 1999

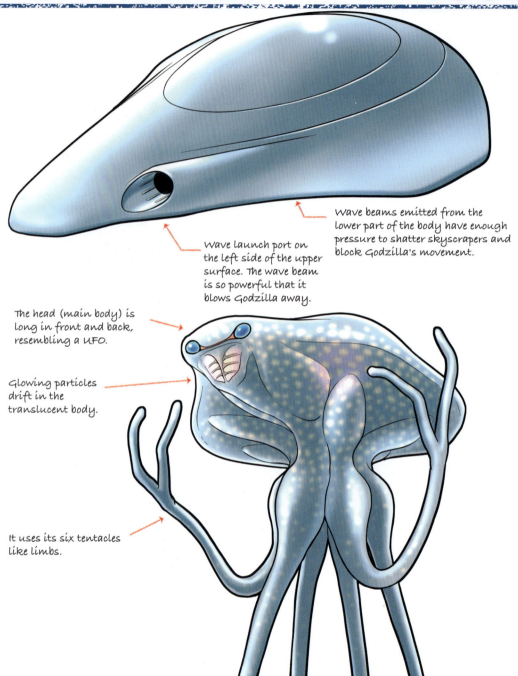

Wave beams emitted from the lower part of the body have enough pressure to shatter skyscrapers and block Godzilla's movement.

Wave launch port on the left side of the upper surface. The wave beam is so powerful that it blows Godzilla away.

The head (main body) is long in front and back, resembling a UFO.

Glowing particles drift in the translucent body.

It uses its six tentacles like limbs.

The tips of the tentacles are divided into two.

Millennian

1999

"Godzilla 2000: Millennium"

Explanation

The first foe for the resurrected Godzilla was a UFO and the extraterrestrial life inside it. The aliens attack Godzilla in their search for Organizer G1 in order to recover their previously lost physical body. Its appearance was reminiscent of the octopus-shaped Martians seen in classic science fiction movies.

At first, the UFO appeared to be a huge block of rock and sank to the bottom of the ocean. It was activated by light transformed into energy.

The creature appears to have regained its original form thanks to Organizer G1, but it is unable to stop further mutating.

The UFO landed on top of a skyscraper and hacked into the surrounding computers through a wired network, then physically manipulated the cables to attack Godzilla.

Alien Millennian, an alien that fits our pre-existing notions

The resurrection of Godzilla from hibernation often depicts it on its own, as in "The Return of Godzilla" (1984) and "SHIN GODZILLA." This is probably due to the idea that the themes that Godzilla itself embodies (i.e. the problems facing human society) should be depicted to the viewer first. To achieve this, both a realistic worldview and Godzilla's absolute existence are necessary. If other monsters were to appear, Godzilla might fade into the background. In this sense, this film might turn into a bit of a snoozefest. While the VS series strives for a realistic worldview, it sometimes seems unrestrained. Even the VS series has avoided aliens because they come off as unrealistic. Apparently, both Godzilla and the audience were confused by the use of aliens in this film. Both the UFO and the Millennian require a classic, simple design, which gives them a lackluster presence that seems to be emblematic of the film.

137

Millennium Series
ORGA

1999

Phase 1
On the left side of its back is a wave launch port similar to that of a UFO, which can fire wave rays and also emit light to manipulate the remnants of the UFO, as if using telekinetic power.

The details of the body are asymmetrical.

The face is said to be inspired by the TriStar version of Godzilla.

In close-quarter combat, it predominantly relies on its huge arms to strike. It has three fingers, one more than Millennian.

It boasts a powerful jumping ability that makes use of the springs in its arms and legs.

The tail looks like a fish fin, which differs from that of Godzilla.

Orga

1999

"Godzilla 2000: Millennium"

Explanation

Although the Millennian appeared to have restored its original physical form, it was unable to control Godzilla's Organizer G1 and morphed into a monster. The Millennian has amazing regenerative powers, but neither its offensive nor defensive capabilities are high, and in order to survive it tries to become more like Godzilla.

After attempting to swallow it, Godzilla's radiation caused Millennian's head to explode, finishing it off.

Phase 2

It swallows Godzilla to absorb more Organizer G1, becoming more like it in color and body surface, even growing dorsal plates.

A membrane with tentacles shoots out from its mouth to envelop Godzilla. The scene was brought to life using CGI.

In order to absorb Godzilla, its mouth opened all the way to the base of its neck.

Tragic Monster Orga's Last Desperate Action

It may not ring a bell as Millennian is an alien in the form of an octopus, but Orga is a rather tragic character in that an intelligent creature is inadvertently transformed into a monstrous entity. To make matters worse, it is a rather weak monster at that. Each time it is bathed in Godzilla's heat rays, it suffers severe gouges and burns, a sight painful to behold. And yet, because of its regenerative ability, it is unable to die, and suffers continuously. It finally dies when it tries to swallow Godzilla and is blasted from inside out, but perhaps this was Orga's intention, as it would have been better off dead anyway.

Orga's story is similar to the process followed by Biollante, who was originally created from human cells (Orga evolved from an alien) and vulnerable to damage, but possessed enhanced regenerative powers and gradually became closer to Godzilla. However, the figure of Orga is even more pathetic, as it is cannot be pitied for trying to conquer the earth.

139

Millennium Series
MEGANULON, MEGANULA 2000

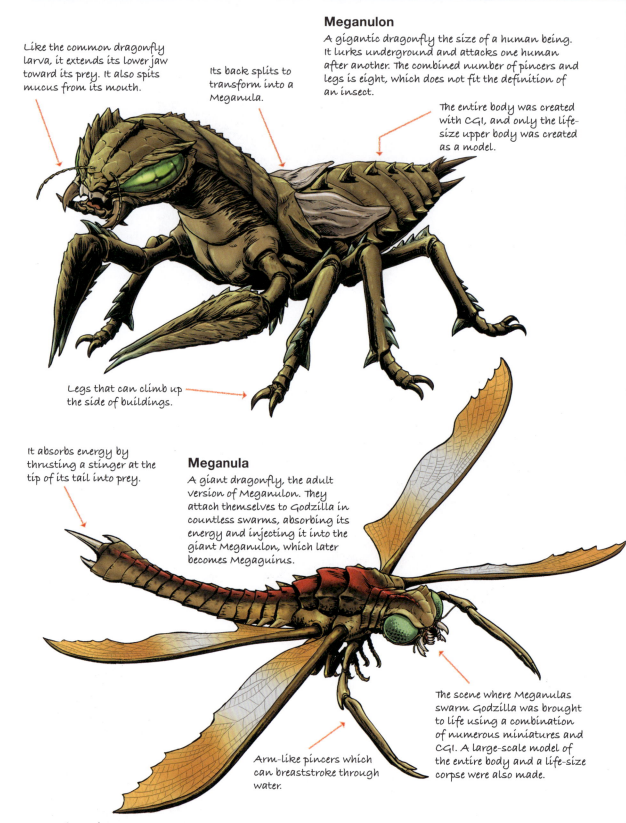

Meganulon
A gigantic dragonfly the size of a human being. It lurks underground and attacks one human after another. The combined number of pincers and legs is eight, which does not fit the definition of an insect.

- Like the common dragonfly larva, it extends its lower jaw toward its prey. It also spits mucus from its mouth.
- Its back splits to transform into a Meganula.
- The entire body was created with CGI, and only the life-size upper body was created as a model.
- Legs that can climb up the side of buildings.

Meganula
A giant dragonfly, the adult version of Meganulon. They attach themselves to Godzilla in countless swarms, absorbing its energy and injecting it into the giant Meganulon, which later becomes Megaguirus.

- It absorbs energy by thrusting a stinger at the tip of its tail into prey.
- Arm-like pincers which can breaststroke through water.
- The scene where Meganulas swarm Godzilla was brought to life using a combination of numerous miniatures and CGI. A large-scale model of the entire body and a life-size corpse were also made.

Meganulon, Meganula

2000

"Godzilla vs. Megaguirus"

Explanation

The ancient giant dragonfly larva Meganulon, which once appeared as Rodan food in "Rodan! The Flying Monster" (1956), has been resurrected in the last year of the 20th century. Meganulon hatches into an adult, becoming a giant kaiju strong enough to take on Godzilla, revealing the full extent of its biology.

The face and body are completely different from those of the old Meganulon, but it's still equipped with the same pincer arms and six legs.

Meganulon's Egg
An egg laid by Meganula, which appeared from the space-time distortion caused by the test firing of the micro black hole cannon "Dimension Tide." Meganulon hatch from each tiny particle.

The Dimension Tide was developed as a weapon against Godzilla, but its launch tests transport Meganula, a giant creature from prehistoric times, to the present day.

A swarm of Meganula clinging to Godzilla, absorbing its energy. These were created with both miniatures and CGI.

Realistic modeling of actual dragonfly larva in giant size

The old Meganulon suit also had an attractive design, but it was massive and could fit three actors. Brought into the modern period, the new Meganulon was represented very realistically, as if it were a gigantic version of an actual dragonfly larva. Although this film has been described in a positive light, scenes in which Meganulon attacks a couple in Shibuya at night, and the scene in which insect hordes paper the wall of a building, may prove traumatic for those who have a phobia of insects.

Because Meganula fly at high speeds in swarms, it is difficult to capture the individual bugs on screen. In fact, it may be said that a swarm is the natural form of Meganula.
No matter how many are incinerated and crushed by Godzilla, they do not hesitate, but continue feeding energy to giant Meganulon and die, showing no sense of individuality. Despite their large size, they are depicted as insects.

Millennium Series
MEGAGUIRUS
2000

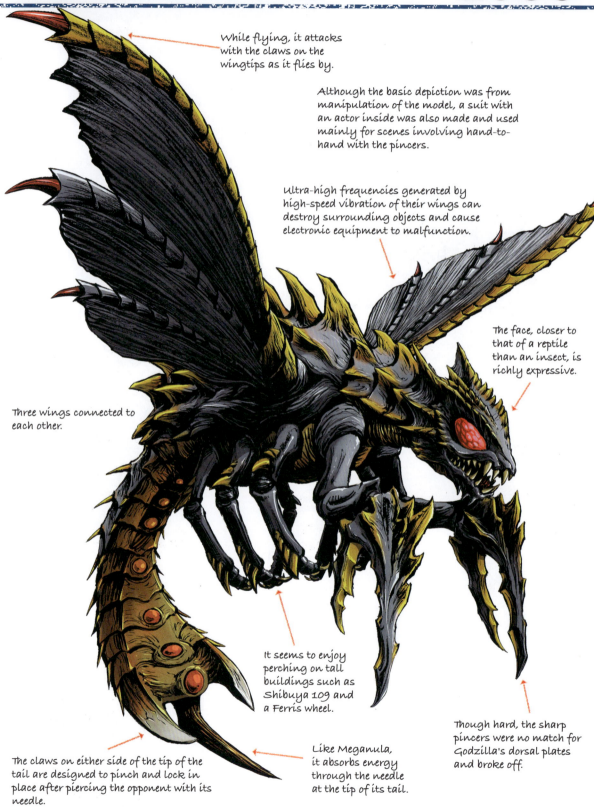

While flying, it attacks with the claws on the wingtips as it flies by.

Although the basic depiction was from manipulation of the model, a suit with an actor inside was also made and used mainly for scenes involving hand-to-hand with the pincers.

Ultra-high frequencies generated by high-speed vibration of their wings can destroy surrounding objects and cause electronic equipment to malfunction.

The face, closer to that of a reptile than an insect, is richly expressive.

Three wings connected to each other.

It seems to enjoy perching on tall buildings such as Shibuya 109 and a Ferris wheel.

Though hard, the sharp pincers were no match for Godzilla's dorsal plates and broke off.

The claws on either side of the tip of the tail are designed to pinch and lock in place after piercing the opponent with its needle.

Like Meganula, it absorbs energy through the needle at the tip of its tail.

Megaguirus

2000

"Godzilla vs. Megaguirus"

Explanation

A giant Meganulon, the only one created from the swarm, becomes Megaguirus after being energized by Meganula and hatching. It plays tricks on Godzilla with its advanced flying abilities, such as rapid acceleration from hovering and high-speed flight.

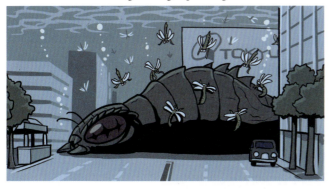

Meganulon, which grew into a giant at the bottom of a submerged lake in Shibuya, received Godzilla's energy via Meganula to eventually hatch and become Megaguirus.

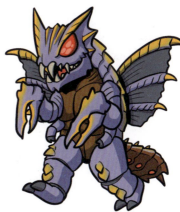

A two-legged suit was also made for movie events, making the character more approachable.

Shinji Nishikawa's design plan

The hatched Megaguirus perched on Shibuya 109 and a Ferris wheel in Odaiba. It seems to have a habit of perching on toweringly high objects.

Megaguirus, a monster whose appearance fit the setting

Megaguirus is a monster that underwent many twists and turns before its plotline was finalized. In the initial version, it had the ability to shift space-time on its own, but was not capable of fighting, and it was intended to float peacefully to allow the surrounding Meganulas to attack its enemies. The wings were also planned to be drawn using computer graphics, so the design drawings are from that stage. Later, due to changes in the setting and restrictions imposed by the switch from CGI to hand manipulation, the figure changed considerably during the modeling stage. Unlike the more insect-like Meganula, Megaguirus is depicted as a highly intelligent and emotional character. The battle between Megaguirus, which uses high-speed flight as its weapon but is destroyed by just a single blow from heat rays, and Godzilla, who employs an unprecedented variety of fighting techniques, demonstrate a flair not seen in other works.

143

Millennium Series
GODZILLA
2001

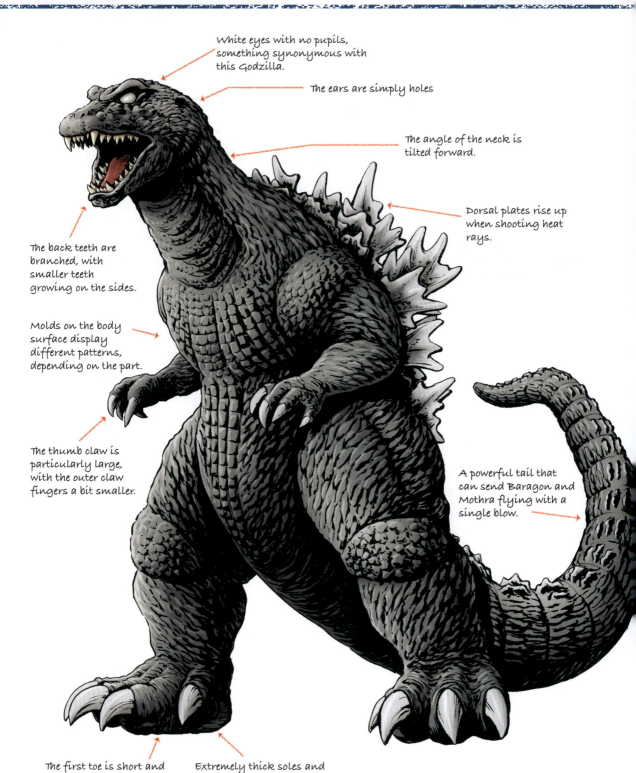

- White eyes with no pupils, something synonymous with this Godzilla.
- The ears are simply holes
- The angle of the neck is tilted forward.
- Dorsal plates rise up when shooting heat rays.
- The back teeth are branched, with smaller teeth growing on the sides.
- Molds on the body surface display different patterns, depending on the part.
- The thumb claw is particularly large, with the outer claw fingers a bit smaller.
- A powerful tail that can send Baragon and Mothra flying with a single blow.
- The first toe is short and unconnected to the others.
- Extremely thick soles and heels to increase height.

144

Godzilla 2001

"Godzilla, Mothra and King Ghidorah: Giant Monsters All-Out Attack"

Explanation

This film was produced under the direction of Shusuke Kaneko, under a different structure from the previous Heisei series, and the setting and modeling of Godzilla was also unprecedented. The occult setting and the appropriate "white-eyed" appearance have become much discussed, and are a symbolic characteristic of this Godzilla.

The foot of Godzilla that crushes the inn on Magonote Island is a modified version of the giant foot created for "Invasion of Astro-Monster" (1965).

The body was punctured by drill missiles, and the heat rays it tried to spew were blown out.

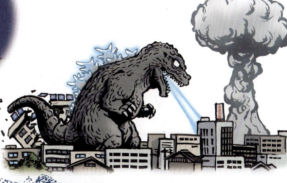

Godzilla explodes at the end of the movie, but its heart resting on the ocean floor begins beating again.

Godzilla, spawned from human resentment

Godzilla in this film is said to be a collection of the residual thoughts of humans who died in the war made into flesh. It consciously targets and slaughters humans and attacks other monsters as if to torment them, making it not only ferocious but also malicious and cruel. Godzilla is a metaphor for war and disaster, but it also communicates to the viewer terror of a different kind. On the other hand, its form is that of a classic Godzilla, with a more dinosaur-like interpretation, but with the flexibility of organic movement. Designed and sculpted by Fuyuki Shinada, who also worked on Biollante and Godzillasaurus, this exquisitely shaped Godzilla strongly evokes both a grudge-like non-living presence yet has a vivid organic feel.

145

Millennium Series
BARAGON
2001

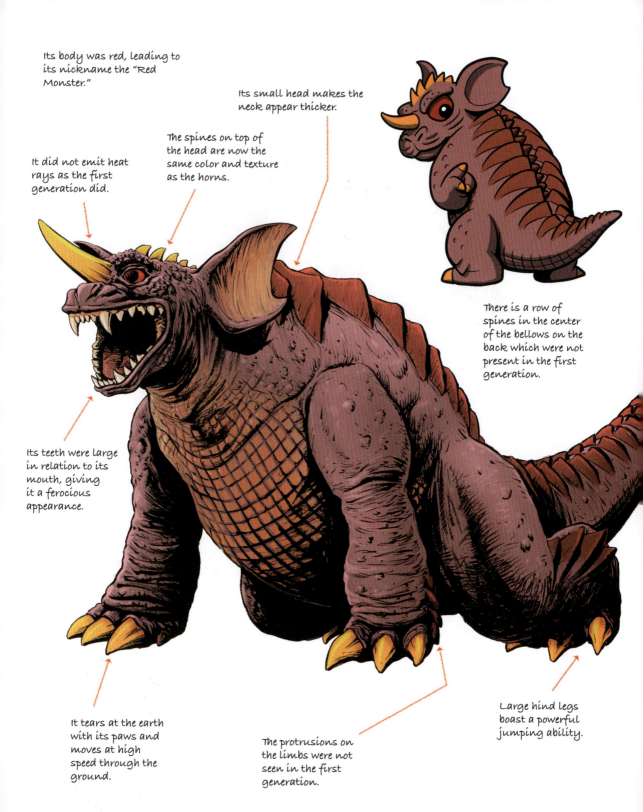

Its body was red, leading to its nickname the "Red Monster."

Its small head makes the neck appear thicker.

The spines on top of the head are now the same color and texture as the horns.

It did not emit heat rays as the first generation did.

There is a row of spines in the center of the bellows on the back which were not present in the first generation.

Its teeth were large in relation to its mouth, giving it a ferocious appearance.

It tears at the earth with its paws and moves at high speed through the ground.

The protrusions on the limbs were not seen in the first generation.

Large hind legs boast a powerful jumping ability.

146

Baragon

2001

"Godzilla, Mothra and King Ghidorah: Giant Monsters All-Out Attack"

Explanation

Made famous in the Showa period, unrevived even for the VS series, Baragon makes its first screen appearance in 33 years. The suit was made as small as possible while retaining the aura of the first generation, and it was the first Toho monster to be played by a female suited actor.

The monster breaks through the wall of the Ōtagiri Tunnel at the foot of Mount Myoko.

The monster digs tunnels under the feet of opponents, a strategy to topple them.

Baragon, the little monster that stood up to Godzilla

The three monsters that fight Godzilla in this film, Baragon, Mothra, and Ghidorah, are considered to be the Protectorate Sacred Beasts of Yamato as described in the "Biography of the Protectorate Sacred Beasts," and their origins differ greatly from those of past films. In this context, Baragon appears in a form and capacity not greatly different from the original. Since Baragon's role in the film is to show Godzilla's power as the mighty spearhead, its suit was made as small as possible to emphasize the size difference between it and Godzilla. This disadvantage of having costumed monsters brought to life by human actors is that there is little variation in size. In this film, both Godzilla and Baragon took this problem to the limit. As a result, the film successfully evoked a "poor Baragon" response from the audience, which also aided in accentuating Godzilla's villainy.

147

Millennium Series
MOTHRA
2001

Explanation
Mothra, sea god of the Yamato Sacred Beast, appeared in Lake Ikeda, Kagoshima Prefecture, Japan. Like the old Mothra, it goes through the three-stage metamorphosis of larva, cocoon, and adult. This Mothra presents a very insect-like and more feminine creature.

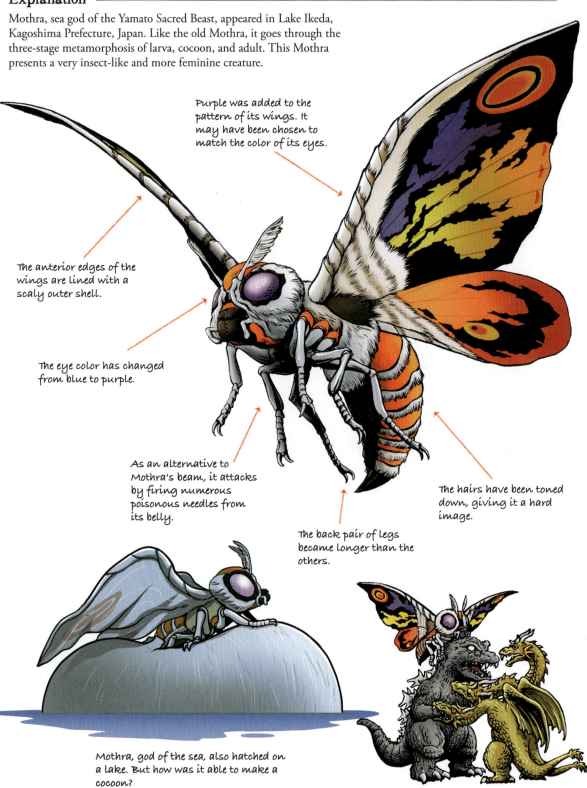

Purple was added to the pattern of its wings. It may have been chosen to match the color of its eyes.

The anterior edges of the wings are lined with a scaly outer shell.

The eye color has changed from blue to purple.

As an alternative to Mothra's beam, it attacks by firing numerous poisonous needles from its belly.

The back pair of legs became longer than the others.

The hairs have been toned down, giving it a hard image.

Mothra, god of the sea, also hatched on a lake. But how was it able to make a cocoon?

148

Mothra

2001

"Godzilla, Mothra and King Ghidorah: Giant Monsters All-Out Attack"

Explanation

The Mothra larva in this film is not a new sculpture, but one that was created for "Mothra" (1996). The larva's internal mechanistic organs are used to undulate its body during movement, a particularly impressive effect. Director Masaaki Tezuka also cited this as an ideal movement when creating the Mothra larva for "Godzilla: Tokyo S.O.S.," and it is an important part of the Millennium Godzilla series in discussing the Mothra larvae. Note that the model used in this film is not a full-body type, but only a slightly larger head sculpture made for the water scene.

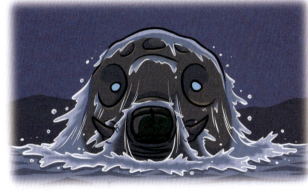

The only appearance in this film is a scene in which the kaiju emerges from the water at night, so it wasn't clearly visible in the film.

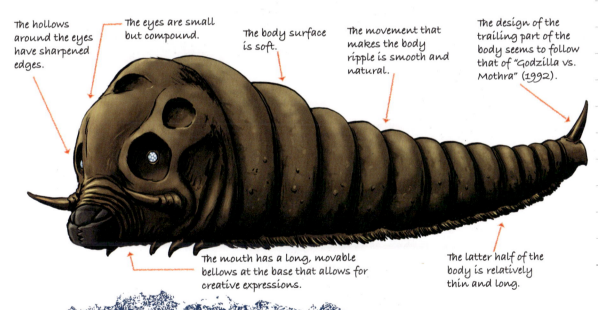

- The hollows around the eyes have sharpened edges.
- The eyes are small but compound.
- The body surface is soft.
- The movement that makes the body ripple is smooth and natural.
- The design of the trailing part of the body seems to follow that of "Godzilla vs. Mothra" (1992).
- The mouth has a long, movable bellows at the base that allows for creative expressions.
- The latter half of the body is relatively thin and long.

Mothra was accepted despite the drastically changed setting

Since the three sacred beasts of the Protectorate were assumed to be "Anguirus, Baran, and Baragon" at the beginning of the project, Mothra and King Ghidorah, except for Baragon, were to appear in a drastically different setting. Gone were the elements that had accompanied Mothra in the past, such as Infant Island and Shobijin, and the fighting style sped up, making full use of CGI. Although Mothra had undergone a major change in appearance and origin, it was accepted without pushback from fans, perhaps because the Heisei Mothra series had been produced in the intervening years. The small body, the sharply angled wings, and the cold-colored patterns are all common to the Heisei Mothra.

149

Millennium Series
KING GHIDORAH 2001

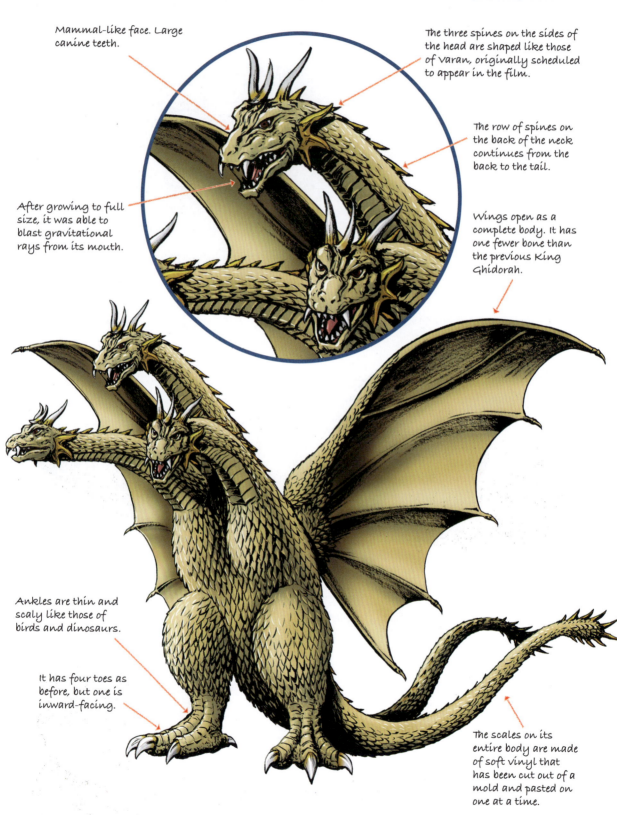

Mammal-like face. Large canine teeth.

The three spines on the sides of the head are shaped like those of Varan, originally scheduled to appear in the film.

The row of spines on the back of the neck continues from the back to the tail.

After growing to full size, it was able to blast gravitational rays from its mouth.

Wings open as a complete body. It has one fewer bone than the previous King Ghidorah.

Ankles are thin and scaly like those of birds and dinosaurs.

It has four toes as before, but one is inward-facing.

The scales on its entire body are made of soft vinyl that has been cut out of a mold and pasted on one at a time.

King Ghidorah

2001

"Godzilla, Mothra and King Ghidorah: Giant Monsters All-Out Attack"

Explanation

The three Yamato sacred beasts were made smaller than Godzilla, and King Ghidorah is no exception. Ghidorah is introduced in its incomplete form with immature wings, and it is not until it has gained Mothra's energy and obtained the perfect body that it is called "King Ghidorah" in reference to the "Millennium Dragon King."

Sleeping in an ice cave in the Sea of Trees (Aokigahara Forest) at Mt. Fuji.

In its incomplete form, it cannot fly because wings have not yet unfolded.

Similar to previous generations, the neck is manipulated using piano wire, in addition to a suit in which the actor inserts both arms to increase freedom of movement.

The battle between Godzilla and King Ghidorah, now in its perfect form, went from air to under the sea.

King Ghidorah as an ally of mankind

King Ghidorah is the character that has evolved the most due to this film's sacred beast of protection storyline. Until now, King Ghidorah has always been on the side of evil, an enemy of mankind, regardless of Godzilla's position in the series, possibly effecting great discomfort among the fans. However, Mecha-King Ghidorah was already an ally of mankind in the VS series, and Mechagodzilla has become a weapon on the side of mankind, so Ghidorah in this film does not seem particularly out-of-place. Ghidorah was only shown fighting Godzilla soon after its resurrection, but I imagine had there been a scene where Ghidorah had wreaked havoc on its own, attacking humans or destroying buildings like Baragon and Mothra previously, it might have created a starkly different impression, but I wonder what could have been.

151

Millennium Series
GODZILLA
2002

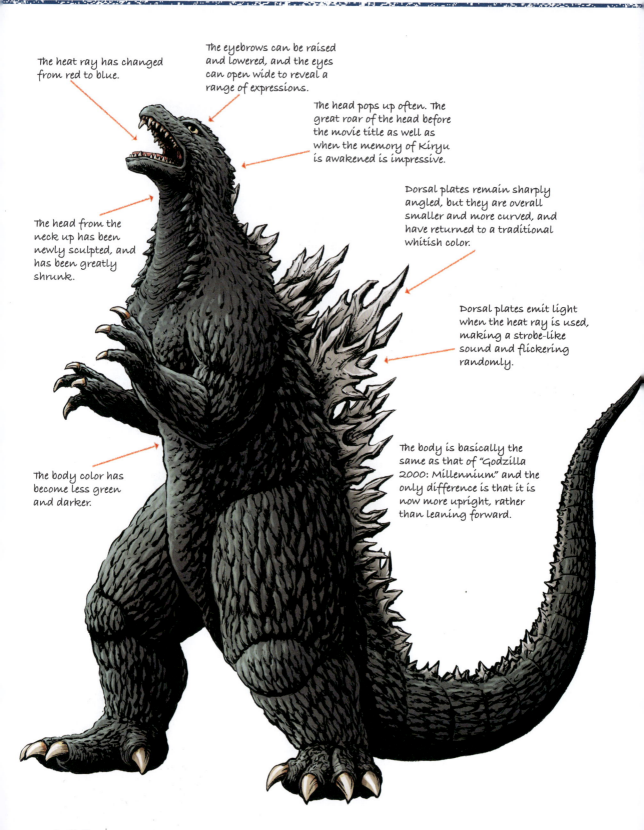

- The heat ray has changed from red to blue.
- The eyebrows can be raised and lowered, and the eyes can open wide to reveal a range of expressions.
- The head pops up often. The great roar of the head before the movie title as well as when the memory of Kiryu is awakened is impressive.
- The head from the neck up has been newly sculpted, and has been greatly shrunk.
- Dorsal plates remain sharply angled, but they are overall smaller and more curved, and have returned to a traditional whitish color.
- Dorsal plates emit light when the heat ray is used, making a strobe-like sound and flickering randomly.
- The body color has become less green and darker.
- The body is basically the same as that of "Godzilla 2000: Millennium" and the only difference is that it is now more upright, rather than leaning forward.

Godzilla

2002

"Godzilla Against Mechagodzilla"

Explanation

After "Godzilla, Mothra and King Ghidorah: Giant Monsters All-Out Attack" (2001), director Masaaki Tezuka once again took up the megaphone for this film, producing a suit based on the "Godzilla 2000: Millennium" version but with modified head and dorsal plates. Here, we would look at it mainly in comparison with the 2000 suit.

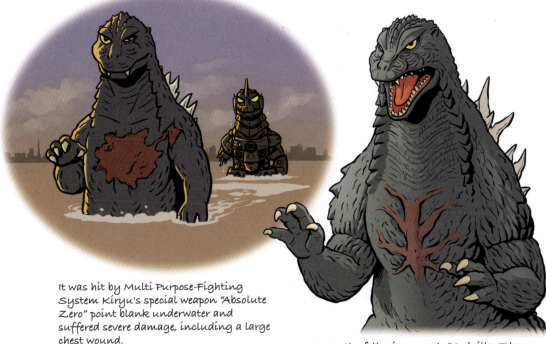

It was hit by Multi Purpose-Fighting System Kiryu's special weapon "Absolute Zero" point blank underwater and suffered severe damage, including a large chest wound.

In the following year's "Godzilla: Tokyo S.O.S.," a suit of the same type with a scar on the chest appeared.

Godzilla seems a little passive and docile

This Godzilla is a more standardized revision of the "Godzilla 2000: Millennium" suit, which was unique in every way. With its small head and upright posture, it resembles more the stout Godzilla of the "VS" series. Also, perhaps because this Godzilla recognizes Kiryu as a companion, made as it was from the bones of the first Godzilla, or perhaps because Kiryu's attacks were ineffective, this Godzilla tends to remain immobile and just allows itself to be attacked, making a rather passive and meek impression. In the next film, "Godzilla: Tokyo S.O.S.," also known as the Kiryu Diptych and the only complete sequel in the Millennium series, Godzilla has a large scar on its chest, the only suit in the entire series to have such a feature.

153

Millennium Series
MECHAGODZILLA 2002

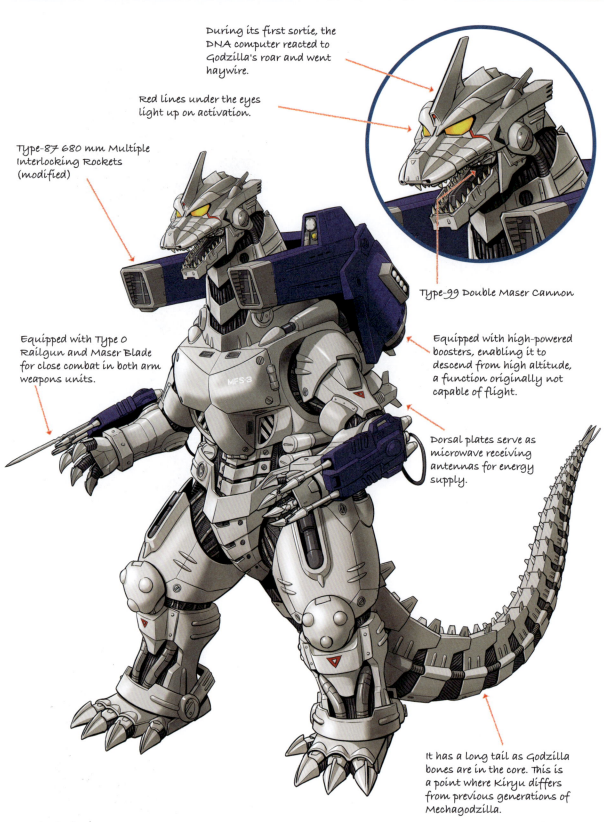

During its first sortie, the DNA computer reacted to Godzilla's roar and went haywire.

Red lines under the eyes light up on activation.

Type-87 680 mm Multiple Interlocking Rockets (modified)

Type-99 Double Maser Cannon

Equipped with Type 0 Railgun and Maser Blade for close combat in both arm weapons units.

Equipped with high-powered boosters, enabling it to descend from high altitude, a function originally not capable of flight.

Dorsal plates serve as microwave receiving antennas for energy supply.

It has a long tail as Godzilla bones are in the core. This is a point where Kiryu differs from previous generations of Mechagodzilla.

Multi Purpose-Fighting System Kiryu
(Heavily Armed Type)

2002

"Godzilla Against Mechagodzilla"

Explanation

The first Mechagodzilla created in the 21st century was the Multi Purpose-Fighting System Kiryu developed by JXSDF. The explanation offered for the Godzilla shape of the weapon is that its internal frame is composed of bones from the first Godzilla. The built-in weapons were therefore considered to have limited functionality, and most of its armament was equipped externally. This fully equipped Kiryu is referred to as a "Heavily Armed Type."

When the chest armor opens, the firing port of Kiryu's most powerful weapon, "Absolute Zero," appears. It is the most powerful special weapon, consuming 40% of its energy to freeze its target to absolute zero and destroy it at the molecular level.

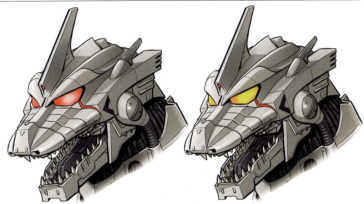

Normally, the eyes are yellow, but they glow red when it goes berserk. After it was modified to prevent it from doing so, vertical lines were molded in.

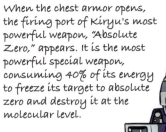

Initial design plan

Mechagodzilla comprised of the skeleton of the first Godzilla

As Kiryu's core is strengthened from the bones of first gen Godzilla, it more resembles a cyborg than a robot, and such elements are visible throughout its design. The structure of the joints is not mechanical, but rather, it is as if the body is covered in armor. The reason for equipping the robot with a large amount of external armament was based on the idea that there should be little space for weapons built into the body. The color purple was chosen by Yuichi Kikuchi, in charge of special engineering, to give it a heroic mecha-robot feel. The presence of Absolute Zero also makes Kiryu in this work more of a fantasy character than a realistic one.

Millennium Series
MECHAGODZILLA 2002

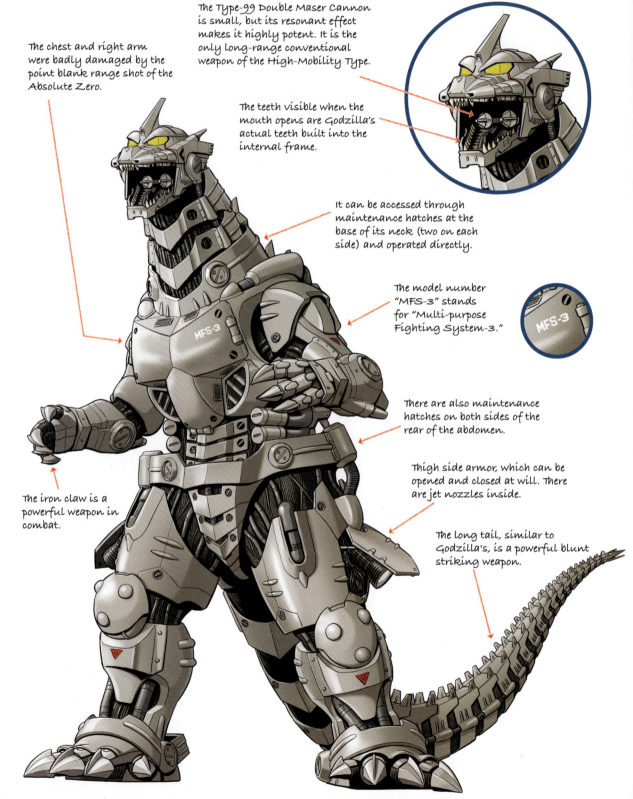

The chest and right arm were badly damaged by the point blank range shot of the Absolute Zero.

The Type-99 Double Maser Cannon is small, but its resonant effect makes it highly potent. It is the only long-range conventional weapon of the High-Mobility Type.

The teeth visible when the mouth opens are Godzilla's actual teeth built into the internal frame.

It can be accessed through maintenance hatches at the base of its neck (two on each side) and operated directly.

The model number "MFS-3" stands for "Multi-purpose Fighting System-3."

There are also maintenance hatches on both sides of the rear of the abdomen.

Thigh side armor, which can be opened and closed at will. There are jet nozzles inside.

The iron claw is a powerful weapon in combat.

The long tail, similar to Godzilla's, is a powerful blunt striking weapon.

Multi Purpose-Fighting System Kiryu
(High Mobility Type)

2002

"Godzilla Against Mechagodzilla"

Explanation

When the Heavily Armed Type Kiryu's armament is destroyed or deemed unnecessary, it disengages to become a lightweight "High-Mobility Type." In addition to mobility that surpasses even that of Godzilla, Mechagodzilla's organic movement is made possible by the high-speed power of its DNA computer, allowing it to fight in combat, something the previous Mechagodzilla struggled to achieve.

In order to create a parallel setting where the original Godzilla's bones were left behind after its defeat by the Oxygen Destroyer, a first-generation Godzilla suit only for the upper half of the body was created, and a scene in which Godzilla melts was filmed anew.

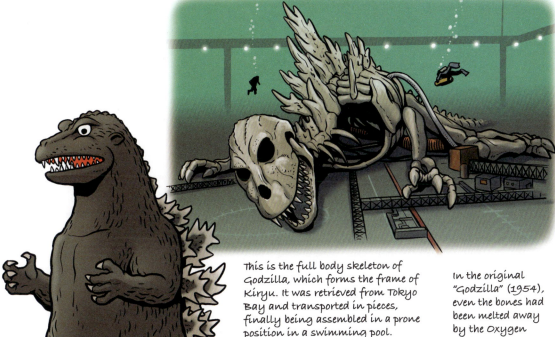

This is the full body skeleton of Godzilla, which forms the frame of Kiryu. It was retrieved from Tokyo Bay and transported in pieces, finally being assembled in a prone position in a swimming pool.

In the original "Godzilla" (1954), even the bones had been melted away by the Oxygen Destroyer.

Mechagodzilla created using "Godzilla bones"

Showa era's Mechagodzilla was brought to life by aliens, and the Heisei era's Mechagodzilla came about through analysis of future science, and one could argue that these settings protected Godzilla's transcendence by imposing limits on it: "A robot comparable to Godzilla cannot be created with the current ability of humanity alone." The core of the Multi Purpose-Fighting System Kiryu, which was to be built in an unprecedentedly realistic setting, i.e. by the Japan Self Defense Force, was "Godzilla's bones." Mankind could not possibly produce a material with strength comparable to these bones. By establishing the fact that they were necessary in the story, they were able to preserve a portion of Kiryu as a being that transcends human understanding.

157

Millennium Series
MECHAGODZILLA 2003

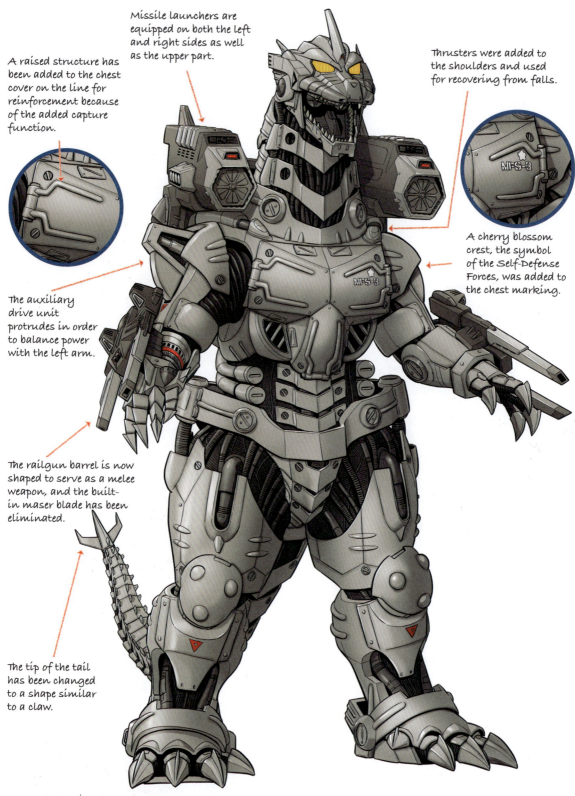

Missile launchers are equipped on both the left and right sides as well as the upper part.

A raised structure has been added to the chest cover on the line for reinforcement because of the added capture function.

Thrusters were added to the shoulders and used for recovering from falls.

A cherry blossom crest, the symbol of the Self-Defense Forces, was added to the chest marking.

The auxiliary drive unit protrudes in order to balance power with the left arm.

The railgun barrel is now shaped to serve as a melee weapon, and the built-in maser blade has been eliminated.

The tip of the tail has been changed to a shape similar to a claw.

158

Multi Purpose-Fighting System Kiryu, Modified

2003

"Godzilla: Tokyo S.O.S."

Explanation

The damaged parts of Kiryu were repaired, and its equipment was replaced and reinforced. In particular, the shape, function, and paint job of the heavily armed external weapons have been changed, lending them a more dignified appearance than the heroic weapons of the previous iteration. On the other hand, the right arm of the High-Mobility Type, which transforms into a drill, adds undeniable flair.

The head was hit by Godzilla's heat rays, damaging the right side of its face, leaving it with one eye.

The backpack ejection used in the previous film was judged to be effective against Godzilla. The left and right rockets can now also be separated and ejected individually.

A mechanism was added to the inside of the chest cover to deploy the claws for capture.

A Triple Maser Cannon was installed on the chest to replace the lost Absolute Zero.

The right arm, now fully mechanized, transforms into a drill with a rotating wrist that can penetrate even Godzilla's epidermis.

Multi Purpose-Fighting System Kiryu, a more realistic weapon

Like Mechagodzilla in the Showa era, Kiryu was restored and appeared in two consecutive films. Its body color is now darker and shaded, the same as in Showa. It is standard for mecha to be more powerful when they reappear, however, Kiryu has lost its special weapon, the Absolute Zero, and its strength has been weakened to match the setting. In addition, while the Kiryu of the previous work was heroically directed by Yuichi Kikuchi, in charge of special technology, the Kiryu of this work is portrayed as a more realistic weapon, with the mechanic as the main human character. The emphasis on the massive appearance rather than speed in the production may therefore be seen as a reduction in power. On the other hand, the drill in its right hand is vicious and effective as a fighting-orientated, High Mobility Type weapon but having been forced to carry so much, I wonder if this is the reason Kiryu grew weary of his human creators.

159

Millennium Series
KAMOEBAS 2003

Kamoebas

In "Godzilla: Tokyo S.O.S." (2003), a carcass with a fatal neck wound washed up on Kujukuri Beach. It was presumed to have been attacked by another giant creature, and there were hints that it might have been Godzilla. It is 20 meters long, the same length as the original, and while most of the monsters in the Godzilla series are the same size or slightly larger than Godzilla as adults, the fact that it is less than half the size of Godzilla gives the viewer a sense of a wider world.

The head also has spines similar to those on the carapace. The "Godzilla: Tokyo S.O.S." version has more clearly defined spines.

The neck expands and contracts for head-butting. The air is used to express the powerful movement of the head.

The two fangs and spikes on the front part of the head are the same characteristics as those of the second generation Anguirus, also sculpted by Nobuyuki Yasumaru.

The skin on the neck and limbs is bellows-like.

The actor enters and exits on the ventral side.

The limbs, belly, and other parts of the body are covered with thin, scaly molds.

Although it is said a Matamata turtle has transformed into a monster, the turtle in the film is crafted from the shell of a bullhead turtle.

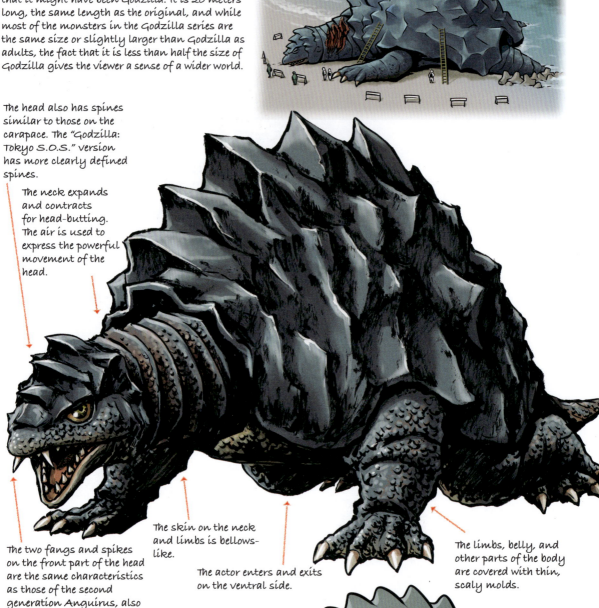

160

Kamoebas

2003

"Godzilla: Tokyo S.O.S."

Explanation

Kamoebas appears in "Godzilla: Tokyo S.O.S." (2003) as the fourth monster without a name in the title. Appearing only as a washed-up carcass, it is not a suit but rather a non-moving sculpture. Still, it is finely molded and has an authentic form.

Kamoebas' first appearance was in "Yog, The Monster From Space" (1970). The popularity of monster movies was at a low ebb, and since Godzilla did not appear in the film, the film has a subdued impression, but the realism that went into the modeling of the creatures is noteworthy.

"Yog, The Monster From Space" (1970), as the title suggests, features Gezora and Ganimes in addition to Kamoebas. Both monsters are Earth creatures that have been transformed into kaiju by amoeba-like space organisms that have taken them over. Their common weakness is their vulnerability to the ultrasonic waves emitted by bats.

Gezora

A thunder squid turned into a monster. It has a low body temperature and freezes anything it touches, but it can't stand up to fire. Since it is defeated by humans before Kamoebas appears, there is no scene in the film in which it fights Kamoebas, something depicted in the posters and other materials.

Ganimes

A Horrid Elbow (Daldorfia horrida) crab that morphed into a monstrous state. Its hard shell can repel bullets, making it more formidable to humans than Gezora. When it falls off a cliff, it is blasted to bits, but an alien possesses a second crab that transforms as well. Deranged by the ultrasound, it battles Kamoebas.

Despite the life-like appearance of the monsters, the fact that a squid walks upright appears to cast it in a slightly poorer light.

The modeling is realistic, and the body shape does not at first glance imply there is an actor inside. The movement of the mouth and other body parts are so lifelike it is almost creepy.

Kamoebas first appeared 34 years ago

The original Kamoebas was a very elaborate suit for the time (1970), made by die-cutting the entire body from a prototype. Before Kamoebas, the only Toho monster made using a similar technique was the first Godzilla 16 years previously, and following this, there were no other Toho monsters until Godzilla 1984, a full 14 years later, which shows how advanced the suit was at the time. The suit's body shape makes movement difficult, but it has an elastic neck mechanism that compensates for the sense of speed, and the savage combat, quite different from human-like fighting, is also appealing. Incidentally, among the past appearances of Kamoebas mentioned in the movie "Godzilla: Tokyo S.O.S." (2003), the first "34 years ago" refers to the year the original movie was released (the time in the movie "Tokyo S.O.S." was 2004), clearly indicating that this is set in the same world. Was this Kamoebas also possessed by a space organism?

161

Millennium Series
MOTHRA

2003

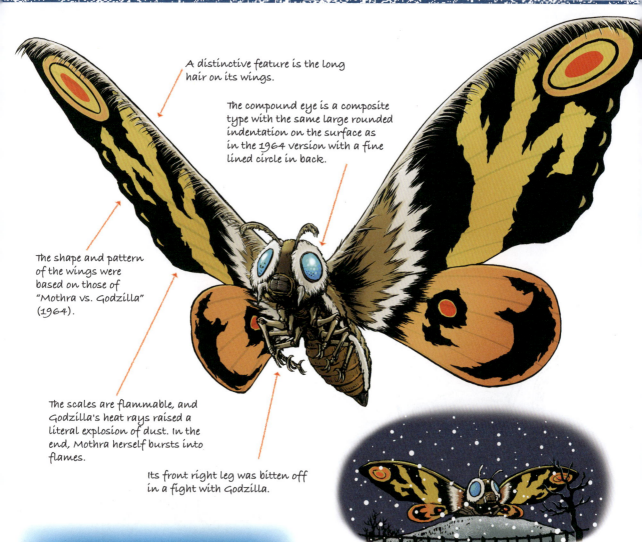

A distinctive feature is the long hair on its wings.

The compound eye is a composite type with the same large rounded indentation on the surface as in the 1964 version with a fine lined circle in back.

The shape and pattern of the wings were based on those of "Mothra vs. Godzilla" (1964).

The scales are flammable, and Godzilla's heat rays raised a literal explosion of dust. In the end, Mothra herself bursts into flames.

Its front right leg was bitten off in a fight with Godzilla.

Mothra visited Shinichi Nakajo from Infant Island with Shobijin. They landed in snowy Karuizawa.

A Self-Defense Forces' aircraft pursued a flying form heading for Japan over the Pacific Ocean. It turned out to be Mothra.

The same sculpture appeared in "Godzilla Final Wars" the following year. It fought a fierce battle with Gigan, and although part of its wing was clipped, it was eventually defeated by the fire heat attack.

Mothra

2003

"Godzilla: Tokyo S.O.S."

Explanation

Mothra, which had been introduced with new versions in the "Heisei Mothra Series" and "Godzilla, Mothra and King Ghidorah: Giant Monsters All-Out Attack," returned to a design similar to that of "Mothra vs. Godzilla" (1964) in this work, as it is a continuation of the Showa Mothra series. Great focus was placed on the modeling and movement of the sculptures, which expressed a supple and powerful wing flapping.

Larvae

Twins were born from an egg laid on the Ogasawara Islands. They are a male and female, with differing antennae lengths, facial spots, etc. Homages to "Mothra vs. Godzilla" (1964) can be seen throughout the film, such as Mothra biting Godzilla's tail and wrapping Godzilla in string to block its movements.

The tip of the tail has finer body segments.

The blue light in the eyes changes to red after witnessing the death of the adult.

The one with longer antennae and more spots on the face is the male.

The jagged mouth bite, characteristic of previous larvae, has been replaced by a deep groove on the surface.

Mothra's scales given a new setting

Although Mothra in this film pays homage to past works in terms of both modeling and direction, director Tezuka requested the scales possess new characteristics separate from the "poisonous scales" of the Showa period or the "heat ray reflection" of the VS series. I then suggested a "dust explosion," a phenomenon that supposes when air filled with a high concentration of particulate matter is ignited, it explodes into flames. This may have been difficult to understand from the film alone. However, it is interesting that the image of "Mothra with burning scales" is unintentionally connected to the final scene in the film, when the adult insect catches fire from Godzilla's heat rays and then performs a "fire heat attack," in which it is engulfed in flames and hits the enemy with its body in the next film, "Godzilla Final Wars."

163

Millennium Series
GODZILLA
2004

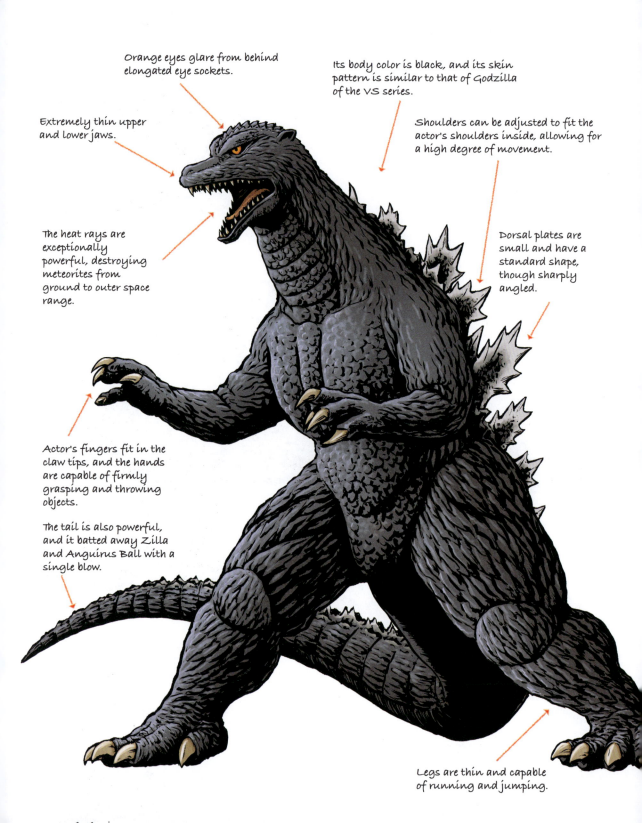

Orange eyes glare from behind elongated eye sockets.

Its body color is black, and its skin pattern is similar to that of Godzilla of the VS series.

Extremely thin upper and lower jaws.

Shoulders can be adjusted to fit the actor's shoulders inside, allowing for a high degree of movement.

The heat rays are exceptionally powerful, destroying meteorites from ground to outer space range.

Dorsal plates are small and have a standard shape, though sharply angled.

Actor's fingers fit in the claw tips, and the hands are capable of firmly grasping and throwing objects.

The tail is also powerful, and it batted away Zilla and Anguirus Ball with a single blow.

Legs are thin and capable of running and jumping.

164

Godzilla

2004

"Godzilla Final Wars"

Explanation

"Godzilla Final Wars" is the final film in the Millennium Series, and it takes on more than a dozen other monsters in a grand showdown. The suit, which required action of a different dimension from that of previous films, was made as slim as possible while rethinking the conventional method of filling the space between the actor and the suit with urethane.

Buried and sleeping under the ice in Antarctica after the battle with Gotengo. It seems to be as vulnerable to low temperatures as previous Godzillas.

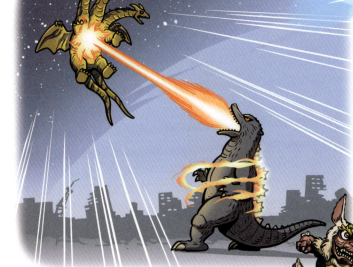

It obtained energy from the new Gotengo and emitted a powerful red heat ray. Its power pushed Kaizer Ghidorah into the stratosphere, where it exploded.

Godzilla, whose action transcends conventional imagery

In keeping with the style of director Ryuhei Kitamura, this film demanded action beyond the conventional image of a monster, not only for the main story but also in the special effects, so Godzilla and the other monsters were made to look more human, with an emphasis on ease of movement. The process of achieving a "movable suit" to the utmost limit was left to modeling, and no design drawings existed. The resulting suit boasts a range of motion that even allows for high kicks, and fully demonstrates the potential of Tsutomu Kitagawa, who has played the heroic role for many years. The action, which drastically reinvents the monster image until this point, may have left many old fans feeling a bit perturbed, but once you get into the groove of this film and its unique vibe, it's sure to be an enjoyable and extravagant experience.

Millennium Series
MINILLA
2004

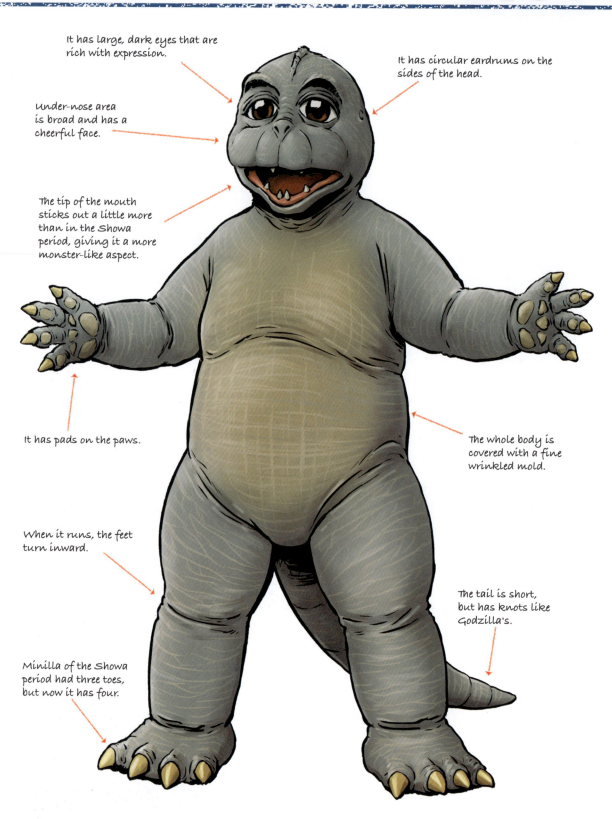

- It has large, dark eyes that are rich with expression.
- Under-nose area is broad and has a cheerful face.
- The tip of the mouth sticks out a little more than in the Showa period, giving it a more monster-like aspect.
- It has circular eardrums on the sides of the head.
- It has pads on the paws.
- When it runs, the feet turn inward.
- Minilla of the Showa period had three toes, but now it has four.
- The whole body is covered with a fine wrinkled mold.
- The tail is short, but has knots like Godzilla's.

166

Minilla

2004

"Godzilla Final Wars"

Explanation

Minilla has not made an appearance in 35 years, since "All Monsters Attack" (1969). It appears life-size and interacts with humans, so realistic animal-like details are applied. It rides in a car and has other humorous scenes, providing a welcome relief from the hard battles in both the film and the special effects.

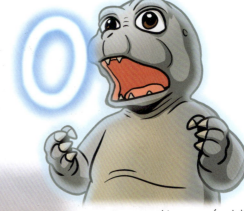

It appeared human-sized, but became excited when it saw Godzilla fighting Rodan, Anguirus, and King Caesar, and after spitting out a ring of heat rays, it ballooned up to giant size.

It went in to stop Godzilla just as it was about to attack humans, and together they left for the sea. As they were leaving, it emitted a full-fledged heat ray, with its dorsal plates glowing.

Minilla, resurrected in the same mold as before

Many fans may have felt that Minilla's resurrection was a reversal of the times after three films in the VS series, Baby, Little, and Junior, depicted the growth of Babygodzilla as a new child image. Minilla is particularly symbolic, but the monster faces in "Godzilla Final Wars" are generally oriented toward the Showa era. I think that the idea of "denial of the VS series by the creators who are Showa era Godzilla fans" that pervades the entire Millennium series may have been at odds with what the audience was looking for. This is off topic, but the use of Minilla's image from "All Monsters Attack" to make it grow from human-sized to gigantic without any particular explanation is a good idea that matches the logic-free, high-tempo development of this work.

Millennium Series
MONSTER X
2004

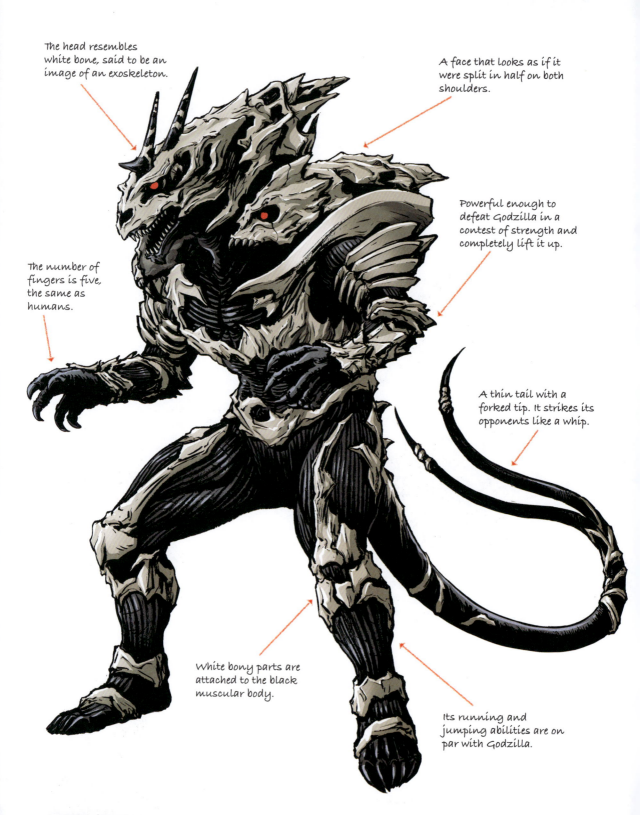

- The head resembles white bone, said to be an image of an exoskeleton.
- A face that looks as if it were split in half on both shoulders.
- The number of fingers is five, the same as humans.
- Powerful enough to defeat Godzilla in a contest of strength and completely lift it up.
- A thin tail with a forked tip. It strikes its opponents like a whip.
- White bony parts are attached to the black muscular body.
- Its running and jumping abilities are on par with Godzilla.

Monster X

2004

"Godzilla Final Wars"

Explanation

Monster X is the only new monster among the many revival monsters in "Godzilla Final Wars." Among all the basic Showa monsters, Monster X's alien-like style sets it apart from its origins. It has a human-like physique suited for action as it goes head-to-head with the lightweight Godzilla of this film.

"Destroyed Thunder," a beam fired simultaneously from its four red eyes, is just as powerful as Godzilla's radiant heat rays.

It emerged from a meteorite exploded by Godzilla's heat rays, and floats down to earth.

The missing halves of its face on both shoulders bulge from within, wings sprout from its back, and it transforms into the three-necked Kaizer Ghidorah.

Monster X, cool all on its own

Godzilla in this film is depicted as an overwhelmingly powerful monster that no other kaiju can match. Monster X, therefore, whose power surpasses even Godzilla, comes off as a major player, including the way it appears in the film. In addition, it teams up with a Modified Gigan to improve its chances… but due to Gigan's reputation as a small-time villain with a screwed-up character, Monster X seems taken down a notch or two. However, the monster battles in this film are characterized by the inclusion of humor, so it was a good decision to show such tricks only when it and Gigan form a tag-team, and to maintain the cool, strong enemy character in the stand-alone scenes.

169

Millennium Series
KAIZER GHIDORAH 2004

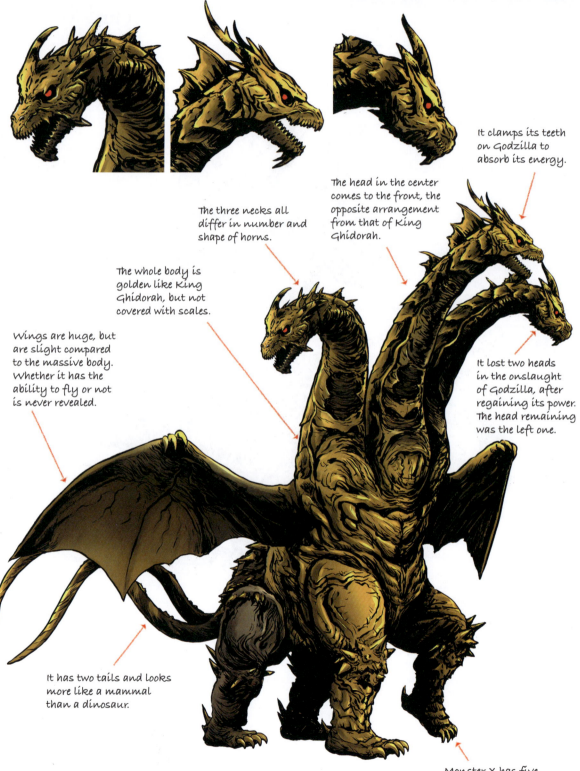

It clamps its teeth on Godzilla to absorb its energy.

The head in the center comes to the front, the opposite arrangement from that of King Ghidorah.

The three necks all differ in number and shape of horns.

The whole body is golden like King Ghidorah, but not covered with scales.

Wings are huge, but are slight compared to the massive body. Whether it has the ability to fly or not is never revealed.

It lost two heads in the onslaught of Godzilla, after regaining its power. The head remaining was the left one.

It has two tails and looks more like a mammal than a dinosaur.

Monster X has five fingers, but Kaizer Ghidorah has four.

170

Kaizer Ghidorah

2004

"Godzilla Final Wars"

Explanation

Kaizer Ghidorah is the transformation of Monster X into its true form. It is interesting to see how Monster X, with its human-like slender body and speedy fighting style, transforms into the huge, heavyweight Kaizer Ghidorah, displaying a unique manner of combat. This marks the first time in the Godzilla series two actors are in a single suit.

Kaizer's anti-gravity ray is capable of levitating Godzilla.

The suit is heavy enough to accommodate two actors, but also allows for sweeping actions such as lifting the paws high.

Kaizer Ghidorah, a heavy four-legged monster

The technique of having two actors enter and take charge of the front and rear legs has long been used in Kabuki-style horses, but when it comes to special effects monsters, the "Dodongo-type," named after the monster first used in "Ultraman," is probably better known. Since then, this type appeared from time to time, and was often seen as the last boss monster, especially because of its size. However, it is also true that this style is not often used due to its difficulty in handling and the unnatural joints of its four legs. Notably in Toho Tokusatsu, an emphasis was placed on creating life-like monsters, so I suspect that it also may have been one of reasons why this style hadn't been adopted thus far. However, in this film, Godzilla stops avoiding human-like traits, and with all the past creatures doing cameos, there's a festive atmosphere that celebrates past styles. This monster in particular exhibited a striking eccentricity as the culmination of it all.

171

Millennium Series
GIGAN
2004

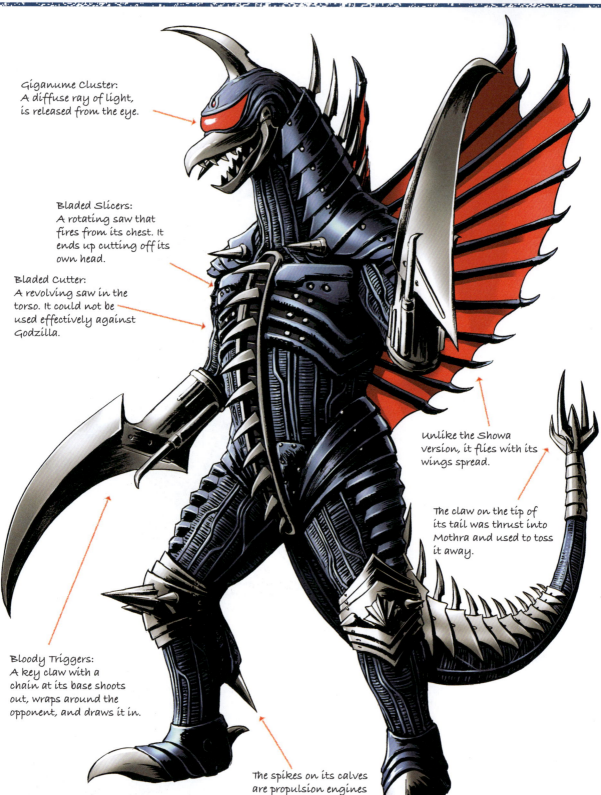

Giganume Cluster: A diffuse ray of light, is released from the eye.

Bladed Slicers: A rotating saw that fires from its chest. It ends up cutting off its own head.

Bladed Cutter: A revolving saw in the torso. It could not be used effectively against Godzilla.

Bloody Triggers: A key claw with a chain at its base shoots out, wraps around the opponent, and draws it in.

Unlike the Showa version, it flies with its wings spread.

The claw on the tip of its tail was thrust into Mothra and used to toss it away.

The spikes on its calves are propulsion engines for flight, a design feature.

172

Gigan

2004

"Godzilla Final Wars"

Explanation

Gigan, a popular monster that had not been given a shot at a comeback for quite a while, made a stylish reappearance. After its defeat by Godzilla, it became more powerful and ferocious.

Modified Gigan

In addition to having its head replaced, the original was destroyed in the Antarctic battle with Godzilla, Gigan was revived with reinforced arms, the sickles from the previous version replaced by chainsaws. It fought Mothra and challenged Godzilla in a joint battle with Monster X.

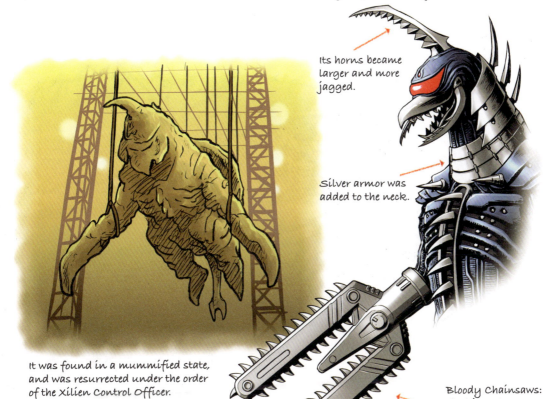

Its horns became larger and more jagged.

Silver armor was added to the neck.

It was found in a mummified state, and was resurrected under the order of the Xilien Control Officer.

Bloody Chainsaws: slashing at opponents, it can be placed on the ground for high-speed locomotion.

Gigan modified to appear more ferocious

The original Gigan boasts a simple yet highly accomplished design with strong character, and is unique in a way that does not allow for the existence of any sublime versions. The original's personality perfectly matched that of designer Yasushi Nirasawa, and it was revived with a design both uniquely Nirasawa and uniquely Gigan at the same time.

A cyborg monster to begin with, Gigan is compatible with artificial parts, and since it has already been modified, it is not unreasonable to develop it with further mods. In fact, the chainsaw weapon, which is even more ferocious and ridiculous, is a truly thrilling concept.

173

Millennium Series
EBIRAH
2004

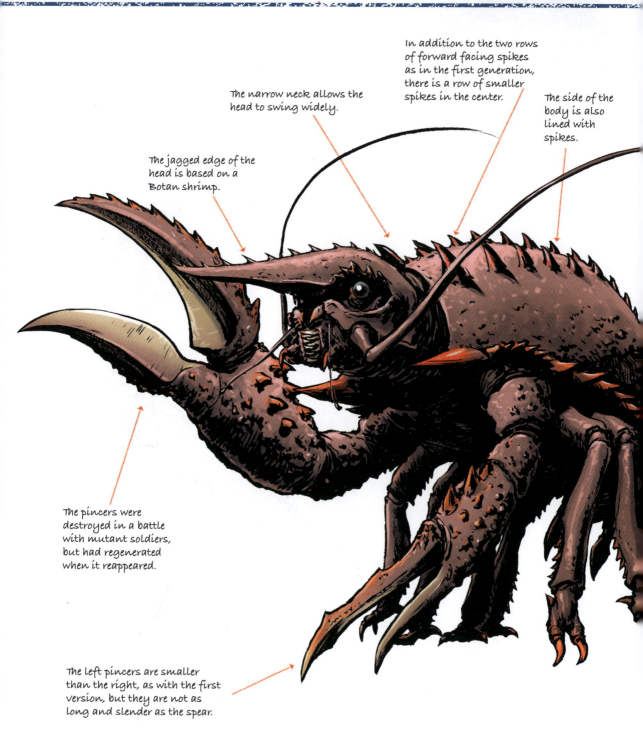

The jagged edge of the head is based on a Botan shrimp.

The narrow neck allows the head to swing widely.

In addition to the two rows of forward facing spikes as in the first generation, there is a row of smaller spikes in the center.

The side of the body is also lined with spikes.

The pincers were destroyed in a battle with mutant soldiers, but had regenerated when it reappeared.

The left pincers are smaller than the right, as with the first version, but they are not as long and slender as the spear.

174

Ebirah

2004

"Godzilla Final Wars"

Explanation

Except for the live film, Ebirah has not been seen since the first appearance in "Ebirah, Horror of the Deep" (1966). Like the first generation, it has a realistic shrimp (crayfish) form that is basically just a giant crustacean, and has no special abilities other than attacking with its pincers.

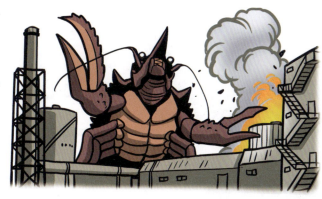

The tail (abdomen) is detachable, and most of the scenes of Godzilla's rampage on land were filmed with only the upper half of the body.

It has a black stripe pattern on its caudal fin.

Along with Hedorah, it was blown out of the waters of Tokyo Bay by Godzilla's heat rays, its pincers impaling Hedorah.

Abdomen with a pair of small fins per body segment.

Ebirah, the first kaiju defeated by humans

Originally a sea monster, Ebirah never made it to land in the original, but in this film it goes on a rampage onshore. It engages a squad of mutant soldiers and becomes the first giant monster in the Godzilla series to be defeated by humans without the aid of other monsters, natural phenomena, or large weapons. However, it is debatable whether the mutants and the weapons they use can be considered conventional weapons just because they are small. Ebirah may have been chosen as a kaiju that could be defeated by humans, but a kaiju with long-range attack techniques would have given more meaning to the explosions that occur so frequently around the mutant unit.

175

Millennium Series
MANDA

2004

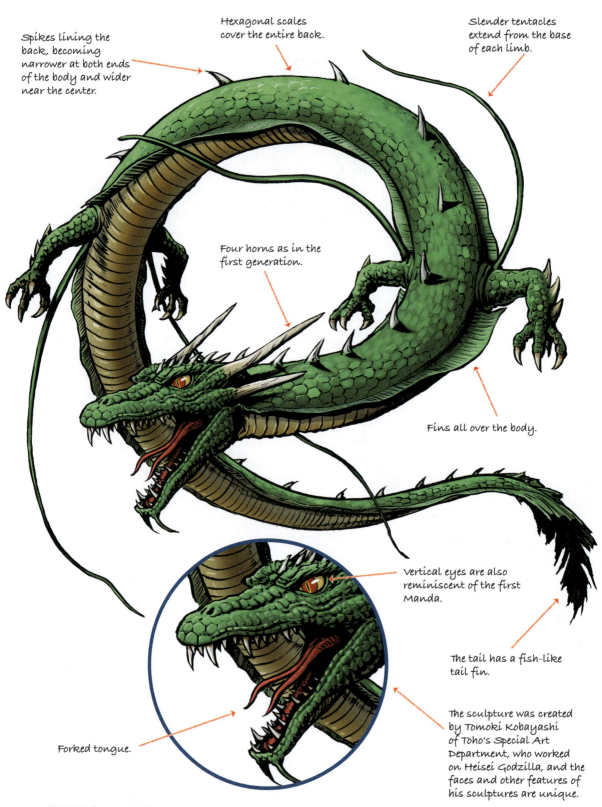

Spikes lining the back, becoming narrower at both ends of the body and wider near the center.

Hexagonal scales cover the entire back.

Slender tentacles extend from the base of each limb.

Four horns as in the first generation.

Fins all over the body.

Vertical eyes are also reminiscent of the first Manda.

The tail has a fish-like tail fin.

The sculpture was created by Tomoki Kobayashi of Toho's Special Art Department, who worked on Heisei Godzilla, and the faces and other features of his sculptures are unique.

Forked tongue.

176

Manda

2004

"Godzilla Final Wars"

Explanation

This is the third style of Manda, following the first one in "Atragon" (1963) and the second in "Destroy All Monsters" (1968). While the swimming scene was represented by CGI, modeling was used to bring to life a wraparound attack on the new Gotengo, just as in the first generation.

The scene in which the Manda is trapped in ice by the Frozen Maser and crushed by a drill was performed using an exploding doll.

Design drawing by Shinji Nishikawa

Manda's shape has returned to that of the first generation

At first glance, the Manda in this film resembles the first generation in shape, including the horns, but is devoid of the backbone of a guardian deity of the Mu Empire, and in that respect it resembles the second generation. Therefore, in design terms as a Manda without "divinity," it has been put together based on the concept of a mere giant creature that is a composite of aquatic creatures rather than a dragon. The fins and slender tentacles on the sides were intended to express a sense of life with their rippling movements. It was assumed that Manda would be represented in CGI, but the movements were too fast and it lacked the desired effect. In most of the scenes in which they appeared, when Manda was wrapped around the new Gotengo, the fins were brought to life through sculptures giving them a sense of presence.

177

Millennium Series
ANGUIRUS
2004

It is similar to the first generation in that the fangs are shorter.

Seven horns on the back of the head as in the first gen, but the side horns are longer than those in the center, a point setting it apart from both first and second generation.

The tip of the tail is a spiked hammer.

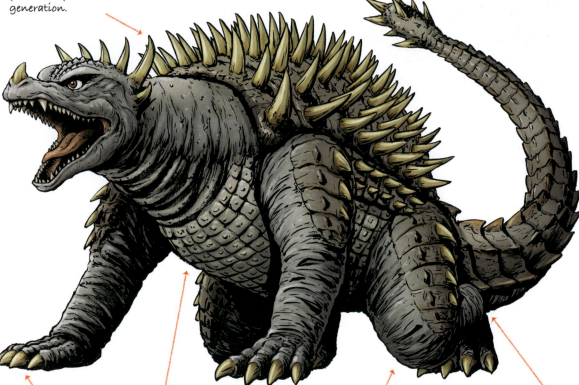

Four digits on each limb.

The pattern of square scales on the ventral side was taken from the design of Baragon, who failed to appear in this film.

It is basically on all fours, but at times rears up on its hind legs.

The limbs also have armor and spikes.

178

Anguirus

2004

"Godzilla Final Wars"

Explanation

Anguirus is another popular kaiju from the Showa period that didn't have a chance to reappear until this outing. It has debuted a new technique, the Anguirus Ball, and has demonstrated its dragon-like abilities by laying waste to the city of Shanghai and shooting down the aerial battleship Karyu, but also suffered the humiliation of being used as a soccer ball.

> The Anguirus Ball is its signature move in which it spins around and smashes enemies with its balled-up body. It is powerful enough to shoot down a fire dragon, Rodan, or an aerial battleship.

Shinji Nishikawa's design

Anguirus equipped with spikes for its special new technique

The design changes to Anguirus are mainly attributed to its ball form. Spiked armor was added to the arms and legs so that there would be no smooth areas when Anguirus curled up. In the design drawing, there is also armor on the neck, but the modeling from the neck up does not conform to the design drawing. The transformation into Anguirus Ball is CGI, but it was accomplished without any discrepancy from the live-action part. Anguirus fought Godzilla along with Rodan and King Caesar, but was turned into a soccer ball by the other two. These three monsters, Godzilla's companions in the Showa series, were defeated, but they were not toppled by heat rays like the others.

179

Millennium Series
RODAN
2004

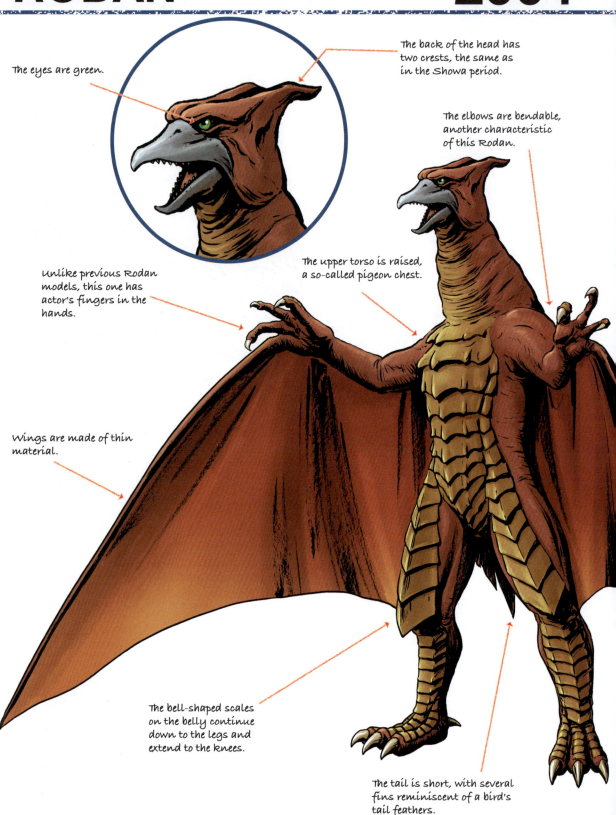

180

Godzilla: The Encyclopedia

Rodan

2004

"Godzilla Final Wars"

Explanation

Rodan was revived in "Godzilla vs. Mechagodzilla" in the Heisei era, but this is the first time since "Destroy All Monsters" (1968) that an actor performs in the suit. The suit itself only appears in a few shots, mostly the flight scenes, with CGI used in New York and a flight model for Fuji's base.

The model was required to be able to cover the face like a cape in the image of Batman.

The wings of the flying model, like those of the suit, are made of thin fabric and flap in the wind.

Design drawing by Shinji Nishikawa

Rodan was required to move along with the actor's arms

I was in charge of designing Rodan for this work. The distinctive feature of this suit is the wings, previously fixed at the elbows and fingers, which can now move with the motion of the actor's arms. This was in response to director Ryuhei Kitamura's request to have the actors use their wings like a cape, but there were reasons for avoiding this procedure, such as unnatural wrinkles that formed on the thin wings when the elbows bend, a phenomenon unnatural for living creatures. I had expected this, so after consulting with the staff, I proposed the solution of "having the wings constantly flap in the wind," which somehow fixed the problem. Although it was inevitable that the movement and body shape would become more human-like, it was the overall policy of this work to give priority to action.

Millennium Series
KING CAESAR
2004

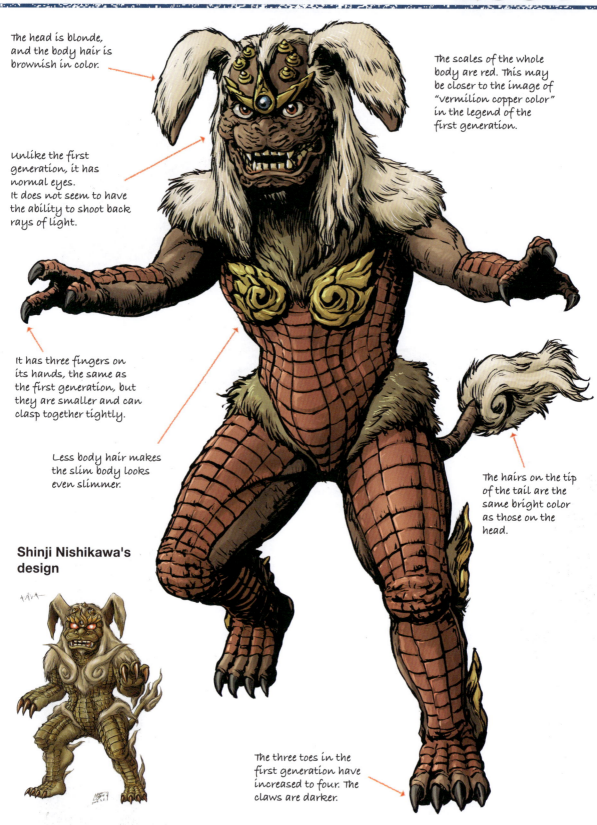

The head is blonde, and the body hair is brownish in color.

Unlike the first generation, it has normal eyes. It does not seem to have the ability to shoot back rays of light.

It has three fingers on its hands, the same as the first generation, but they are smaller and can clasp together tightly.

Less body hair makes the slim body looks even slimmer.

Shinji Nishikawa's design

The scales of the whole body are red. This may be closer to the image of "vermilion copper color" in the legend of the first generation.

The hairs on the tip of the tail are the same bright color as those on the head.

The three toes in the first generation have increased to four. The claws are darker.

182

King Caesar

2004

"Godzilla Final Wars"

Explanation

King Caesar makes its first appearance since "Godzilla vs. Mechagodzilla" (1974). It is the guardian god of Okinawa, a fact not mentioned in this film. As a particularly nimble and human-like kaiju among the Earth monsters, it shows off its acrobatic fighting skills against Godzilla.

Controlled by X aliens, King Caesar appeared in an industrial area in Okinawa and laid it to waste.

It has very strong legs, jumping high and punting back Anguirus Ball.

The ears still stand up when excited.

King Caesar, an unexpected resurrection

Among the many Showa monsters revived in this film, King Caesar may have been the most unpredictable. It is hard to argue that it is a popular monster, and its appearance is a bit puzzling because it is the guardian god of Okinawa. Nevertheless, it was chosen to appear in the film, probably because director Ryuhei Kitamura had a strong attachment to it. The only time I had a retake requested by Director Kitamura was with this monster I designed. I was asked to make the head a bit larger, and although I made adjustments as requested, the resulting head of the suit didn't end up significantly larger, perhaps due to considerations of balance with its slender body.

Although it was cut from the completed film, there was a scene in the script in which an old Okinawan man says, "Our God Caesar, what is going on?"

Millennium Series
KAMACURAS
2004

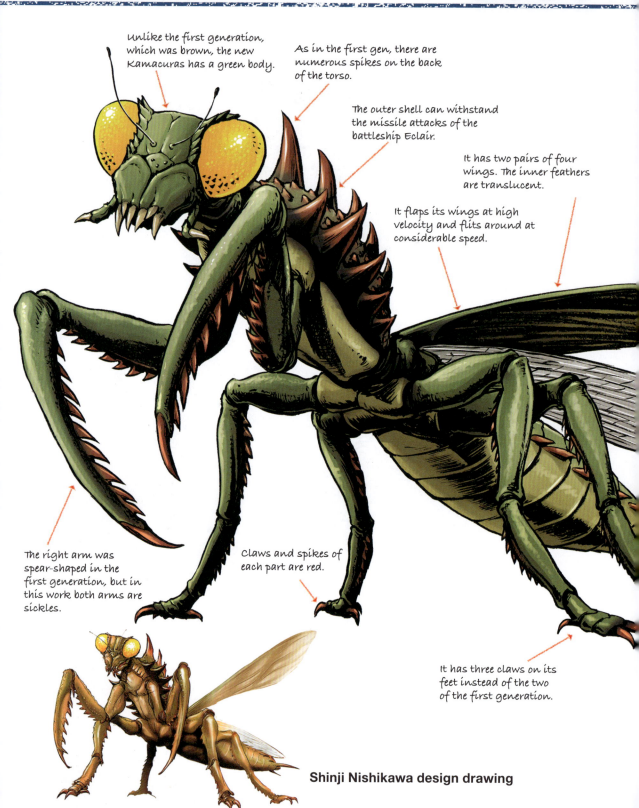

Unlike the first generation, which was brown, the new Kamacuras has a green body.

As in the first gen, there are numerous spikes on the back of the torso.

The outer shell can withstand the missile attacks of the battleship Eclair.

It has two pairs of four wings. The inner feathers are translucent.

It flaps its wings at high velocity and flits around at considerable speed.

The right arm was spear-shaped in the first generation, but in this work both arms are sickles.

Claws and spikes of each part are red.

It has three claws on its feet instead of the two of the first generation.

Shinji Nishikawa design drawing

Kamacuras

2004

"Godzilla Final Wars"

Explanation

This is the first minor monster to make a comeback since the debut film "Son of Godzilla" (1967), except for the live films. It was a crude monster that was no match for Godzilla, even when three of them were working together, but in this film it has risen surprisingly in the ranks, defeating an aerial battleship and even fighting Godzilla one-on-one.

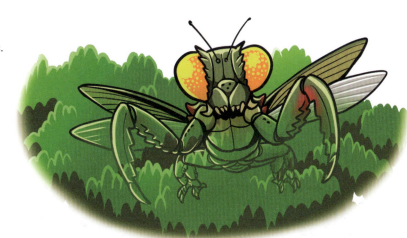

When Godzilla was intercepted in Manazuru, it showed the ability to disappear due to its protective camouflage.

Godzilla tossed it overboard and skewered it on a steel tower, killing it.

Kamacuras, an evolution from the first generation

This appearance for Kamacuras, which gives more of an impression as a mere giant creature than a monster, marks a major coup simply for being chosen for this film and its action. But on top of that, at the preparatory draft stage of the film, it was even chosen as one of the "Four Guardians" to intercept Godzilla at Mt. Fuji, along with Anguirus, Rodan, and King Caesar. The battle against the aerial battleship Eclair in Paris was probably a vestige of this.

The biggest difference from the first generation is that its hands are now scythes, the idea being to make it easier to handle the Anguirus Ball. The body color alteration was made in reference to "phase mutation" in which the color and characteristics of a group of grasshoppers change as they increase in density. The first generation, which appears in groups, is the brown swarm phase, and this film, in which only one grasshopper appears, being the green solitary phase.

Millennium Series
KUMONGA
2004

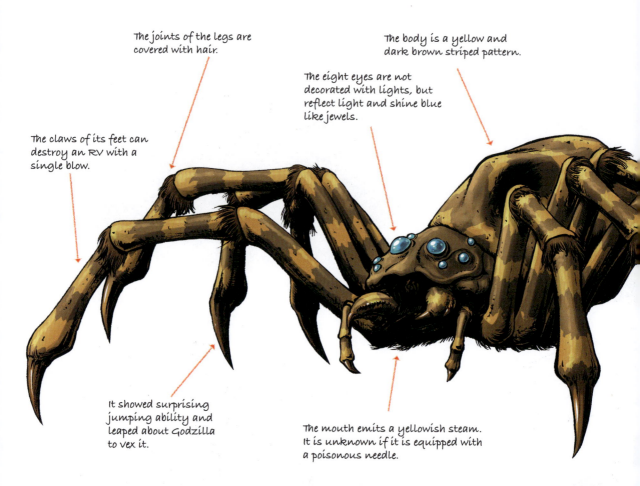

The joints of the legs are covered with hair.

The body is a yellow and dark brown striped pattern.

The eight eyes are not decorated with lights, but reflect light and shine blue like jewels.

The claws of its feet can destroy an RV with a single blow.

It showed surprising jumping ability and leaped about Godzilla to vex it.

The mouth emits a yellowish steam. It is unknown if it is equipped with a poisonous needle.

Shinji Nishikawa design drawing

First appearance in Arizona, in the U.S., where it destroyed a mobile home.

Kumonga

2004

"Godzilla Final Wars"

Explanation

Kumonga is back after 36 years since "Destroy All Monsters" (1968). It first appeared in Arizona, and later intercepted Godzilla in the jungles of New Guinea. In its debut film, "Son of Godzilla" (1967), it came across as a rather formidable monster, but in this film it was defeated without giving Godzilla much of a fight.

Yellow web spits from its mouth, the bundle spreading like a net in the air to cover the enemy.

Godzilla grabbed it by its web and threw it into the distance with a giant swing. It is said to have survived.

Kumonga in a cartoonish performance

The original Kumonga was a monster from the mature period of Showa-era manipulative acting technique, and it must be said that compared to its movements, Kumonga in this film is decidedly inferior. Only one piano wire per leg is used for manipulation, and the joints, other than the base of the leg, hardly move at all. They do not walk using their legs in a functional manner and move exclusively by jumping, probably because it was difficult to make them walk properly. The production style of the film is cartoonish, with the net-like web and the mysterious mechanism of the spider, and the way it is thrown so far away that Godzilla loses sight of it, which may allow even those who are not fond of spiders to enjoy the film without feeling a graphic creepiness.

Millennium Series
HEDORAH
2004

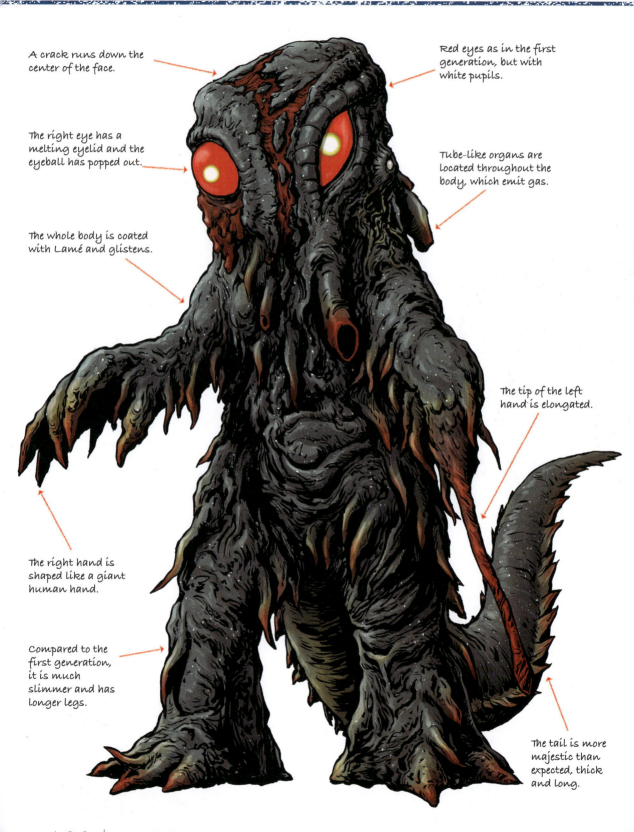

- A crack runs down the center of the face.
- The right eye has a melting eyelid and the eyeball has popped out.
- The whole body is coated with Lamé and glistens.
- The right hand is shaped like a giant human hand.
- Compared to the first generation, it is much slimmer and has longer legs.
- Red eyes as in the first generation, but with white pupils.
- Tube-like organs are located throughout the body, which emit gas.
- The tip of the left hand is elongated.
- The tail is more majestic than expected, thick and long.

Hedorah

2004

"Godzilla Final Wars"

Explanation

Hedorah has a cult following due to its strong impact, but this is the first time it has made a comeback since its debut in "Godzilla vs. Hedorah" (1971). However, its appearance was so brief that its personality and strength were never fully developed, and it may be the monster that caused the greatest dismay and disappointment among fans.

Since it was killed off so quickly in the film, the staff was considerate enough to film a scene of it running amok in the city, which was used in the end roll.

Ebirah's pincers pierced this undersea creature, and Godzilla's heat rays blew away the building and all inhabitants.

Shinji Nishikawa's design

Hedorah incorporates a design that demonstrates growth

It is fair to say that the appeal of the first Hedorah lies in its origin from pollution and the careful depiction of the different stages of its development. As this would be impossible to achieve during such a brief appearance in this film, the intention was to include elements in the design that illustrate growth stages. Specifically, in the expression of the eyes, the left is normal, the right is the crumbling eye, and the barnacle-like area further left of the left eye is meant to resemble the eye of a larval tadpole. While the first generation was mineral and had the body of Hedorah itself, the Hedorah of this film also displays biological organs, and it is possible that it was easily defeated because it was not immortal after all.

189

Millennium Series
ZILLA

2004

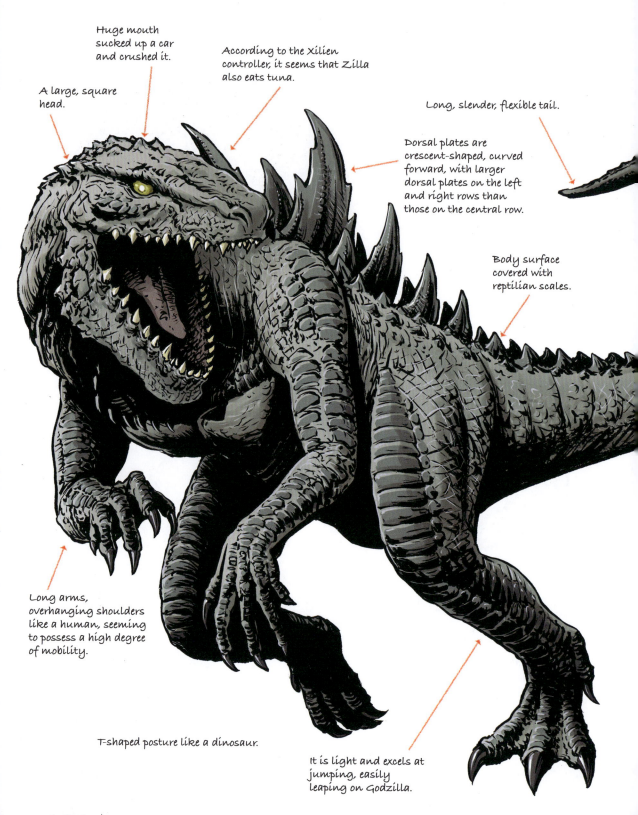

- Huge mouth sucked up a car and crushed it.
- According to the Xilien controller, it seems that Zilla also eats tuna.
- A large, square head.
- Long, slender, flexible tail.
- Dorsal plates are crescent-shaped, curved forward, with larger dorsal plates on the left and right rows than those on the central row.
- Body surface covered with reptilian scales.
- Long arms, overhanging shoulders like a human, seeming to possess a high degree of mobility.
- T-shaped posture like a dinosaur.
- It is light and excels at jumping, easily leaping on Godzilla.

Zilla

2004

"Godzilla Final Wars"

Explanation

A monster that looks exactly like Godzilla appeared in the Hollywood Tristar version of "GODZILLA" (1998) under the name of "Zilla." The confrontation with Godzilla was a battle between a suited creature and a full CGI monster.

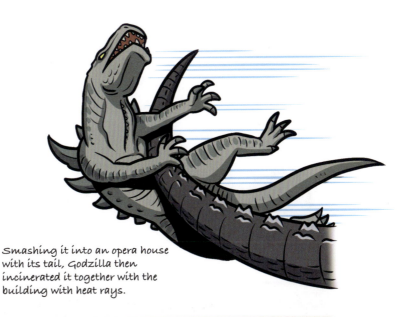

Smashing it into an opera house with its tail, Godzilla then incinerated it together with the building with heat rays.

The Hollywood version of Godzilla was an iguana turned monster.

"GODZILLA" (1998) was the first Godzilla movie produced in Hollywood. Godzilla in this film is said to be an iguana transformed into a monster by French nuclear tests, and is depicted as a normal creature rather than a kaiju, in that it has no heat ray, eats fish such as tuna, lays many eggs, and is killed by conventional weapons. Although the film was criticized as "un-Godzilla-like," there are many aspects of the giant creature that are worth enjoying, such as the suspense that precedes its appearance and the sense of enormity it conveys, as well as elements that later Japanese Godzillas seem to have adopted, such as how it swims underwater and the way the sea surface swells before it arises.

The Hollywood version of Godzilla appears

When Zilla first appears in Sydney, it is portrayed in a straightforward manner as a large monster, but in battle it is instantly wiped out by Godzilla. It is no exaggeration to say this showed off the power differential between original Godzilla and Hollywood's. The Tristar version (the original Zilla) was entertaining enough and well-made, but it received harsh reviews because of a lack of resemblance to the original, and it was felt a true Godzilla fan should be critical of it. However, it wasn't a classy move for the original Godzilla to poke fun at Zilla to garner favorable public opinion. It is sinful to have delightfully accepted an endorsement the Xilien controller's line, "A monster that eats tuna is miserable."

191

GODZILLA ANATOMICAL FILE
SHIN GODZILLA

Godzilla (2nd Form)
2016 "SHIN GODZILLA"

The giant creature discovered in Tokyo Bay rises up from the mouth of the Tama River near Haneda Airport, passes through the Nama River, and comes ashore in Kamata. Initially, it was thought that the creature could not support its own weight and would disintegrate upon landing, but it rapidly evolved into a terrestrial form and made its way overland to Shinagawa.

Godzilla (3rd Form)
2016 "SHIN GODZILLA"

It landed in Kamata with undeveloped legs, but as it adapted to terrestrial life, they completely formed. On the other hand, now superfluous gills wasted away. Due to an incomplete heat exhaust mechanism, it moves from the Keihin Canal into Tokyo Bay to cool down.

Godzilla (4th Form)
2016 "SHIN GODZILLA"

While incubating in Sagami Bay, Godzilla evolved further and morphed into its perfect terrestrial form. It re-emerges from Inamuragasaki in Kamakura, Kanagawa Prefecture, and engages the Self-Defense Forces, who set up a defensive line at the Tama River, eventually driving them off. It then proceeded to spread radioactive material and lay dormant at Tokyo Station.

GODZILLA ANATOMICAL FILE
Theatrical CGI Animated Film

Godzilla Earth
2017 "GODZILLA: Planet of the Monsters"

An apex predator that has decimated mankind and civilization with an impenetrable defense that blocks all physical interference and charged particle heat rays that burn everything around it. Furthermore, it has acquired a gigantic body with a total height of 300 meters over 20,000 years due to continuous evolution and growth without aging.

Godzilla Filius
2017 "GODZILLA: Planet of the Monsters"

A close relative of Godzilla, it is encountered by an emigrant ship on its return to Earth. It is a downsized version of Godzilla Earth, and was initially thought to be Godzilla due to its near identical appearance and capabilities at the time Earth was evacuated.

Servum
2017 "GODZILLA: Planet of the Monsters"

A close relative of Godzilla. Like Godzilla, its body composition closely resembles metal. It resembles a dragon and diverges into two species, one that flies and another that crawls on the ground, being both predator and prey. Both species move in flocks and are characterized by their ferocious attacks on anything that moves.

GODZILLA ANATOMICAL FILE
Godzilla Singular Point

Godzilla aquatilis
2021 "Godzilla Singular Point"

The name means "Aquatic Godzilla." It has been witnessed swimming at 50 knots (92.6 km/h) and at a depth of 900 m by submarines. It appears in Tokyo Bay after chasing a school of Manda, and comes ashore at Tsukiji while feeding on them. Its limbs are fin-like and optimized for aquatic life.

Godzilla amphibia
2021 "Godzilla Singular Point"

It metamorphosed into a body adapted to terrestrial life when it came onto land. Its name means "Amphibian Godzilla." When bombarded by the Self-Defense Forces, it releases flammable gas at minus 20 degrees Celsius, causing it to immolate itself. In this form, it is given the name Godzilla.

Godzilla terrestris
2021 "Godzilla Singular Point"

Godzilla was carbonized by the explosion, but underneath the hardened outer layer was an irregularly-shaped chrysalis. The outer shell peeled off and it emerged again, now embodying the "terrestrial" Godzilla. It can now walk on two legs and emit a halo by blasting light from its dorsal plates.

Manda
2021 "Godzilla Singular Point"

A giant sea serpent-like monster that capsized a fishing boat in the Uraga Channel. It has a habit of swarming, invading Tokyo Bay and spreading Red Dust as it engages the Maritime Self-Defense Force. The Cabinet decided to name it Manda, meaning "mammoth-class snake."

Salunga
2021 "Godzilla Singular Point"

A monkey-like monster that suddenly appears from the basement of a research facility in Upala, India. It is believed to be able to control Red Dust, using it as a defense mechanism. In Upala, it is called Sharanga, "the bow of Vishnu," because of the pattern on its forehead.

Kumonga
2021 "Godzilla Singular Point"

A monster with a spider-like form. It has enough strength to move about even when its body is split in two. It is not clad in Red Dust and is the only monster that preys on humans. Some have wings, some have scythes, and some possess all these features through metamorphosis.

SHIN GODZILLA (2016)

Godzilla (5th Form)
2016 "SHIN GODZILLA"

Operation Yashiori freezes Godzilla in its fourth form and humanity is saved from an unprecedented crisis. However, at the end of Godzilla's frozen tail, a shape with a spine similar to that of the human body was observed to be on the verge of diverging into multiple forms, giving the impression of a fifth form.

Godzilla Anime Trilogy (2017-2018)

Mechagodzilla
2017 "GODZILLA: Planet of the Monsters"

A nano-metal battle-weapon used against Godzilla, created with technology provided by the alien Birsardo. Destroyed by Godzilla before it could be activated, it was abandoned. After that, the head unit continued to self-propagate, and it took on the shape of a fortress city encroaching on its surroundings.

Ghidorah
2017 "GODZILLA: Planet of the Monsters"

A god worshipped by the alien Exif. It is said to devour monsters spawned at the end of civilization. Because it exists outside the rules of the physical world, it is undetectable by the five human senses, save for the gravitational field it creates.

Godzilla Singular Point (2021)

Godzilla ultima
2021 "Godzilla Singular Point"

The ultimate form of Godzilla, signifying the end of the great beast. The skeleton enshrined in the basement of Misakiok is said to be that of Godzilla ultima, and as a singularity, is believed it will lead humanity to its doom. This is the form that resulted from the metamorphosis of Godzilla terrestris after being bombarded by the Self-Defense Forces.

Rodan
2021 "Godzilla Singular Point"

A flying creature that suddenly appears one day in Chiba Prefecture. It is said to be similar to Quetzalcoatlus, which lived in the Cretaceous period. They believe it is attracted to radio waves and received its name because the radioactive substance radon was detected in its body.

Anguirus
2021 "Godzilla Singular Point"

A terrestrial monster that seems to have come in search of Rodan's corpse. It has been suggested it has the ability to predict the future, exhibiting a reaction speed that is impossible with the neurotransmission rate of normal living creatures. It got this name because the grandson of the mayor of Nigashio City mistook it for an ankylosaurus.

Jet Jaguar
2021 "Godzilla Singular Point"

Developed by Goro Otaki, president of Otaki Factory, to protect the earth. Initially a bipedal piloted-type, it went through a three-wheeled boarding type and was reborn as a combat robot equipped with newly-developed legs and Jung, an AI developed by Yun.

SHIN GODZILLA
GODZILLA
2016

2nd Form

With its large gills, the 2nd Form Godzilla is an aquatic creature, but its strong hind legs enable it to move on land as well. The forelimbs are underdeveloped, and the creature moves as if crawling.

Large, long tail. The tip is like a fin.

Unusually large, expressionless eyes.

When they move their bodies, a large amount of red fluid is shed from their gills.

Their thorax slides against the ground as they walk forward.

The forelimbs are folded at the elbows and seem fused together.

Godzilla's first form remains a mystery

What is Godzilla's original form? In the movie, the tail that appeared at sea after the Aqua-Line accident seems to have become the common conception of the first form, but the official story is that it is already in its second form (in the "SHIN GODZILLA 2" Gashapon released in 2017, the preview announced "Godzilla 2016 1st Form" but by the time of its release, it had been changed to "Giant Unidentified Creature Appears.") In other words, the supposed first form never makes an appearance. As the second form developed hind limbs first, like a frog metamorphosis, it is conceivable the first form may have been tadpole-like, but whether this was after it mutated by ingesting radioactive waste from the ocean floor, or whether it was a normal creature, remains a mystery.

194

Godzilla 2016

"SHIN GODZILLA"

Explanation

In "SHIN GODZILLA" (2016), the first domestic Godzilla film in 12 years, the big lizard surprised fans by appearing in a form far removed from what they were used to seeing. It was also the first Godzilla to undergo a major transformation in the film.

Unable to control its rising body temperature, it expels hot breath from its mouth.

3rd Form

Rapidly changed its body structure and became bipedal. Its body cooling function was incomplete and it could not remain on land for long periods of time.

Its forelimbs developed and took on the shape of arms, albeit smaller.

Skin changed to a reddish color.

A new Godzilla that grows and changes its appearance

Under the direction of Hideaki Anno, "SHIN GODZILLA" is the first film since the original Godzilla movie to depict a world where Godzilla makes its first appearance. The film also made possible ideas for Godzilla settings and expressions that would have been unacceptable in the past, most notably a shape-shifting Godzilla. The second form of Godzilla, which completely eliminated the "coolness" that had been essential to Godzilla, was particularly impactful, and it became surprisingly popular among fans, who nicknamed it "Kamata-kun." This change in mindset not only among fans, but also among the production team was significant for expanding the creative possibilities. This approach was carried over to the TV animation "Godzilla Singular Point."

195

SHIN GODZILLA
Godzilla

2016

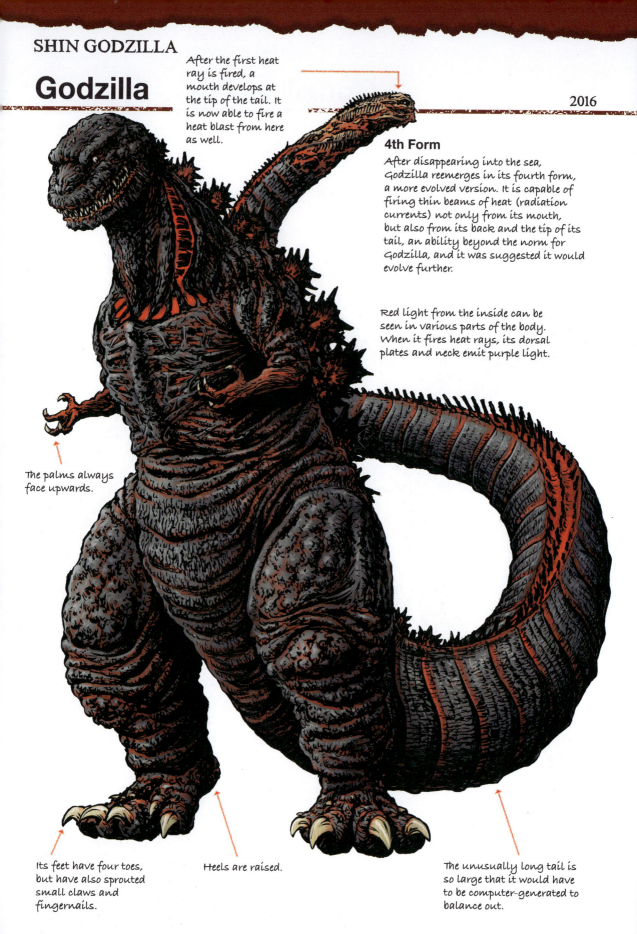

After the first heat ray is fired, a mouth develops at the tip of the tail. It is now able to fire a heat blast from here as well.

4th Form
After disappearing into the sea, Godzilla reemerges in its fourth form, a more evolved version. It is capable of firing thin beams of heat (radiation currents) not only from its mouth, but also from its back and the tip of its tail, an ability beyond the norm for Godzilla, and it was suggested it would evolve further.

Red light from the inside can be seen in various parts of the body. When it fires heat rays, its dorsal plates and neck emit purple light.

The palms always face upwards.

Its feet have four toes, but have also sprouted small claws and fingernails.

Heels are raised.

The unusually long tail is so large that it would have to be computer-generated to balance out.

Godzilla: The Encyclopedia

Very small eyes. When it senses danger to the head, metallic shutters close to protect them.

The messily-formed teeth are not designed for chewing food, and there is no tongue in the mouth.

When spitting out heat rays, the mouth opens wide. The lower jaw can also open left and right.

Shoots numerous radiation streams from between its dorsal plates to intercept enemies from above.

5th Form

Injected with a blood coagulant, Godzilla was cryogenically frozen and ceased its destruction, but the tip of its tail had begun the transformation into its fifth form. It was predicted that it was on the verge of splitting into a group of humanoid creatures capable of flight.

Godzilla depicted in full CGI

The fourth form of Godzilla can be described as a reconstruction of the first Godzilla. Its head shows the image of the design drawing and template that is said was inspired by the first Godzilla's mushroom cloud. The overall form is also based on the first iteration, although the proportions of the various parts have been emphasized. Many fans were concerned about a full CGI rendering of Godzilla, but the results were good enough to dispel any misgivings. The fact that the skin is harder and less organic than that of the second form may have helped, but there is no doubt that "SHIN GODZILLA" has changed the old fan mindset that "monsters have to wear suits."

197

Theatrical CGI Animated Film
"GODZILLA: Planet of the Monsters" 2017

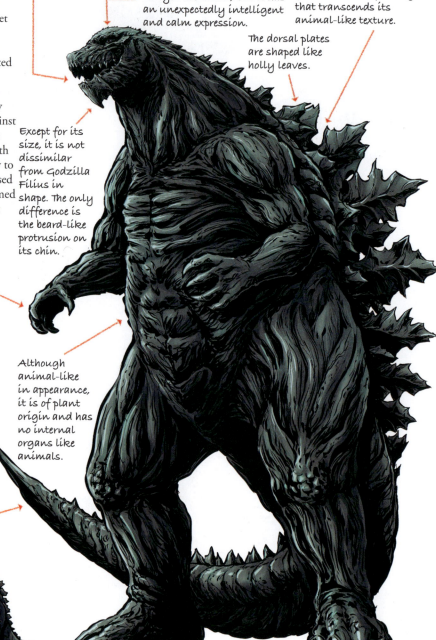

Explanation

The first Japanese-made animated Godzilla film, "GODZILLA" is a trilogy of movies. Told in the fore-title of the first film, "Planet of the Monsters" (details of which were also revealed in the novel), Humanity is being hunted by various monsters surfacing around the world. Humanity is eventually driven from Earth by the appearance of Godzilla, against whom they are defenseless. The human race later returns to Earth to reclaim their homeland, only to find that 20,000 years have passed and the ecosystem has transformed into one in which Godzilla is at the top.

Godzilla Earth

Over a period of 20,000 years Godzilla never ceased growing and has now reached the massive height of 300 meters. It reigns over the Earth with an overwhelmingly large physique, a shield that repels all attacks, and heat rays that emit tremendous destructive power.

Godzilla Filius

Godzilla emerges before the humans that return to Earth after their 20,000 year sojourn. It is 50 meters tall, as big as before, but its defense shield is breached, leading to its destruction. We find out later it is not the original, but a subspecies that arose later.

Annotations

- Super-vibration waves, rather than traditional heat rays, shoot from its mouth.
- Its eyes are small, but it has an unexpectedly intelligent and calm expression.
- The undulating muscles, modeled after those of the Niou Guardian statue, give it a sense of strength that transcends its animal-like texture.
- The dorsal plates are shaped like holly leaves.
- Except for its size, it is not dissimilar from Godzilla Filius in shape. The only difference is the beard-like protrusion on its chin.
- The teeth and claws are an extension of Godzilla's body and are an integral part of its structure.
- Although animal-like in appearance, it is of plant origin and has no internal organs like animals.
- The energy from its dorsal plates is concentrated in its tail, and with a single swing, it cleaves a wide area.
- Its legs are long and thin, especially from the knees down. The body shape is reminiscent of a foreign sumo wrestler.
- The toes are not spread out, but shaped like human feet.

198

Godzilla: The Encyclopedia

Servum

A subspecies of Godzilla that lives in large numbers on Earth 20,000 years in the future and is composed of metallic cells similar to those of Godzilla. Pteranodon and worm types exist, and while the Pteranodon type has the power to destroy human weapons, it also subsists on the worm type.

"Pteranodon type" Total length: about 15 m

- Its back is lined with dorsal plates similar in shape to those of Godzilla, albeit smaller.
- Tail as long and slender as the neck
- Wings with no apparent skeleton.
- In addition to wings, it has short arms.
- A long, slender neck not unlike that of Godzilla.
- Many red eyes
- Hard teeth that can eat through the armor of landing craft and powered suits.

"Worm type" Total length: approx. 6.4 m

- Numerous red eyes as in the Pteranodon type.
- Head has a round mouth with rows of sharp teeth.

While previous Godzillas fired heat rays from the mouth, this creature collects energy and fires it from the tip of its nose while keeping its mouth closed.

The fiber structure contains the metallic elements that make up its entire body generate powerful electromagnetic energy, the source for the heat rays and shields.

The Godzilla must not die rule

One of the unwritten rules of Godzilla movies is that "Godzilla must not die (after being defeated by humans or monsters)." The only exception to this rule is the first version, which is what makes the "Godzilla" (1954) film so special. Its death in "Godzilla vs. Destoroyah" (1995) is a self-destruction, and in GMK (2001), it just barely avoids death with only the heart surviving. On the other hand, breaking this unwritten rule may have made the Tristar version of "GODZILLA" (1998) a hard pill to swallow for the fans. In this outing, Godzilla is unexpectedly defeated, but the surprise is that it isn't the original, but a subspecies similar to Servum that was introduced earlier in the film. Immediately following this, original Godzilla appears at an extraordinarily gigantic 300 meters, thereby increasing the sense of despair, a clever twist we didn't see coming.

199

Theatrical CGI Animated Film

"GODZILLA: City on the Edge of Battle"

2018

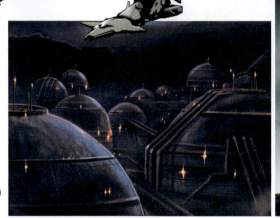

Mechagodzilla
Mechagodzilla is an anti-Godzilla weapon composed of "Nanometal" created by the scientific power of the alien Birsardo. It was Earth's last hope, but failed to activate and was destroyed by Godzilla. Mechagodzilla is only seen in a few shots in the fore-title of the first film, "Planet of the Monsters."

Mechagodzilla City
The head of Mechagodzilla, which remained unscathed, continued to produce nanometals without limit, resulting in a huge city-like structure over a period of 20,000 years. Birsardo has rebuilt the control system, which now functions as a building factory.

Approaching Servum were captured and used as material for proliferation.

Mechagodzilla without a figure
Mechagodzilla was thought unlikely to appear in this series due to its hard science fiction flavor. However, following the tease in the first film, expectations for its appearance in part two were high, especially with its cool, innovative design. When it debuted on screen as a literal city, without any trace as a monster, this was met with some disappointment from fans who wanted a more conventional style of kaiju movie. This change was also an embodiment of the "expansion of the monster concept," which could be argued is the theme of this series. Of course, it would have been easier to swallow if a monster-type Mechagodzilla had come out, but I believe that this would have made the story harder to comprehend.

"GODZILLA: The Planet Eater"

2018

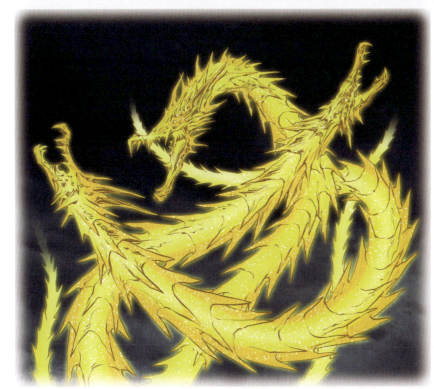

Ghidorah
A higher dimensional being obeying a different set of physical laws from this universe, preys on both the planet itself, which has developed a highly scientific civilization, as well as the monsters emerging from it.

Only the long neck is revealed from the black sphere, and the mere silhouette of the whole body is depicted in the film, but the full body image is sold in soft vinyl.

Metphies, a priest of the alien Exif, used the sacred weapon Garbetrium to guide it and captured Godzilla in this dimension. When Garbetrium was destroyed, Ghidorah was captured by the physical laws of the Earth dimension, materialized, and was subsequently destroyed by Godzilla.

Garbetrium, the sacred object of Exif. It is a key part of the ritual to call Ghidorah to Earth, and also functions as an observation device that allows Ghidorah to detect the location of beings in the Earth dimension. The seven-pointed star on it is said to represent Ghidorah's three heads, two wings, and two tails.

201

"Godzilla Singular Point" 2021

Explanation

Godzilla in this film is the singularity (singular point) that will bring catastrophe to the world, and the transformation of Godzilla's form, which is akin to biological evolution, is itself linked to the approaching catastrophe, bringing an urgency to the film. Each of Godzilla's changing forms incorporates the motif of a Toho monster appropriate to each stage of its evolution, and while this imparts to them different personalities, the way in which they are applied to the continuity of the design is exquisite and humorous. Common elements of each form include dorsal plates like Godzilla, a long tail more than twice the length of the main body, and a large amount of Red Dust generated from the body, which dyes red the surrounding environment.

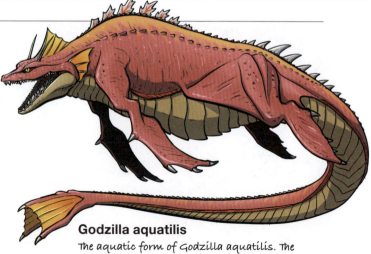

Godzilla aquatilis

The aquatic form of Godzilla aquatilis. The Titanosaurus can be seen as a design motif. It came out after Manda and showed a tendency to bite, suggesting that it may have been preying on it.

Godzilla amphibia

The morphed form of Aquatilis after it came ashore. It became a quadruped reminiscent of Varan, and the icy air blasted from its mouth caused an explosion that ended up carbonizing itself. At this point, the government decides to call it "Godzilla" (1st Form).

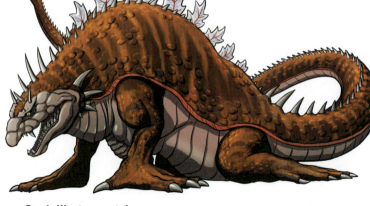

Godzilla terrestris

This is the second form that emerged after the carbonized surface of Godzilla collapsed. Its dinosaur-like body shape and blue color are reminiscent of Gorosaurus. The ring-shaped beam it shoots from its mouth may be an homage to Minilla, the juvenile form of Godzilla. It has the ability to capture and neutralize missiles by extending Blood tentacles from its body surface.

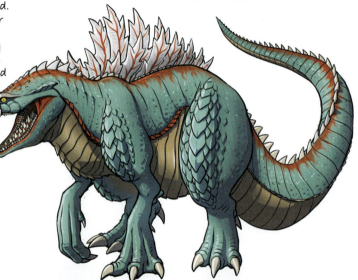

202

A pair of huge fangs growing from the outside of the upper jaw.

Multiple layers of teeth in the oral cavity. This seems to be a common feature not only in Godzilla's various forms, but in all Red Dust creatures as well.

The lower jaw is wider than the upper and protrudes slightly.

Spiny scales line the sides of the neck and from the center of the front face to the chest.

A row of spiny scales from elbow to wrist.

Godzilla ultima

The appearance of "Godzilla ultima," the complete form of Godzilla, comes late at the end of the 10th episode of the 13-episode series. However, the accumulation of form changes to that point, a heart-racing story, and Godzilla's theme music with lyrics played for the first time all combine in a crescendo of excitement in this episode.

Multiple rings of light are generated in front of the mouth, which converge to fire a powerful atomic beam that blasts through the center.

The skin of the entire body is a bellows structure, like a layer of thick armor.

Three toes plus one claw-like toe growing under the calf.

Thick, muscular legs worthy of supporting its enormous body.

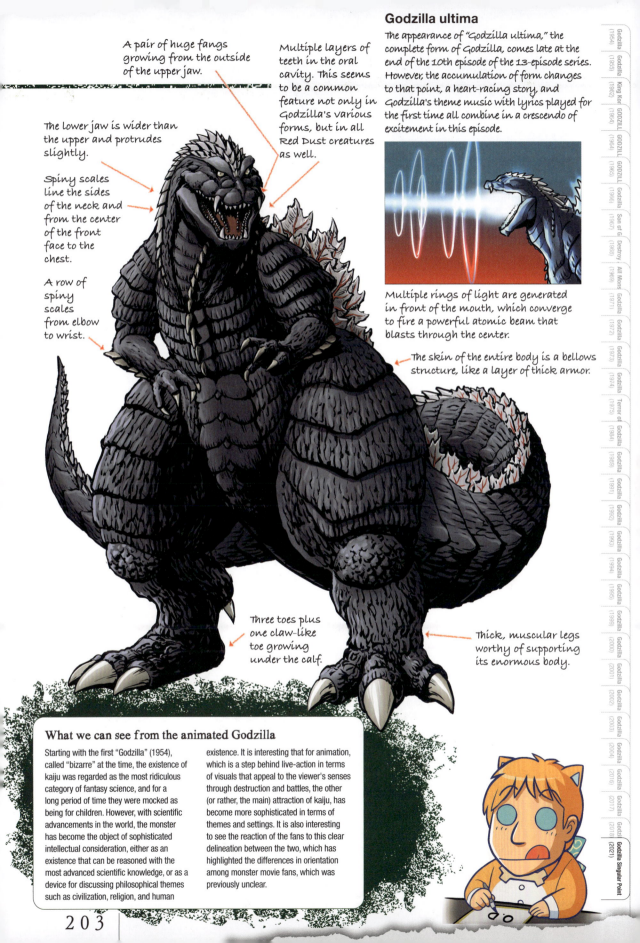

What we can see from the animated Godzilla

Starting with the first "Godzilla" (1954), called "bizarre" at the time, the existence of kaiju was regarded as the most ridiculous category of fantasy science, and for a long period of time they were mocked as being for children. However, with scientific advancements in the world, the monster has become the object of sophisticated intellectual consideration, either as an existence that can be reasoned with the most advanced scientific knowledge, or as a device for discussing philosophical themes such as civilization, religion, and human existence. It is interesting that for animation, which is a step behind live-action in terms of visuals that appeal to the viewer's senses through destruction and battles, the other (or rather, the main) attraction of kaiju, has become more sophisticated in terms of themes and settings. It is also interesting to see the reaction of the fans to this clear delineation between the two, which has highlighted the differences in orientation among monster movie fans, which was previously unclear.

203

"Godzilla Singular Point"

2021

Rodan

The first monster in the animation program. It perished quite suddenly due to a failure to adapt to its environment. It emitted radio waves and the radioactive material radon was detected in its body, hence its name "Radio Monster Rodan."

The figure below depicts the second form of Rodan, which more successfully adapted to its environment. In addition to a smaller body size, its body color and details have changed, causing it to more resemble Showa period Rodan. They fly in groups from the reddish sea, generating Red Dust from their bodies and turning the sky red as well. While generating Red Dust, they swarm together in large numbers, eventually becoming so numerous they begin to fly around the world.

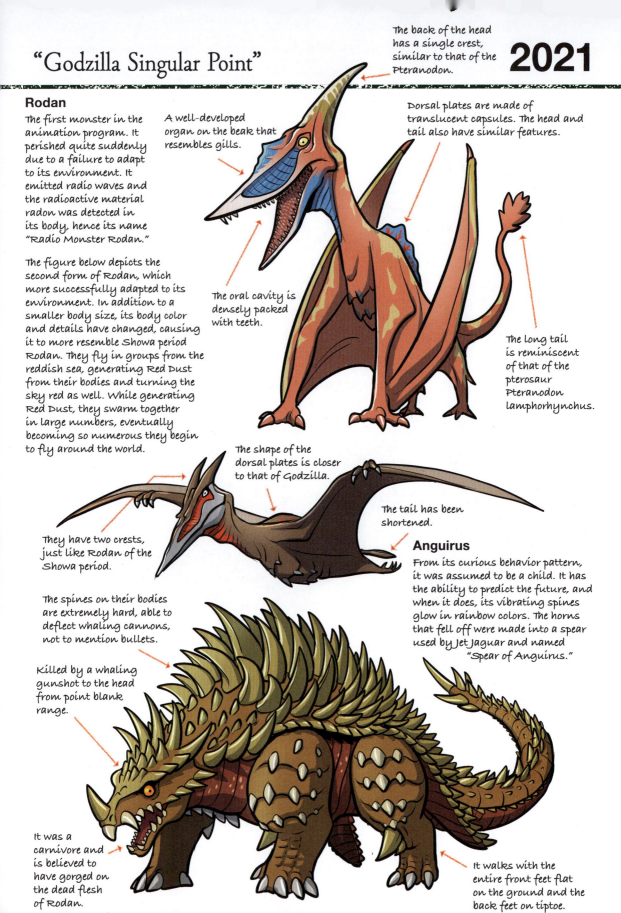

- The back of the head has a single crest, similar to that of the Pteranodon.
- A well-developed organ on the beak that resembles gills.
- Dorsal plates are made of translucent capsules. The head and tail also have similar features.
- The oral cavity is densely packed with teeth.
- The long tail is reminiscent of that of the pterosaur Pteranodon lamphorhynchus.
- The shape of the dorsal plates is closer to that of Godzilla.
- They have two crests, just like Rodan of the Showa period.
- The tail has been shortened.
- The spines on their bodies are extremely hard, able to deflect whaling cannons, not to mention bullets.
- Killed by a whaling gunshot to the head from point blank range.
- It was a carnivore and is believed to have gorged on the dead flesh of Rodan.
- It walks with the entire front feet flat on the ground and the back feet on tiptoe.

Anguirus

From its curious behavior pattern, it was assumed to be a child. It has the ability to predict the future, and when it does, its vibrating spines glow in rainbow colors. The horns that fell off were made into a spear used by Jet Jaguar and named "Spear of Anguirus."

204

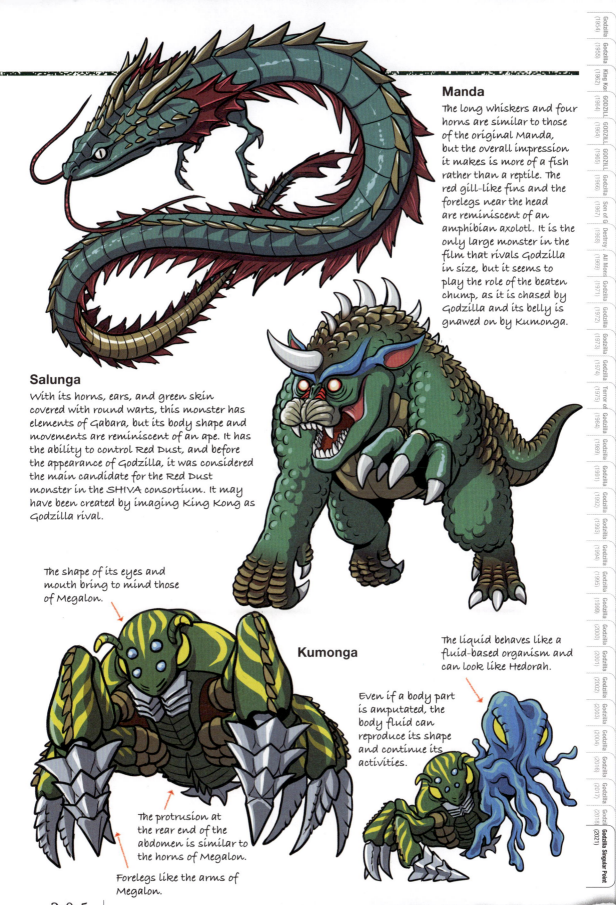

Manda

The long whiskers and four horns are similar to those of the original Manda, but the overall impression it makes is more of a fish rather than a reptile. The red gill-like fins and the forelegs near the head are reminiscent of an amphibian axolotl. It is the only large monster in the film that rivals Godzilla in size, but it seems to play the role of the beaten chump, as it is chased by Godzilla and its belly is gnawed on by Kumonga.

Salunga

With its horns, ears, and green skin covered with round warts, this monster has elements of Gabara, but its body shape and movements are reminiscent of an ape. It has the ability to control Red Dust, and before the appearance of Godzilla, it was considered the main candidate for the Red Dust monster in the SHIVA consortium. It may have been created by imaging King Kong as Godzilla rival.

Kumonga

The shape of its eyes and mouth bring to mind those of Megalon.

The protrusion at the rear end of the abdomen is similar to the horns of Megalon.

Forelegs like the arms of Megalon.

The liquid behaves like a fluid-based organism and can look like Hedorah.

Even if a body part is amputated, the body fluid can reproduce its shape and continue its activities.

205

"Godzilla Singular Point" 2021

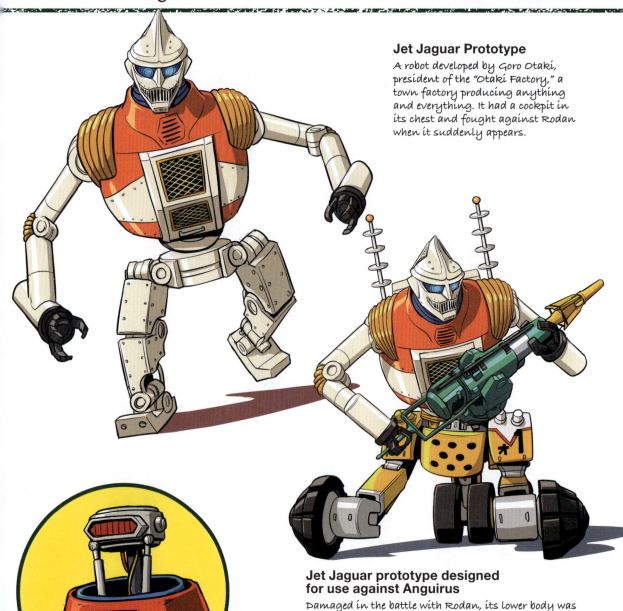

Jet Jaguar Prototype
A robot developed by Goro Otaki, president of the "Otaki Factory," a town factory producing anything and everything. It had a cockpit in its chest and fought against Rodan when it suddenly appears.

Jet Jaguar prototype designed for use against Anguirus
Damaged in the battle with Rodan, its lower body was replaced with a three-wheeled work robot, and the battery on its back was equipped with a radio wave transmitter. It fights Anguirus with a hand-held whaling cannon.

The head was blown off in the battle with Anguirus, and the exposed internal mechanism was designed to resemble the second head of Mechagodzilla (1975). It installed Yun Arikawa's support AI "Jung," detached its damaged rear wheels, and continued the battle as a two-wheeled machine.

Jung
Jung is a communication support AI "Naratake" developed by Arikawa Jung, installed on Jung's smartphone and endowed with its own personality. Once transferred to Jet Jaguar and obtaining a body, its personality developed further. Another Naratake, installed on Mei Jinno's computer, was given the name "Pero 2" and took on a separate personality.

206

Godzilla: The Encyclopedia

Jet Jaguar Beta flight unit specification

With the cooperation of the Self-Defense Forces, Jet Jaguar Beta was equipped with a flight unit and a seat in the back from which Yun Arikawa can ride. To avoid catastrophe, it heads for Godzilla at Tokyo Station.

Jet Jaguar Beta

Equipped with new, larger legs. Its cockpit has also been eliminated to become a fully AI-enabled robot. It fights against Kumonga's hordes with the "Spear of Anguirus," made from a horn of Anguirus.

After repeated forced updates, it is reverted to a child-like state and renamed "Jet Jaguar PP." After the protocol that turns Jet Jaguar into its strongest form is triggered, it balloons to gigantic size, fights Godzilla, and loses half of its head, but activates the Orthogonal Diagonalizer.

Jet Jaguar defies reason

Jet Jaguar, which appeared in "Godzilla vs. Megalon" (1973), has been regarded as one of the most unrealistic characters in the Godzilla series because of its absurdly illogical development, in which "a robot has a mind" and "grows into a giant by sheer force of will." In this work, which imparts a science fiction setting to the unreasonable existence of a monster, an attempt is made to apply the same logic to Jet Jaguar. The setting is esoteric, requiring a certain amount of knowledge and understanding, but it also links to the core of the story and has an appeal that draws you in even if you don't fully understand it, and it elevates Jet Jaguar to one of the main characters in the story.

207

Lecture on how to draw Godzilla's face

It is easy to draw Godzilla's face based on the basic structure of the two main types of Godzilla faces: "Showa" and "Heisei." Here, we will introduce the key points of each type of face.

Basic structure of Godzilla

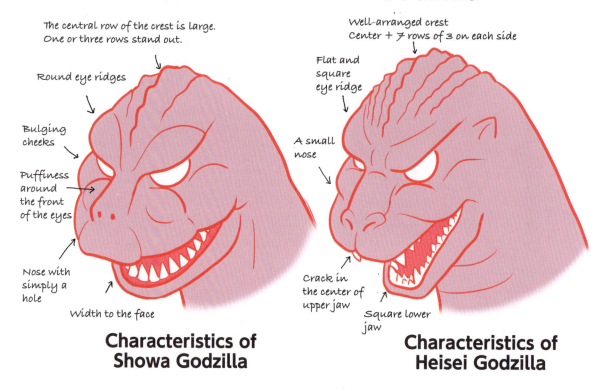

Characteristics of Showa Godzilla

Characteristics of Heisei Godzilla

Features of each Godzilla

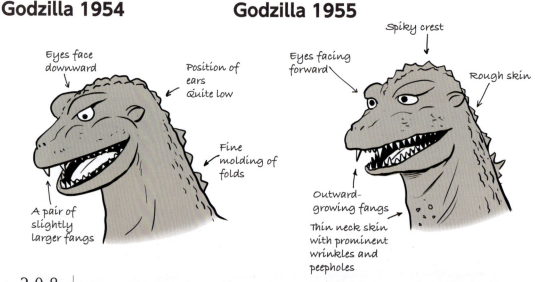

Godzilla 1954

Godzilla 1955

208

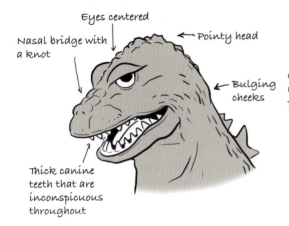
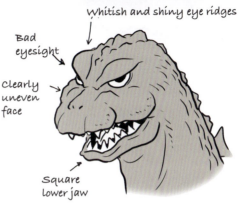
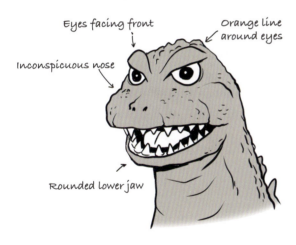
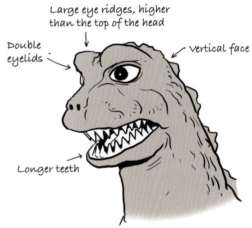
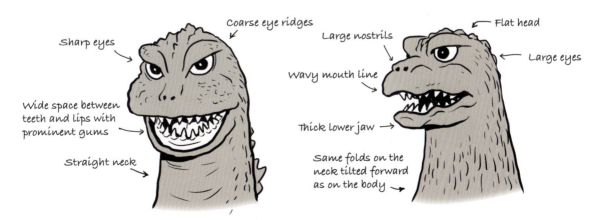

Godzilla 1984

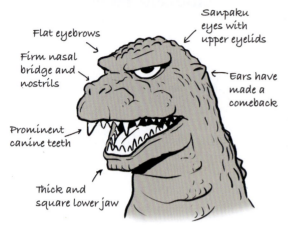

- Flat eyebrows
- Firm nasal bridge and nostrils
- Prominent canine teeth
- Sanpaku eyes with upper eyelids
- Ears have made a comeback
- Thick and square lower jaw

Godzilla 1989

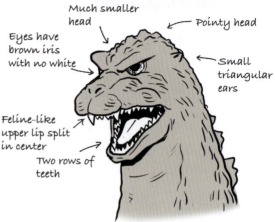

- Much smaller head
- Pointy head
- Eyes have brown iris with no white
- Small triangular ears
- Feline-like upper lip split in center
- Two rows of teeth

Godzilla 1995

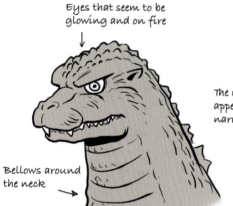

- Eyes that seem to be glowing and on fire
- Bellows around the neck

Godzilla 1999

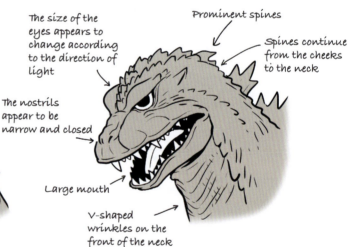

- The size of the eyes appears to change according to the direction of light
- The nostrils appear to be narrow and closed
- Prominent spines
- Spines continue from the cheeks to the neck
- Large mouth
- V-shaped wrinkles on the front of the neck

Godzilla 2001

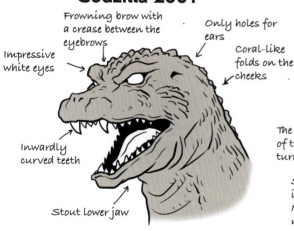

- Frowning brow with a crease between the eyebrows
- Impressive white eyes
- Only holes for ears
- Coral-like folds on the cheeks
- Inwardly curved teeth
- Stout lower jaw

Godzilla 2002

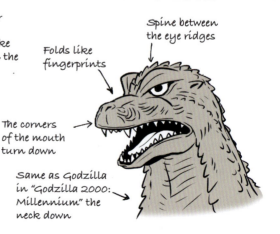

- Spine between the eye ridges
- Folds like fingerprints
- The corners of the mouth turn down
- Same as Godzilla in "Godzilla 2000: Millennium" the neck down

210

Godzilla: The Encyclopedia

Godzilla 2004

- Forehead is round
- Slit eyes
- Ears are shaped like those of the first Godzilla. The position is high.
- Nose at the tip of the face
- Both upper and lower jaw are extremely thin

GODZILLA 1998

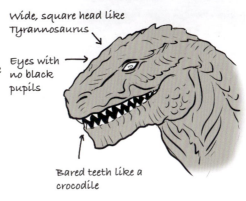

- Wide, square head like Tyrannosaurus
- Eyes with no black pupils
- Bared teeth like a crocodile

Godzilla 2016 (2nd Form)

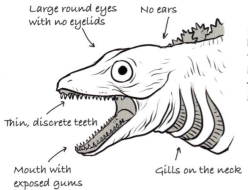

- Large round eyes with no eyelids
- No ears
- Thin, discrete teeth
- Mouth with exposed gums
- Gills on the neck

The size of the eyeball itself does not change from the second to the fourth form, but appears to change in proportion to the body size.

Godzilla 2016 (4th Form)

- Flat top of head without a crest
- Very small eyes
- Dorsal plates starting from the back of the head
- No lips and bare teeth. They grow in different places and sizes.
- Remnants of gills on the neck
- Lower jaw that opens left and right when it fires its radiation stream

Godzilla Earth

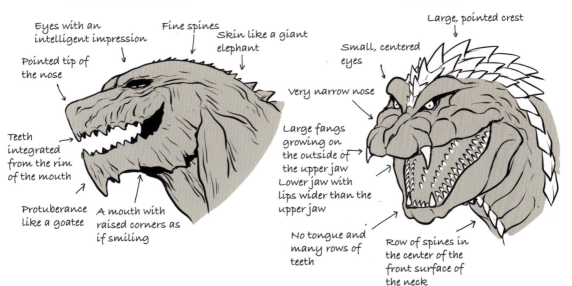

- Eyes with an intelligent impression
- Fine spines
- Skin like a giant elephant
- Pointed tip of the nose
- Teeth integrated from the rim of the mouth
- Protuberance like a goatee
- A mouth with raised corners as if smiling

Godzilla ultima

- Large, pointed crest
- Small, centered eyes
- Very narrow nose
- Large fangs growing on the outside of the upper jaw
- Lower jaw with lips wider than the upper jaw
- No tongue and many rows of teeth
- Row of spines in the center of the front surface of the neck

211

Shobijin (Small beauties)
1964 "Mothra vs. Godzilla"
1964 "Ghidorah, the Three-Headed Monster"
1967 "Ebirah, Horror of the Deep"
Twin sprites who live on Infant Island and can communicate with Mothra

Xilien
1965 "Invasion of Astro-Monster"
The female type of Xilien who came to invade the Earth by controlling the kaiju.

Mafune Katsura
1975 "Terror of Mechagodzilla"
Died in an accident, but revived as a cyborg to control Titanosaurus and Mechagodzilla.

Heroines deeply involved with the monster

Godzilla: The Encyclopedia

Miki Saegusa

1989 "Godzilla vs. Biollante"
1991 "Godzilla vs. King Ghidorah"
1992 "Godzilla vs. Mothra"
1993 "Godzilla vs. Mechagodzilla"
1994 "Godzilla vs. Spacegodzilla"
1995 "Godzilla vs. Destoroyah"

Possesses the psychic ability to perceive monsters and can communicate telepathically with Cosmos.

Cosmos

1992 "Godzilla vs. Mothra"

A race that built an advanced civilization on ancient Earth. These two are its sole survivors and can communicate with Mothra.

Emmy Kano

1991 "Godzilla vs. King Ghidorah"

Futurian of the 23rd century. She left Drats behind in 1954 and King Ghidorah was born.

People and terms

Showa Period Cast and Crew

Eiji Tsuburaya • Called the "God of Special Effects" for his unique innovations in special effects, he worked on the FX team for "Godzilla" (1954) and as special effects director and supervisor on "Godzilla Raids Again" (1955) and later on "All Monsters Attack" (1969).

Haruo Nakajima • The first suited actor for Godzilla. After playing the role of the first Godzilla with Katsumi Tezuka, he worked as a Godzilla actor until his retirement from the screen in "Godzilla vs. Gigan" (1972).

Sadamasa Arikawa • He was in charge of cinematography and served as the cameraman for the first Godzilla, since then being involved in the filming of the Godzilla series. After working as a special effects cameraman for Eiji Tsuburaya, he became involved as an FX director after "Ebirah, Horror of the Deep" (1966).

Yasuyuki Inoue • Art Director. He was transferred from New Toho to Toho as art director and participated in the production of "Godzilla" (1954). He created many miniatures, drawings and built sets that included the National Diet Building. Since then, he has been involved in many Godzilla series as an art assistant and art director.

Teizo Toshimitsu • Art director and modeler. He worked in Toho's special technology division and was in charge of modeling various monsters, including the first Godzilla. His work ranges from clay prototypes to the production of stuffed animals. He was involved in the Godzilla series until "Godzilla vs. Hedorah" (1971).

Kanju and Yasuei Yagi • Modelers. They worked in Toho's Special Technical Section, producing stuffed animals and miniatures, and collaborating with Toshimitsu and other special art and modeling staff in the production of monster costumes.

Akira Ifukube • Composer. After composing the soundtrack for "Godzilla" (1951), he worked on music for that series, Toho Tokusatsu films, and various other projects. After a brief hiatus from film music, he composed music for the VS series following "Godzilla vs. King Ghidorah" (1991).

Yoshimitsu Banno • Film director. After working as an assistant director for Toho, he planned and directed "Godzilla vs. Hedorah" (1971) based on the idea of a pollution monster. Following this, he was rarely involved in the Godzilla series, but produced a variety of films.

Heisei Era Cast and Crew

Nobuyuki Yasumaru • Art director and modeler. He worked on "Mothra" (1961) as a part-time miniaturist, and was involved in the production of the Godzilla series from "Destroy All Monsters" (1968) to "Godzilla vs. King Ghidorah" (1991).

Koichi Kawakita • Special effects director. He has been involved with the Godzilla series since working as assistant director on "Godzilla vs. Hedorah" (1971). In addition, he was the FX director from "Godzilla vs. Biollante" (1989) to "Godzilla vs. Destoroyah" (1995).

Fuyuki Shinada • Sculptor. He sculpted Biollante in "Godzilla vs. Biollante" (1989) and went on to work on Godzillasaurus in "Godzilla vs. King Ghidorah" (1991) and Godzilla in "Godzilla, Mothra and King Ghidorah: Giant Monsters All-Out Attack" (2001).

Takao Okawara • Film director. First entered the Godzilla series with "Godzilla vs. Mothra" (1992). Since then, he went on to direct "Godzilla vs. Mechagodzilla" (1993), "Godzilla vs. Destroyah" (1995), and "Godzilla 2000: Millennium" (1999).

Satsuma Kenpachiro • Actor. He appeared in the Godzilla series as a suited actor the first time as Hedorah in "Godzilla vs. Hedorah" (1971). Since "The Return of Godzilla" (1984), he has portrayed Godzilla in the Heisei Godzilla series.

Noriyoshi Orai • Illustrator. He illustrated movie posters for "The Return of Godzilla" (1984) and other films in the Heisei Godzilla series. In addition to posters, he is also well-known for his illustrations for the novel series "Harmagedon: Genma taisen" and the game series "Saga of Three Kingdoms."

Millennium Cast and Crew

Tomomi Kobayashi • Sculptor. He worked on the Godzilla series for the first time in "Godzilla vs. Megalon" (1973). After working on a number of Godzilla series films, he served as chief sculptor on "Godzilla vs. King Ghidorah" (1991). He continued to work on "Godzilla Final Wars" (2004).

Yuji Sakai • Sculptor. He first worked on "Godzilla vs. Destoroyah" (1995) as a member of the monster sculpting staff, later was put in charge of Godzilla design for "Godzilla 2000: Millennium" (1999).

Kenji Suzuki • Special technology. Kenji joined the Godzilla series as an assistant director for "Godzilla vs. King Ghidorah" (1991). He worked on "Godzilla 2000: Millennium" (1999) and "Godzilla vs. Megaguirus" (2000) as a special engineer.

Yuichi Kikuchi • Special effects director. His first outing in the Godzilla series was as an assistant director for "Godzilla vs. Megaguirus" (2000). After working on "Godzilla, Mothra and King Ghidorah: Giant Monsters All-Out Attack" (2001), he took charge of special effects for "Godzilla Against Mechagodzilla" (2002).

Masaaki Tezuka • Film director. He made his directorial debut with "Godzilla vs. Megaguirus" (2000) as he entered the Godzilla series. He directed "Godzilla against Mechagodzilla" (2002) and "Godzilla: Tokyo S.O.S." (2003).

Shusuke Kaneko • Film director. He directed "Godzilla vs. Mothra" (1992) and "Godzilla, Mothra and King Ghidorah: Giant Monsters All-Out Attack" (2001). He is also known for directing the Heisei Gamera series as well as "All Quiet on the Recruit Front" (1991).

Ryuhei Kitamura • Film director. After directing movies such as "Azumi" (2003) and "Metal Gear Solid the Twin Snakes" (2004), he directed "Godzilla Final Wars" (2004).

Hideaki Anno • Film director. His directorial debut was the animated film "Aim for the Top! GunBuster" (1988). He is the general director of the Evangelion series and has directed many films including the live-action "Love & Pop" (1998). For "SHIN GODZILLA" (2016), he was in charge of general direction, screenplay, and others.

Tsutomu Kitagawa • Action actor. He has appeared in many Power Rangers and Masked Rider series, portraying Godzilla in "Godzilla 2000: Millennium" (1999). Since then, he has played Godzilla in the Millennium series.

Yasushi Nirasawa • Illustrator. He specializes in creature designs and is also a sculptor, going on to work on many Masked Rider series. He designed Gigan, Xilien, and more for "Godzilla Final Wars" (2004).

Company

Build-Up • Art production company that focused on modeling, and later also worked on VFX and other projects. It was responsible for some of the monster suits in "Godzilla vs. Biollante" (1990) and "Godzilla vs. King Ghidorah" (1991).

Terminology

Showa series • A generic term for the Godzilla films produced during the Showa period, beginning with "Godzilla" (1951), directed by Inoshiro Honda and Eiji Tsuburaya. "The Return of Godzilla" (1984) was actually released in Showa, but is not included in this category.

Champion Festival • The Champion Festival, an entertainment program for children, was held from 1969 to 1978 as a Toho attempt to cope with slumping box office revenue from the decline in the appeal of theatrical films caused by the popularity of television. Godzilla was also to be shown in this program, but at the same time production costs were drastically reduced, new actors were used, production staff was cut back, and the filming period was shortened.

Heisei series (VS series, Heisei VS series) • The Heisei Series is a generic name for the films produced over the 11 years from "The Return of Godzilla" in 1984 to "Godzilla vs. Destoroyah" in 1995, as the story centers around the same 1984-era Godzilla. Among these, the six films from "Godzilla vs. Biollante" (1989) to "Godzilla vs. Destoroyah" (1995) are referred to as the "VS Series" because they focus on monsters that are hostile to Godzilla. Also generally known as the "Heisei VS Series."

Millennium Series • The "Millennium Series" is the generic name for the six films produced during the millennium, from "Godzilla 2000: Millennium" (1999) to "Godzilla Final Wars" (2004). "Godzilla 2000: Millennium," "Godzilla vs. Megaguirus," "Godzilla, Mothra and King Ghidorah: Giant Monsters All-Out Attack" are all set after "Godzilla" (1951) and are unconnected to the previous films.

SHIN GODZILLA • Like the first Godzilla film, it depicts a world in which Godzilla appears for the first time. It is distinctive in that Godzilla, until then portrayed by a performer in a suit, is now fully CG thanks to VFX.

Theatrical CGI animated film • A theatrical Godzilla produced entirely in full CG animation, the trilogy is "GODZILLA: Planet of the Monsters" (2017), "GODZILLA: City on the Edge of Battle" (2018), and "GODZILLA: The Planet Eater" (2018).

Godzilla Singular Point • This was broadcast as an animated TV series in 2021, consisting of 13 episodes and was set in Japan circa year 2030.

Index

Kaiju

Anguirus 12, 46, 178
Babygodzilla 114
Baragon 52, 146
Batra 102, 104
Biollante 86, 88
Destroyer 126
Dorat 93
Ebirah 34, 174
Gabara 56
Ganimes 161
Gezora 161
Ghidorah 201
Giant Condor 33
Gigan 62, 172
Godzilla 6, 10, 14, 18, 30, 32, 36, 44, 64, 80, 84, 90, 98, 106, 116, 124, 134, 144, 152, 164, 194
Godzilla amphibia 202
Godzilla aquatilis 202
Godzilla Earth 198
Godzilla Filius 198
Godzilla Jr. 130
Godzilla terrestris 202
Godzilla ultima 203
Godzillasaurus 48
Godzillasaurus 92
Hedorah 58, 188
Jet Jaguar 68
Kamacuras 40, 184
Kamoebas 160
Kaizer Ghidorah 170
King Caesar 72, 182
King Ghidorah 26, 94, 150
King Kong 16
Kumonga 42, 186
Littlegodzilla 120
Manda 50, 176
Mecha-King Ghidorah 96
Mechagodzilla 70, 74, 108, 200
Megaguirus 142

Megalon 66
Meganula 140
Meganulon 140
Millennian 136
Minilla 38, 166
Modified Multi Purpose-Fighting System 158
Multi Purpose-Fighting System Kiryu 154, 156
Kiryu 158
M.O.G.U.E.R.A. 122
Monster X 168
Mothra 20, 22, 100, 148, 162
Orga 138
Radon 24, 112, 180
Servum 199
Shockirus 83
Space Godzilla 118
Super Mechagodzilla 110
Titanosaurus 76
Varan 54
Zilla 190

Cast and Crew

Akira Ifukube 109
Eiji Tsuburaya 15, 31, 35, 61
Fuyuki Shinada 145
Haruo Nakajima 19, 31, 37, 39, 45, 53,
Hideaki Anno 195
Kanju Yagi 65
Kenji Suzuki 134
Kenpachiro Satsuma 124
Koichi Kawakita 85, 87, 89, 97, 99,
Masaaki Tezuka 149, 153
Nobuyuki Yasumaru 65, 80, 161
Noriyoshi Orai 95, 111
Ryuhei Kitamura 165
Sadamasa Arikawa 35
Shusuke Kaneko 145
Takao Okawara 115
Teizo Toshimitsu 65
Tomomi Kobayashi 176
Tsutomu Kitagawa 165
Yasuei Yagi 65
Yasushi Nirasawa 173
Yasuyuki Inoue 35
Yoshimitsu Banno 61
Yuichi Kikuchi 155
Yuji Sakai 135

Godzilla: The Encyclopedia by Shinji Nishikawa

First designed and published in Japan in 2023 by Graphic-sha Publishing Co., Ltd.
1-14-17 Kudan-Kita, Chiyoda-ku, Tokyo 102-0073, Japan

© 2023 Graphic-sha Publishing Co., Ltd.
TM & © TOHO CO., LTD.
© Shinji Nishikawa
This English edition is published in 2024 by Titan Books
All rights reserved.

Original edition creative staff
Art Director: Takuji Segawa
Writer: Naomichi Tanaka
Editor: Akira Sakamoto
 (Graphic-sha Publishing)

English edition creative staff
English translation: Sean Gaston, Yuko Wada,
 Haruka Yoshio
English edition layout: Shinichi Ishioka
Foreign edition Production: Takako Motoki, Yuki Yamaguchi
and management (Graphic-sha Publishing)

Published by Titan Books, London, in 2024.
10 9 8 7 6 5 4 3 2

No part of this publication may be reproduced, stored in a retrieval system, or transmitted, in any form or by any means without the prior written permission of the publisher, nor be otherwise circulated in any form of binding or cover other than that in which it is published and without a similar condition being imposed on the subsequent purchaser.

TITAN BOOKS

A division of Titan Publishing Group Ltd
144 Southwark Street
London SE1 0UP
www.titanbooks.com

Find us on Facebook: www.facebook.com/titanbooks
Follow us on X: @TitanBooks

A CIP catalogue record for this title is available from the British Library.
ISBN: 9781835410363

Printed in China.

Afterword

The illustration column "Godzilla Grand Dissection by Shinji Nishikawa," which was included in the booklet of DeAgostini's "Creating Godzilla Weekly" for two years starting in 2019, was a project I undertook to create a comprehensive summary of my activities over the years illustrating Godzilla and other kaiju, as well as my monster design. This book is based on that project, with significant additions and restructuring. I am deeply moved by the fact that I was able to combine illustrations of over 100 monsters in a single volume brought to life with great enthusiasm, as well as stories and discussions about each one. In addition, I am proud to have produced something that both Godzilla newbies and enthusiasts will find enjoyable. We hope that this book will give you a new appreciation for the fascination surrounding these incredible monsters.

Shinji Nishikawa
Manga artist and character designer.
Born in Kyoto. While a student at Doshisha University, he published "The Legend of Godzilla" at his own expense under the pen name "MASH" in 1986 with the aim of becoming a manga artist. He attracted attention not only from the fanzine world but also from major publishers. After working for a game software company, he debuted as a cartoonist in 1988 with "Clay Idol Family." His representative works include "YAT Untroubled Space Tours," "Grandma and Grandpa Fight!" and "Sashimi of the Blue Sea," etc. He did design work for "Godzilla vs. Biollante" in 1989. Since then, he has been active in monster and mechanical design for the "Godzilla" series and the "Heisei Mothra" series.